Digital
Nature and
Landscape
Photography

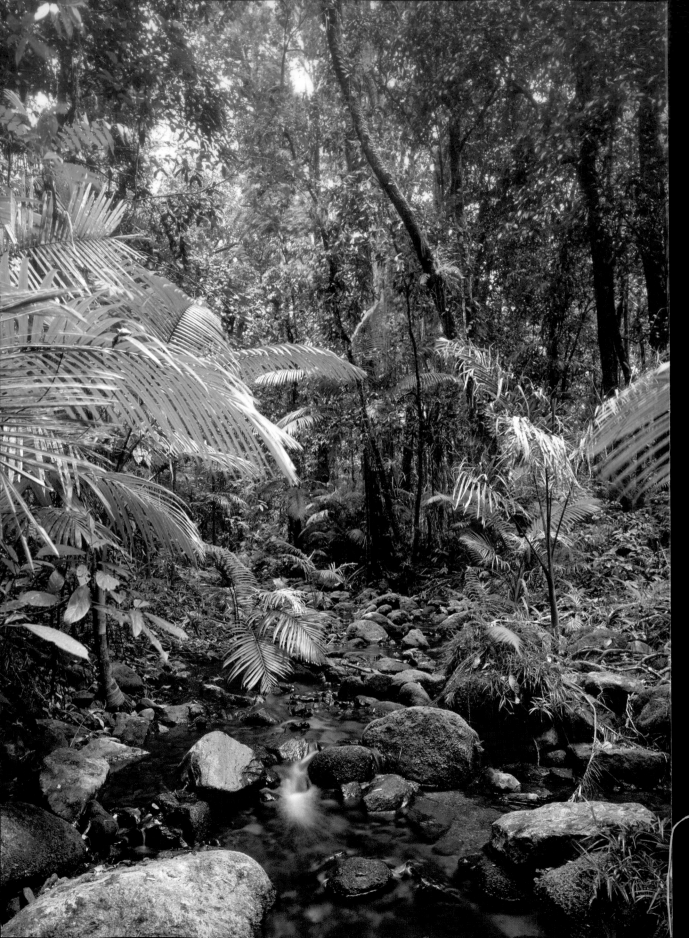

Digital
Nature and
Landscape
Photography

MARK LUCOCK

photographers'
pip
institute press

First published 2007 by
Photographers' Institute Press / PIP
an imprint of
The Guild of Master Craftsman Publications Ltd,
166 High Street, Lewes, East Sussex, BN7 1XU

ISBN 978-1-86108-514-6

British Cataloguing in Publication Data. A catalogue record of this book is available from the
British Library.

Production Manager: Jim Bulley
Managing Editor: Gerrie Purcell
Photography Books Project Editor: James Beattie
Managing Art Editor: Gilda Pacitti
Designer: James Hollywell

Typeface: ITC Avant Garde Gothic
Colour reproduction by Altaimage
Printed and bound by Hing Yip Printing Co. Ltd

contents

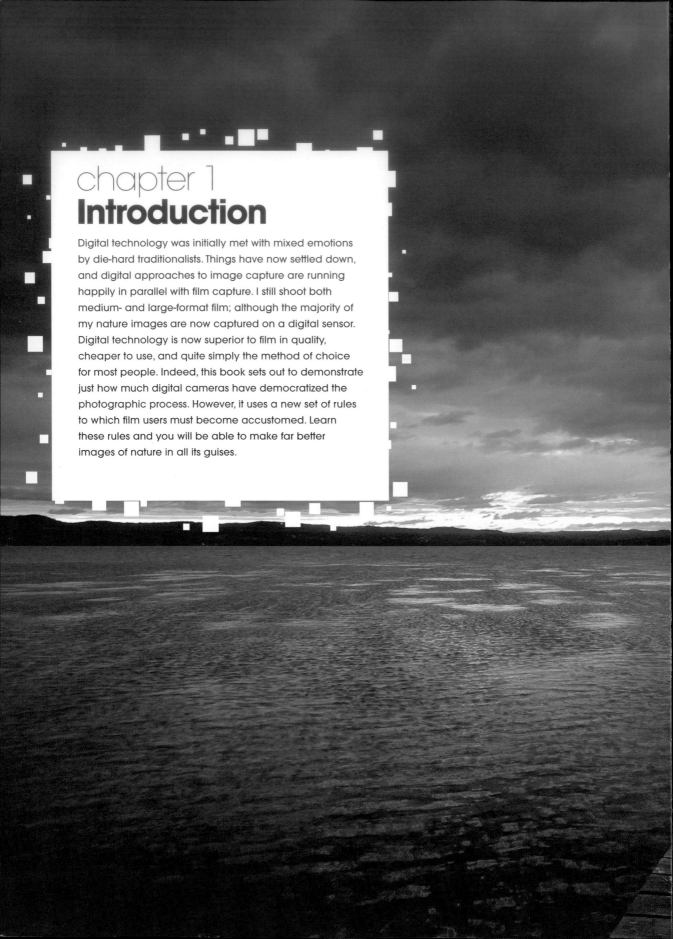

chapter 1
Introduction

Digital technology was initially met with mixed emotions by die-hard traditionalists. Things have now settled down, and digital approaches to image capture are running happily in parallel with film capture. I still shoot both medium- and large-format film; although the majority of my nature images are now captured on a digital sensor. Digital technology is now superior to film in quality, cheaper to use, and quite simply the method of choice for most people. Indeed, this book sets out to demonstrate just how much digital cameras have democratized the photographic process. However, it uses a new set of rules to which film users must become accustomed. Learn these rules and you will be able to make far better images of nature in all its guises.

A brief history

The ground rules have now shifted such that the savvy modern photographer has to use sophisticated imaging and asset-management software, web design, and even publication layout and production skills. This book will set you on a course to a different, more mature type of photography; one in which you remain in control from start to finish, even if you employ the skills of a professional lab. I have tried to make this book useful to everyone, from beginners and keen amateurs, to aspiring and established professionals. It is primarily aimed at those interested in nature photography, but I hope that there will also be plenty of information that will prove useful in many other photographic genres. But, before we jump in at the deep end, let's first take a look back over the history of photography to illustrate just how far we have come in the pursuit of images.

The photographic process has changed greatly over the past few years; however, photography with camera and lens is still the main portal for all forms of still-image capture. Where it all began is slightly unclear, although we do know that photography in one form or another has been around for a very long time. Leonardo da Vinci produced a drawing in the early Sixteenth Century of a 'Camera Obscura', translated literally as a 'darkroom'. However, this prototype imaging device – essentially a container (often an entire room) with a small hole in one wall that produces an inverted image on the opposite wall – was in fact known about more than a thousand years ago. As we shall see, photographic technology has come a very long way from this early, oversized pinhole camera.

As if foreshadowing recent arguments between proponents of film and those of digital capture, painters and other artisans during the early 1800s saw the photographic process as a threat to their art form. Around this time, Louis Daguerre discovered a rapid (30 minute) method of developing photographic plates, in which a latent image could be rendered permanent by treating it with a saline solution. In 1839 the Daguerreotype became an instant success, and a viable alternative to the artist's brush.

Unfortunately, the Daguerreotype process was expensive, and each picture was a one-off rendition, with no means of being reproduced. William Henry Fox Talbot addressed this problem with his invention of the 'Calotype'. Although the early Calotype could not match the quality of a Daguerreotype, it offered the advantage that one could generate an unlimited number of positive prints. The earliest paper negative (1835) is 1in (25mm) square, and immortalizes a window at Lacock Abbey.

As the process evolved, attention moved from paper to glass that was coated with chemically sensitized egg albumen. Eventually the 'Collodion' process was developed by Frederick Scott Archer in 1851. This photographic method cut exposure times to just a few seconds, and was the harbinger of modern photographic processes.

The next major step in the evolution of photography, as we know it today, came with the advent of the gelatin-based dry-plate process. Richard Maddox used gelatin as a substitute for glass, allowing images to be developed more rapidly.

◀ **Yorkshire Moors National Park near Fylingdales early warning station, Yorkshire, UK.** Blending old and new. This is just the sort of image that a view camera was made for; I employed front tilt to ensure everything was in focus from near to far, and used my filter system to enhance colour instead of Photoshop. The image was taken on my Ebony RSW 5x4 view camera with an 80mm wideangle lens. I used an 81C warm up filter in combination with a two-stop neutral-density graduated filter. The Velvia sheet film was then scanned professionally to produce a 300dpi file that can be used to produce very large and sharp prints (beyond what is possible with a DSLR). The rock provides a foreground interest that anchors the image and leads into the heather, and on to a dark, brooding sky.

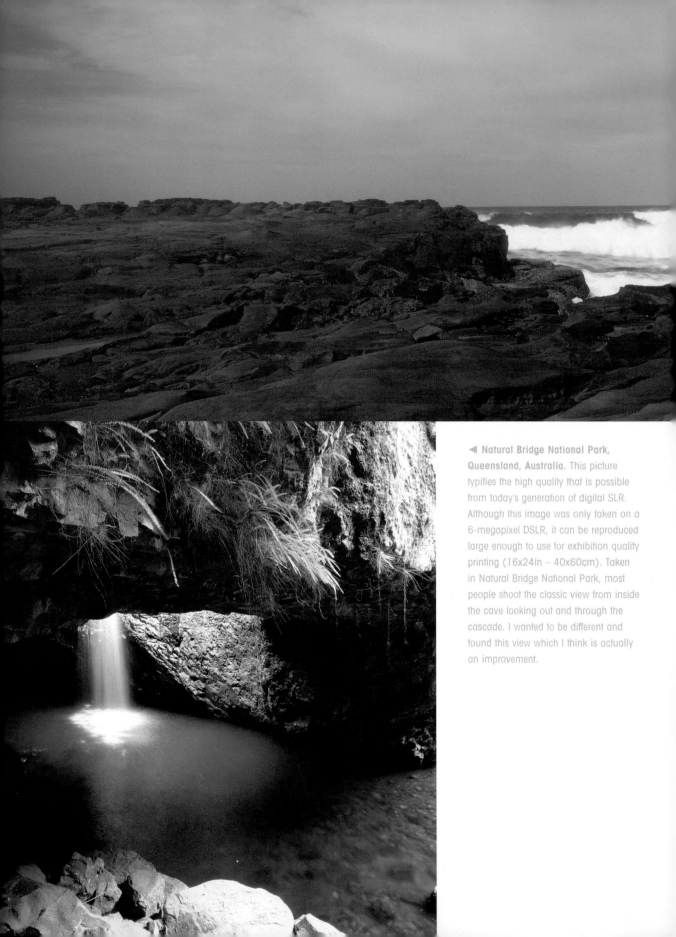

◀ **Natural Bridge National Park, Queensland, Australia.** This picture typifies the high quality that is possible from today's generation of digital SLR. Although this image was only taken on a 6-megapixel DSLR, it can be reproduced large enough to use for exhibition quality printing (16x24in – 40x60cm). Taken in Natural Bridge National Park, most people shoot the classic view from inside the cave looking out and through the cascade. I wanted to be different and found this view which I think is actually an improvement.

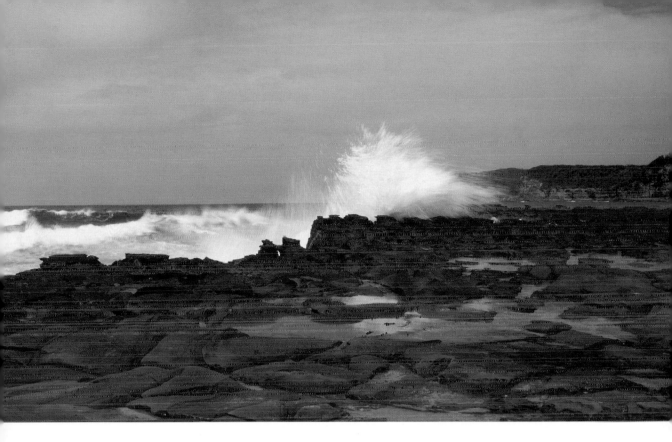

Celluloid was invented in the mid-1800s, and it wasn't long before this new material was being used as a backing for a light-sensitive coating. Most photographers are familiar with George Eastman who, in 1884, introduced a flexible celluloid based film akin to that we would recognize today. Within five years he had produced and marketed the now famous 'box' camera, and hence introduced photography to the masses.

Photography has come a long way since then, although it could be argued that despite obvious refinements, the basic principle of the photographic process remained the same until only recently, when the advent of digital image capture created a sea change in the way pictures are captured, printed and manipulated.

The availability of a variety of accessible techniques is only part of the story in making photography so popular; the medium has also been popularized by a number of key figures over the years. In 1994, *American Photo* voted fashion photographer Richard Avedon the most important person in photography of that year. In 1997 it was Diana, Princess of Wales, whose death caused a controversy in relation to the paparazzi. In 2005 Mark Getty and Jonathan Klein were voted into the number one position – their partnership, Getty Images, makes them one of the most dominant forces in photography today. Clearly, not all influential figures in photography carry a camera.

Everybody has their own influence, and many of us first picked up a camera to emulate some well-known icon of photography: David Bailey, Frans Lanting, Annie Leibovitz, Steven Meisel, Art Wolf, and the list goes on. Personally, I responded to the great American landscape photographers. Ansel Adams created landscape masterpieces; along with fellow artisans such as Edward Weston he co-founded the photographic association 'Group f/64'. He also developed the 'Zone System': a process that permits the photographer to render a visual impression of their subject that yields the

▲ **North Avoca beach, New South Wales, Australia.** The use of film has a long pedigree that continues to this day, but in order to realize the full potential of film, one has to employ digital technology. This panoramic scene was taken on a Fuji GX617 panoramic camera with a 90mm lens. The final Velvia transparency was scanned at home on an affordable Epson flat-bed scanner with a slide adapter. The final file is set to print at roughly 36x12in (90x30cm) using an output resolution of 300dpi.

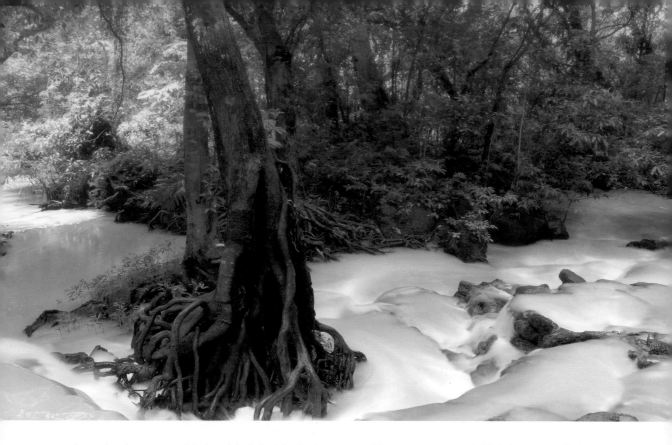

maximum tonal range possible from black & white film. In a sense, this was an early example of image enhancement to bring out the best from a picture – something that we can all do so much more easily these days using image-editing software. Contemporary landscape photographers who follow in Adams' footsteps undoubtedly enhance their images in programs such as Photoshop with much greater ease than he did in the darkroom using a chemical approach. While landscape photography often only requires subtle tweaking in image-editing software, there are many other influential photographers who push the limits of how far a photograph can be manipulated much further. Some digital manipulations have parallels in the traditional darkroom, others do not; this book aims to bring to your attention all the new possibilities that the digital era has ushered in for nature and landscape photographers. This includes the optimum approach to scanning transparencies for exhibition-quality output, the best way to turn a proprietary RAW file into a work of art that can be printed large and, within certain limits, compete with drum-scanned film for quality; in other words creating an efficient and effective 'workflow' to produce the best possible end result.

Perhaps of greatest significance is the way in which we can communicate, promote and disseminate our work. I will show you how easy it is to produce your own website without recourse to expensive webmasters or the plethora of fixed template sites that are available online. Microsoft FrontPage and Adobe Dreamweaver are fairly straightforward to use, and need not be feared. The rise of sensor technology, the Internet, and on-demand publishing are not just revolutionizing our photography; they are democratizing the entire process. Given the average home computing power and storage capacity, we are all capable of producing, and even selling, amazing nature and landscape photographic products. What could be better than owning an online shop window for your nature and landscape photography? Also on-demand

▲ **Silt-laden stream, Thailand.**
This swirling silt-laden stream in spate after monsoon rains was shot on a DSLR, which is an ideal tool for combining quality and convenience.

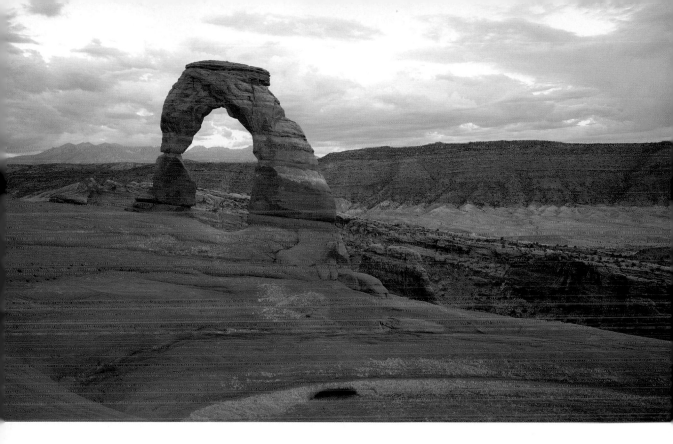

publishing, now offers you the capability to produce 'coffee-table' books of a quality that is quite staggering, and often better than many traditional publishing houses currently produce.

The digital revolution

Few people would argue against the fact that photographers are living in dynamic and interesting times. After decades of relative stability, photography has undergone a monumental revolution. As photographers we have recently found ourselves on a remarkably steep and often intimidating learning curve. After years of indulging our passion using the stable, highly evolved technology of film, we now find ourselves chasing ever-advancing technology, and in constant dialogue with our bank managers as we seek to afford the latest and greatest digital camera.

Comparing an image from one of today's amazing digital cameras with the output from the first generation of their digital ancestors is analogous to comparing the quality of a 5x4in Velvia slide with that of a Calotype, the changes have been so great; but the history of digital imaging is short compared to that of film. In 1972 Texas Instruments was first to patent a non-film electronic camera. In 1981 the first commercial electronic camera was released by Sony: the 'Mavica electronic still camera' – essentially a video camera that froze video frames.

Important work was undertaken by Kodak from the 1970s onwards and led to the development of early image-sensor technology that produced true digital images on solid-state sensors. Kodak's first 1.4-megapixel camera was released in 1984; however, it wasn't until 1991 that it was followed by Kodak's first genuinely professional-level digital-camera system. This model was aimed squarely at photojournalists, and was a 1.3-megapixel camera housed in a Nikon F3 body.

▲ **Delicate Arch, Arches National Park, Utah, USA.** This image shows the most famous rock arch in the world and the La Salle Mountains illuminated by the setting sun. It was taken on a Fuji GSWIII 6x9 medium-format rangefinder. The one second exposure at f/8 required a sturdy tripod. However, getting a good exposure on film was a problem because of all the other people sharing in the Delicate Arch sunset experience. I went through several rolls of film to obtain just a couple of decent shots that didn't have people in view. A DSLR would have been an easier, more effective and more economical tool to use in this situation. This file was scanned professionally to allow very large prints to be produced.

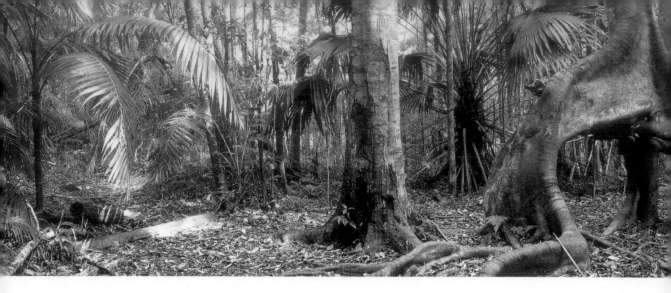

From the mid-1990s a procession of digital cameras were marketed by companies such as Sony, Kodak and Casio. However, at this time photography was still led by film-based media. Canon did much to shift the mass market from film to digital capture, and the 4-megapixel EOS 1D became a major tool for photojournalists, while the competitively priced 6-megapixel EOS 10D, followed by the EOS 300D/Digital Rebel (the first digital SLR below $1,000) introduced high-quality imaging to the masses. Today a huge range of manufacturers produce everything from digital compacts, through digital SLRs, to extremely high-resolution medium-format cameras and backs.

When sensors first hit the 6-megapixel mark, they achieved an image quality that matched, and many would argue actually bettered 35mm film. As the resolution of cameras increased even further, so the quality possible moved into the realms of what is expected from medium-format film. The bottom line is that digital cameras are now at a level that should satisfy even the most discerning of photographers. The question is: 'how do you get the most out of your digital camera, and how can you create the best images of a broad range of subjects?'

The answer lies in a combination of timeless camera craft, with some knowledge of computer systems, and particularly software programs such as Adobe Photoshop. Master these and the possibilities are endless – limited only by your imagination.

There can be little doubt that as a craft, photography has become far more interesting and challenging than ever before. This book aims to provide you with enough background information to set you firmly on the path to success in nature and landscape photography, no matter whether you use a digital SLR, digital compact or even prefer to stick with traditional photographic tools such as 35mm, medium-format, large-format or panoramic cameras, and then scan transparencies to make the most of options available in Photoshop. Whatever path you choose, this book will be your guide into a new world of imaging – one that is changing very rapidly, and is certainly very different from even five years ago.

Such a rapid change in the way we capture images can be a frightening, not to mention expensive, transition for many of us. Without a crystal ball, there is no way of predicting where we will be in another five years' time. What you can be sure of is that this book will help you adapt to today's digital world, and prepare you for whatever further developments tomorrow holds in store for photographers.

A brief overview

Unlike many contemporary digital-photography guides and books on nature and landscape photography, the content of this book aims to offer precisely what you need to become highly proficient in the skills of creating, processing, archiving and printing digital files. However, it also goes well beyond this, providing an in-depth reference for photographers of all levels of experience and ability.

The following chapters discuss traditional camera skills, photographic principles, digital image capture via scanners or cameras and, perhaps of greatest importance, the essentials of Photoshop and other related imaging software.

Just a few years ago, photographers had no need to know anything about digital capture or Photoshop manipulation. That's all changed a couple of hours before sitting down to write this, I finished processing 47 RAW image files taken on my Canon EOS 1D MkII DSLR. All were landscapes – lily ponds, forested creeks and so on. When I first converted the RAW files into TIFFs (tagged image format files), I was left with 47 drab, flat and soft images. One and a half hours later, I had used Photoshop to work on these TIFFs, altering resolution, brightness, contrast, saturation and sharpness in all the images. The result was 47 pin-sharp, perfectly exposed and luminously saturated images that simply leapt from the screen – they were all far better than any Velvia slide I have ever exposed. The bottom line is that in order to make the most of your digital camera, you need a good understanding of programs such as Photoshop. In this book, I will outline all the skills you need to get the most out of your camera and thus optimize your ability to render beautiful images of your chosen subject and introduce you to various software programs.

Some of the most important image-processing techniques are illustrated with worked examples using 'screengrabs' to show you precisely how to create the final effect. The techniques are largely the same, irrespective of your genre of photography; however, the emphasis here is on the natural world.

As I have already mentioned, this book will also introduce you to the world of website construction, and the process of producing your own on-demand 'coffee-table' books, which, when combined, offer arguably the best forms of self-promotion that are currently available to the budding nature and landscape photographer.

▲ **Strangler fig, Katandra Reserve, New South Wales, Australia.** This strangler fig was shot on a compact digital camera in PhotoStitch mode. It is one of my first successful 'stitches', and demonstrates the power of even relatively simple digital compacts. It shows just how far digital photography has come in attacking the classic methods of generating panoramas with expensive film cameras. Digital techniques are now so easy and accessible that they are democratizing the whole of photography.

The following chapter will introduce you to the concept of a 'workflow', and the types of hardware and software that photographers will need to edit images digitally. Chapter three will discuss the 'nuts and bolts' at the heart of the digital process, while chapter four will set out what you can do with various image-editing techniques, while it will also introduce you to the printing options that are available. Chapters five and six cover how the new digital technology applies to traditional photographic and field craft skills; while the final chapter will help you gain a professional perspective and introduce you to new skills such as web authoring, designing your own promotional material and on-demand publishing, which I would argue are a necessary part of any photographers repertoire of expertise.

▲ **Dyed silk, Souk, Marrakesh, Morocco.** Shot on 35mm film and scanned for relatively small print output. For me, this picture sums up the vibrant colour and frenetic pace of life in Marrakesh. DSLRs weren't available when I took this image, so while I would prefer to have a digital RAW file of this scene, I have to settle for a 35mm slide instead – I have tens of thousands of slides and I would be an old man if I were to try to digitize all of these to a standard I would be happy with.

▶ **Mount Warning National Park, New South Wales, Australia.** This view is a stereotypical rainforest scene – I half expected Tarzan to swing out of the canopy on a vine! Shot on a Canon DSLR with a 17–40mm lens and tripod.

▶ **Pair of American alligators.** A DSLR is an ideal tool for a wide range of subjects, as these alligators shot with a macro lens show. A DSLR's flexibility means that with a relatively modest array of kit you are able to shoot, intimate animal portraits, sweeping vistas and everything in between.

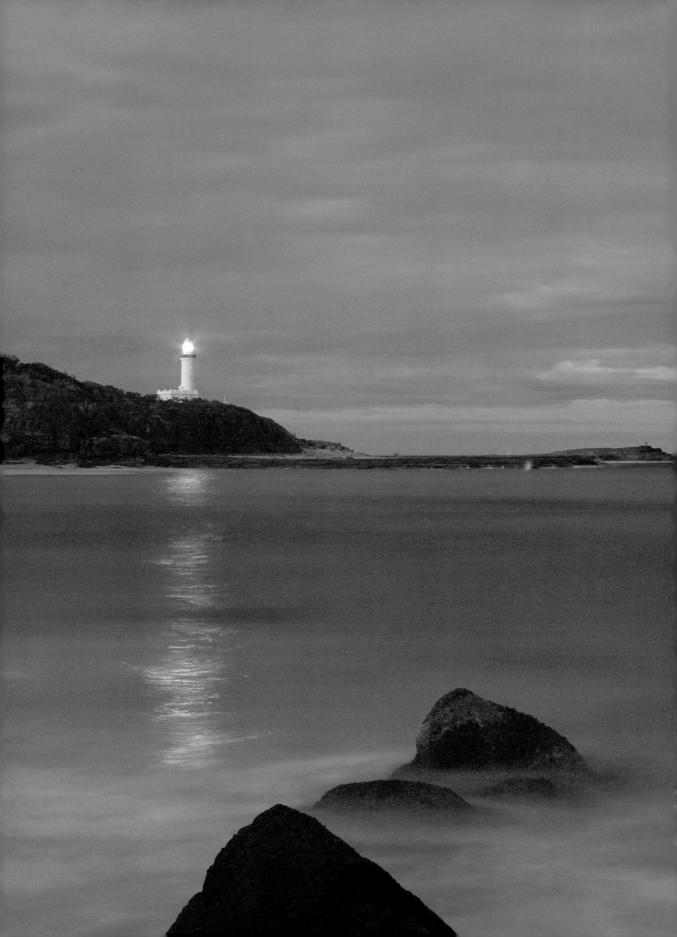

Norah Head Lighthouse from Soldiers Beach, New South Wales, Australia

I took a succession of pictures on this evening trying to get the balance between all the elements just right. Only two of the frames taken on my Canon DSLR fitted with a 50mm lens turned out to be perfect, and just what I was after. I filled a 512MB memory card with all the pictures that I took. Just imagine how much that would have cost if it was 5x4 sheet film that I had used instead!

- I needed to apply a constant downward pressure on the tripod to counter a moderate breeze that would otherwise have caused camera shake. As well as find a location that did not cause flare from the beacon's powerful light.

- The smooth texture of the sea, foreground rocks and lighthouse is exactly what I was after, and the file looks great when printed large. Even though exposure was 60 seconds, little noise is evident; although a few 'hot' pixels needed to be corrected, as is invariably the case with long exposures made on any DSLR. The secret was to add a polarizer and moderately strong neutral-density filter to increase the length of the exposure.

- Curves were applied in Photoshop, some red was added along with 10–20% saturation. Then the file was interpolated using Extensis Smartscale to create a file suitable for a 24in (60cm) print. The image was then sharpened using Unsharp Mask

chapter 2
Early considerations

Before moving into the detailed world of digital imaging, I want to introduce you to the concept of a 'digital workflow'. This is fundamental to everything you do with your camera and computer. It is the elaborate process from capturing to manipulating and printing or archiving the image. Clearly, there are many variations on the theme of digital workflow, but I'll give you my approach, which I'm sure is similar to that employed by many other pros, and you can adapt it for your own purposes. At each stage of the digital workflow, I will refer you to the key processes described in detail later in the book, just remember the purpose of your workflow is to manage your images efficiently, leaving you with more time to enjoy taking photographs.

◄ **Flamborough Head, Yorkshire, UK.**
This view of Flamborough Head was
taken on my Ebony RSW 5x4 view
camera with an 80mm wideangle
lens. The sheet film was then scanned
professionally to produce a high-
resolution file suitable for large prints.

Film or digital

Before discussing the workflow, I feel obliged to answer the seemingly eternal
question of digital capture versus film capture: 'which is best?' While it might
seem strange for a book called *Digital Nature and Landscape Photography*,
the answer is simply that neither is better in an absolute sense, and that film
still has a role to play in the digital workflow. Digital has lower running costs
and is more flexible, although more labour-intensive. Film is more expensive,
and less forgiving of most mistakes; however, in terms of ultimate image
quality, little can compare with a 5x4 sheet of Velvia. Despite this, digital
capture is probably now superior in all respects to 35mm film, and the latest
generation of high-resolution sensors can match the quality of medium-
format film. Clearly, the DSLR has now evolved far beyond its film origins.

As far as I'm concerned, in terms of convenience, cost and quality, a
digital camera wins over film virtually every time. At the time of writing it's five
years and counting since I exposed my last 35mm frame. I keep thinking that

DIGITAL DETAILS

Digital photography is essentially
very similar to film photography.
However, to realize its full
potential you need to acquire
some rudimentary photo-editing
skills in Photoshop.

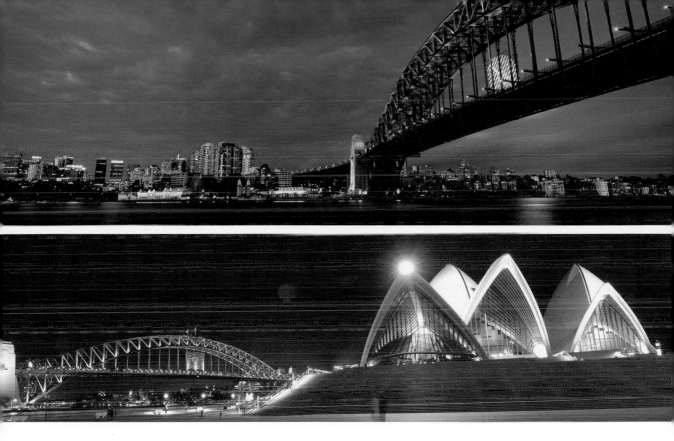

I should get out and shoot more 6x17cm film panoramics, but why bother when any of my DSLRs or even my digital compact cameras can shoot absolutely superb panoramics with the help of image-stitching software? Many photographers have been debating the relative merits of film and digital for some time now. The truth is that we waste our time on trying to address this question. The advent of digital photography benefits everybody – the amazing new technologies along with savings in cost means that photography is once again exciting and fun. Indeed, photography has taken on a whole new meaning: it's fun to read the monthly magazines to see what's new on the digital front, it's fun to experiment with digital capture without worrying about processing costs, it's fun to view image files via all manner of different mechanisms, including your TV set. In fact, it's hard to say anything negative about digital photography; and I often wonder what was ever exciting about a newly marketed film camera – they all did pretty much the same thing – unlike digital cameras, which are on an exciting path to ever-greater image quality. Digital technology is a breath of fresh air that will invigorate your photography, and rekindle your interest and desire to experiment. Best of all, I no longer have to find the money to process my film every time I return from a trip abroad. True, I haven't shot any 35mm film for a long while, but on trips I still sometimes take either medium- or large-format film equipment to augment my digital cameras – that was the norm until the end of 2005, when I plucked up enough courage to travel to the Northern Rivers region of New South Wales, Australia armed only for digital capture. It was invigorating not to have to worry about cost, and has since become my usual way of shooting.

▲▲ **Sydney Harbour Bridge, New South Wales, Australia.** Shot on a Fuji GX617 panoramic camera with a 90mm lens. This image of the Sydney Harbour Bridge has been scanned professionally to produce 3ft (90cm) prints at 300dpi. I shot around three rolls of Velvia to get one decent image – which adds up to a fair bit when you take film and processing costs into account. It's a good picture, but no better than some of the digital panoramics shown elsewhere in this book. For example, compare it to the digital shot that is shown of the same subject from a different angle.

▲ **Sydney Opera House and Harbour Bridge, New South Wales, Australia.** This is a cropped version of an extreme panoramic photostitch. I took enough images to cover a 270-degree view. This was shot with a DSLR and a 17–40mm wideangle lens, using exposures of 40sec at f/8, ISO 100. The camera was mounted on a tripod with a panoramic head; however, the image worked best when I cropped it back to this view.

Digital workflow
– a new concept

There are many committed photographers who would reply to my positive assessment of digital photography by saying: 'yes, but what about digital workflow – that's a real pain in the neck'. Well, yes, digital workflow is a bit of a nuisance at times, but if you get yourself organized, you can reduce the impact that this process has on your photography. After all, how many of us really want to spend any more time in front of a computer screen than is absolutely necessary? Get organized and you will have far more time to make great images.

The diagram on the page opposite shows a digital workflow that is suitable for photographers who use both digital and the combination of film and scanner to generate files. The individual elements of this workflow are dealt with later in the book, but the diagram should provide a useful reference for those photographers who are new to the principles of digital imaging.

▶ **Watkins Jetty, Tuggerah Lake, New South Wales, Australia.**
One of a number of jetties that protrude roughly westward into Tuggerah Lake on the New South Wales central coast, where I live in Australia. I used a two-stop neutral density graduated filter to hold back the amazing sunset, and used the wooden jetty as foreground interest and a lead-in line.

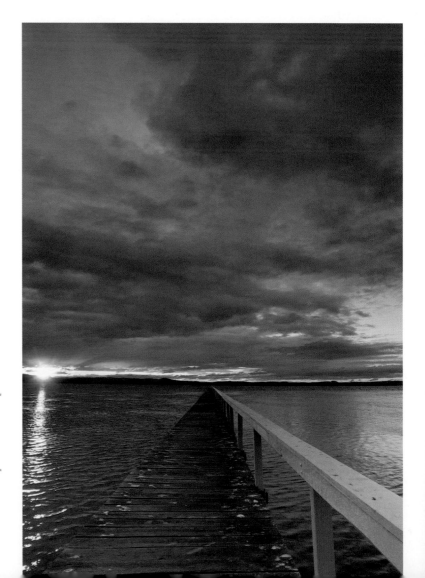

Select a digital camera system:
- Compact
- 'Prosumer' SLR-style compact
- DSLR
- Digital back for medium-format film camera or high-end bespoke digital camera

Digital capture

▼ ▼

JPEG or TIF files ## RAW files

▼

Download and process high-quality RAW files on your computer:
- Adjust RAW file exposure settings (such as brightness, sharpness and white balance) in proprietary or third-party RAW conversion programs
- Download, convert and save as 16-bit TIF files to optimize the potential for later enhancement in Photoshop

Storage:
- Archive onto CD/DVD and organize into quality storage wallets or filing-cabinet system.
- Archive RAW files, straight from camera JPEG/TIFFs, and Photoshop enhanced TIFFs
- Commercial-grade TIFF images should be selected and stored on an external hard drive with a virtual lightbox program to allow for easy access, selection and viewing of images

▼ ▲

Open unedited TIF file in Adobe Photoshop:
- Crop the image if necessary
- Remove any dust registered from the sensor using the 'healing brush'
- Adjust 'curves' and or 'levels' as required
- Adjust 'saturation' and or 'colour balance' as required (if file size is acceptable, sharpen and save)
- If file size too small, interpolate (resize/resample) image to maximum size required at 300dpi
- Sharpen (I tend to use unsharp mask)
- Save

▲

Film capture ▶ Process film ▶ Prepare slide by cleaning with a fine brush and/or compressed air ▶ Scan to 300dpi output resolution using:
- film scanner
- flat-bed scanner
- drum scanner

▶ **Tidy up slide:**
- **Using 'digital ICE' at scanning stage to remove dust**
- **Using 'healing brush'/'clone tool' in Photoshop post scan to remove dust specks**
- **Save as unedited, but cleaned up TIF file**

▲

Select a film format:
35mm
645
6x6cm
6x7cm
6x9cm
6x12cm
6x17cm
5x4in

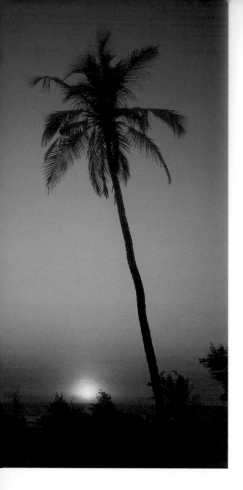

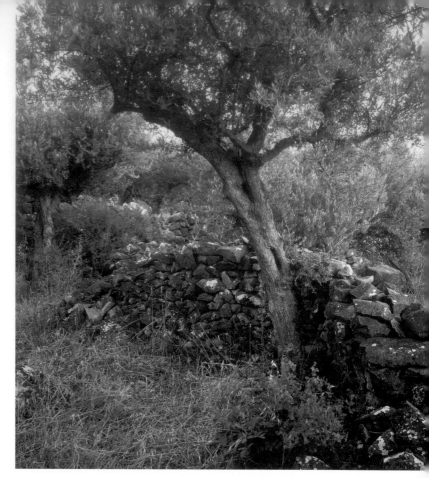

▲ **Palm tree at sunset, India.**
A radical crop of a scanned 6x4.5cm transparency. With scanned film or DSLR capture, cropping is the very first job on opening a TIFF.

▶ **Olive tree, Taygetos Mountains, Greece.** I took this picture because to me it sums up the Mediterranean. It was shot on a Fuji GA645Zi camera using ISO 50 Velvia film, and scanned on an Epson flat-bed scanner using a transparency adapter. The interesting thing to note in relation to workflow is that while processing a batch of DSLR files takes much longer than it used to take to file slides away, scanning, cleaning and optimizing a single transparency can take a long time and certainly much longer than it takes to process and optimize a single DSLR RAW file.

As can be seen, a digital workflow involves taking a 'straight from camera or scanner' image file and enhancing it according to your needs. The image file is then archived and/or printed. The detail involved in this process, which is what much of this book is about, depends very much on a photographer's requirements. I produce a lot of prints over a huge range of sizes, so I choose to scan transparencies to a high resolution or to interpolate TIFFs converted from RAW files. Because I print a lot of nature and landscape fine-art images, it's imperative that my picture files are also optimized in Photoshop to give them maximum sales impact. I have read that many commercial photographers (particularly wedding and social photographers) limit their workflow to shooting JPEGs and then directly archive or print them. While I can understand this truncated approach in the face of a heavy workload, it is not the best approach to realizing the full potential of your images, and the increasing ease of use of programs such as Adobe Photoshop Lightroom and Apple Aperture makes file handling far less of a problem in any case. As you will see, good camera craft (getting a good image 'in camera'), coupled to a knowledge and imaginative use of appropriate software can yield amazing results that justify the investment in workflow time.

'Workflow' requires 'workspace'. So your first job is to create an area dedicated to your workflow. With the power of laptops these days, it need not be large – the two diminutive external hard drives on my desk substitute for the battery of filing cabinets that house all my tens of thousands of transparencies.

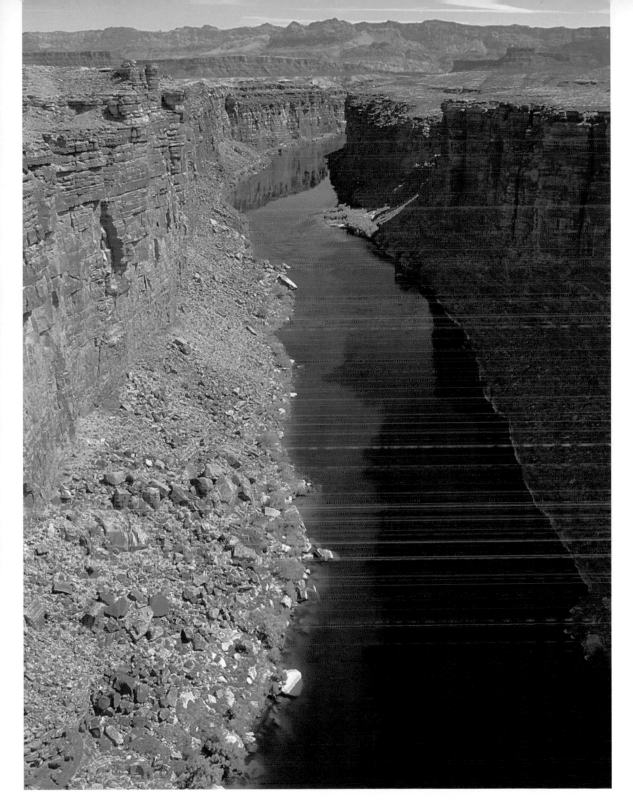

▲ **Colorado River, Arizona, USA.** Shot on a 35mm SLR and scanned, the file is fine for editorial use and smaller prints, but not large wall art. My view is that even at 6 megapixels the pixel structure of a DSLR permits better enlargement than many 35mm scanned files. Obviously, this comparison varies with the quality of the lens, use of tripod and other factors, but my choice these days is always a DSLR and never 35mm film.

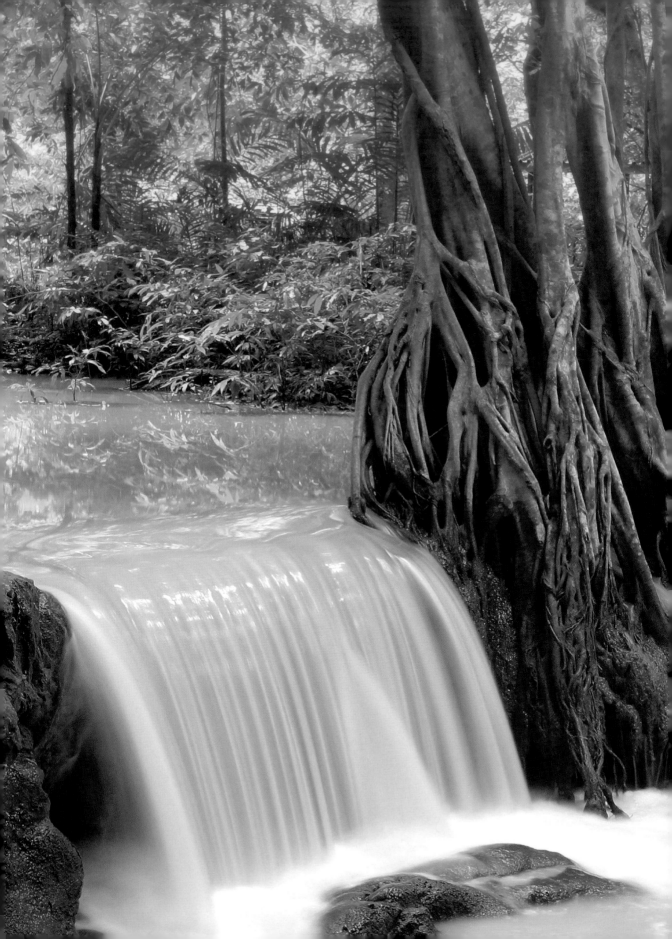

Silt-laden waterfall and strangler fig, Thailand

This shot of a waterfall was taken after the monsoon rain and shows a heavily silt-laden stream passing by a strangler fig. To shoot this I needed a longish shutter speed, and hence a tripod was absolutely essential.

- I wish I had taken this shot on 5x4 sheet film, but a DSLR was, in reality, a far more practical and portable option.

- Rainforests are hot and humid, so I opted for a lightweight tripod which worked very well, and kept the camera perfectly still, but was also easier to carry around.

- I applied curves as appropriate, added some red via the colour-balance function, applied 10–20% saturation and then interpolated the file to 24x16in (60x40cm) using Extensis Smartscale, and sharpened it.

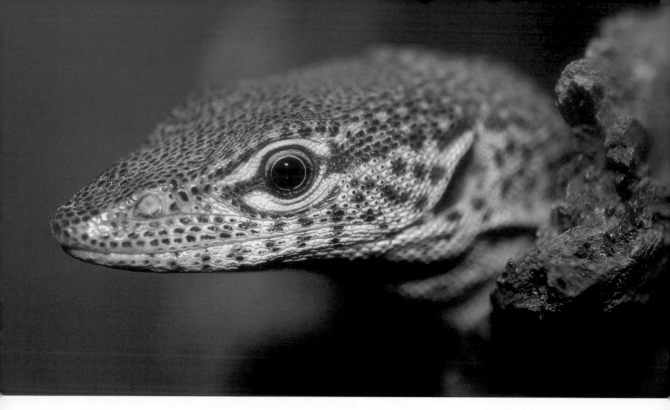

Choosing your first
digital camera

When choosing a digital camera, your choice is between a digital compact, a digital SLR, an interchangeable digital back for your medium- or large-format camera, and a digital medium-format camera.

If you haven't already gone digital, the question on your mind may well be 'when should I go digital?' Well, the quality is available now, so go for it. If you wait, of course new cameras will come on the market with ever more bells and whistles, and better resolution; but if you want the equivalent of 35mm quality and beyond – it's here now. Modern DSLRs are outstanding. When I use my Canon DSLRs, I no longer even consider 35mm. Instead I take my digital compact with me, as the results from this are good enough for editorial use in books and magazines, and the photostitch option can produce gallery-quality panoramics. I just love the economy of shooting without worrying how much the processing costs are going to be.

If money is less of a factor, and you already have a good 35mm-SLR set-up, then you will probably be thinking of investing in a DSLR; but which one should you select? Is it possible to advise what the best DSLR camera would be for anyone thinking of making the change from film to digital? Well, at the time of writing, Canon has been ahead of the pack in terms of how many cameras it sells for quite a few years now. However, Nikon is right up there too, with some amazing DSLRs, as are other manufacturers. The best option is to review the photographic press and websites such as www.dpreview.com, which compare various cameras in an objective manner. At the time of writing I use Canon's 12.8-megapixel EOS 5D for landscape photography and the Canon EOS 1D Mk II for wildlife, particularly when I need to shoot frames in quick succession.

▲ **Freckled monitor lizard.** This is a favourite image of mine. It was taken using a 6-megapixel DSLR with a 100mm macro lens and off-camera TTL flash. Although I now use cameras with higher resolutions, I still keep my badly battered 6-megapixel Canon EOS 10D because it is capable of superb images such as this, exceeding any expectations I formerly had for 35mm film.

▲ **Nikon D40x.** Cheaper DSLRs are designed to appeal to the serious amateur and offer excellent value for money. The market is so competitive that they combine relatively high specifications at low prices and offer better general specifications than their film equivalents ever did; however, don't expect the number of frames per second, autofocus performance or build quality to match professional-specification cameras.

▼ **Canon Powershot G7.** If you are limited by budget, and a full-blown DSLR kit doesn't make financial sense, then a high-level digital compact will be adequate for almost all of your needs.

These are well-specified professional models that have provided me with some excellent images. Consumer DSLRs are obviously more common and will appeal more to the serious amateur. I don't want to spend time detailing specifications on any individual camera, as the market is extremely dynamic, and in the time between me writing these words and you reading them there will very likely be a whole new generation of DSLRs. As I said earlier; digital is now at a level that compares favourably with 35mm analogue capture, and in many ways improves on it; so don't wait – buy now.

The first specification that the majority of people will look at on any camera is its resolution. This is the number of pixels that are located on the sensor and this determines, to a certain degree, just how much detail there is in an image and how large it can be used. For example, a 6-megapixel camera might have a sensor with 3,072x2,048 pixels, printed at 300dpi this will create an image of a little larger than 10x6in (25x15cm) without interpolation; but with interpolation an image can be printed considerably larger. It's all too easy to get obsessed with resolution, and while it is important it is not the end of the story. It is also worth remembering that the continuous increases in resolution yield apparently diminishing increases in final print sizes; to continue the example, you might think that a print straight from a 12-megapixel file would be twice the physical dimensions of the print from a 6-megapixel image, but actually it is roughly 14½x9¾in (35x24cm), with the doubling of resolution not even increasing the length and width by half as much again. The reason for this is that we should actually be considering the increasing area of the image, rather than just its individual dimensions. Even so it highlights the fact that increasing resolutions

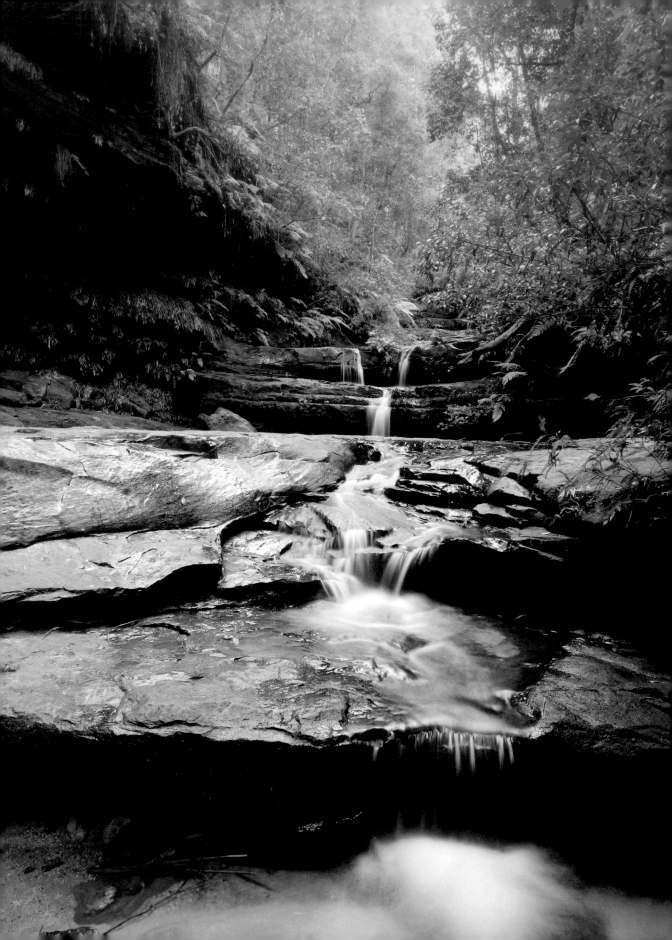

are not the technological panacea that they might at first appear to be. With that in mind, it is time to take a look at the other, often equally important, features of a digital camera, which you should consider.

The quality of the image output is partly determined by the resolution, but not totally. Even cameras that use exactly the same sensor sometimes offer differing image qualities. While quality, with all its subjective connotations, can be difficult to pin down you should take the time to look at the objective comparisons that are provided by websites such as www.dpreview.com. Quality issues can generally be split into two categories: sensor issues and processing issues. There are a number of aspects of sensor architecture that have an impact on the quality of the data gathered by the sensor. It would be impossible to go into all of these here (anyway, we are more interested in the end product), but it is worth noting that there is a correlation between the size of individual pixels and the quality of their output. The larger a pixel is the less likely it is to suffer from various failings, such as sampling error. This gives cameras with 'full-frame' sensors (where there is more room for each pixel) a built-in advantage, not just of resolution, but also of quality, and is also one reason why a DSLR with its larger sensor will typically offer greater quality than a compact of the same resolution. Anyway, as I have already said, it is best to concentrate on the effect rather than the cause, and providing that you are aware that greater resolution doesn't always mean greater quality, then the rest can be left to the kind of in-depth comparisons that you can read online.

While on the subject, another aspect of sensor design is the aspect ratio and size. As intimated earlier, not all sensors are the same shape or size and this will obviously have a knock-on effect on the final image. All of these issues regarding sensors are discussed in greater detail from page 50 onwards.

Another feature that you should consider, particularly if you shoot fast-moving subjects such as wildlife, is the memory buffer. This is the processing element of a digital camera and takes the raw data from the sensor, applies any set parameters and writes a file to the memory card. This takes time, but how much time depends on the camera. There are two aspects of the buffer that have practical implications for photographers: the burst rate and the burst speed. The burst rate is the number of frames that can be taken per second, obviously, if you are shooting fast moving subjects then the higher the burst rate the better. The burst depth is the number of frames that you may take in a row before the shutter-release button is locked or the burst rate slows considerably. Both of these measures of buffer capacity vary from one camera to the next, and in fact alter depending on the file type that you are recording. However, it is true to say that consumer-level cameras generally have slower burst rates and smaller burst depths than professional-level cameras.

Whether you need a super-fast camera with a huge burst depth is up to you to decide. On the one hand, such a camera means that you are less likely to miss that elusive, award-winning image; but on the other, there is a cost attached, which may be pointless if you are shooting static landscapes.

For those who really want to push the boat out, there is the option of a digital back for a medium- or large-format camera outfit. Cameras such as those by Hasselblad and Mamiya are common vehicles for digital backs. This form of digital capture is extremely expensive. Most people who buy these are serious professionals who have a high throughput, and will be able to work their digital back hard in order to turn a profit. The only reason they are able to buy one is that in the long term the additional quality will make them money, so don't consider buying one to indulge your hobby.

◀ **Terrace Falls, Blue Mountains, New South Wales, Australia.** This image, which was taken on an 8-megapixel DSLR, is marginally, although not significantly better than one taken on a 6-megapixel DSLR.

These digital backs are not subject to the same high turnover as the DSLR market. Although models are updated, the cycle of replacement is far slower at this end of the market. Unfortunately, their high cost means that the average landscape photographer is unlikely to be able to justify the investment. And, because these are aimed at professionals, I don't think we are likely to see the price of these backs drop in the same dramatic way that DSLR prices have.

All-in-one medium-format cameras are another, more recent, option. These are essentially medium-format cameras with fixed backs. As is the case with separate digital backs, the size of the sensors allows for extremely high resolutions and excellent image quality. However, such cameras have relatively low burst rates and depths; not a problem for landscapes, but a real obstacle for wildlife shots.

Whatever type of digital camera you opt for – whether DSLR, compact or medium format – the build quality is a massive consideration. You can expect your camera to take plenty of punishment in the course of nature and landscape photography, both day-to-day wear and tear and the odd accidental bump or scrape. Some digital compacts are poorly equipped to withstand this level of use, while at the other end of the market professional-level DSLRs will take almost anything in their stride. Everything comes at a cost, but just be aware that spending a little extra on a more robust camera may well be worth it if it postpones the day when you will have to replace it.

Benefits of digital capture

There are many benefits to digital capture and these are listed on page 37; however, it is worth noting again that the quality of the majority of digital images is more than a match for the uses to which they are put. Many so called 'pixel peepers' have elaborate ways of comparing and assessing the ultimate quality of a digital image. However, we need to be rational about such things. Nobody views images at a level at which pixelation occurs, we look at them as images reproduced at a size that our old film images were reproduced. Speaking for myself, I have never made even an A3 print from a 35mm transparency. For this size and above, I would always use medium-format equipment. If a digital camera can produce a good A3 print, as far as I'm concerned, it has therefore already exceeded my expectation for 35mm film. Perhaps the question we should be asking instead is whether the equipment is up to the job for which it is required. Well, in my case images are used for two main purposes: editorial use in books and magazines and as exhibition-quality prints. How does a digital image with today's generation of camera hold up to these uses? Well, to put it bluntly – perfectly well in most cases, and far better than 35mm film.

As far as editorial use is concerned, 6-megapixel cameras are more than adequate for jaw-dropping images. My last book – *Succeed in Landscape Photography* – included some great reproductions from a 3.2-megapixel point-and-shoot digital camera, which was my first step into the digital arena. From my higher-specification cameras, gallery prints are fine up to A3, and even beyond when using interpolation software. In my opinion, there is a digital camera out there that is suitable for almost any application, and they are constantly becoming more affordable.

▶ **Lindisfarne Priory, Holy Island, UK.** Ebony RSW 5x4in view camera and 75mm wideangle lens. I had this sheet of Velvia scanned to a very high resolution professionally; the final output is amazing, as you would expect from a large-format film camera.

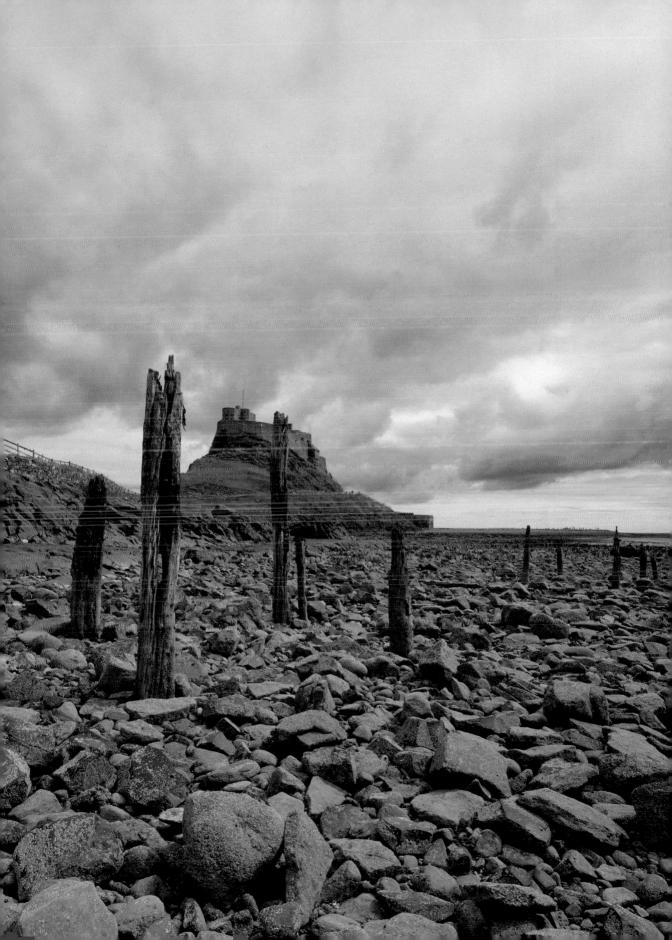

◀ **The Border Ranges National Park, New South Wales, Australia.** This is a very primal place, and this is my favourite image from a recent visit, showing the magnificent vegetation that lines Brindle Creek. All the scenic elements conspire to provide the perfect tapestry in this shot. This image will interpolate well and looks superb at 18x24in (45x60cm) when matted and framed. It is the quality of images like this shot from a DSLR which have moved me away from film, and most certainly from 35mm.

DIGITAL DETAILS

Don't let the photographic media engender a frame of mind in which you feel you need ever more megapixels. Cameras at 6–8 megapixels are simply brilliant, and are the equal of 35mm film. Judge the worth of a DSLR by the maximum size you can print to and still retain the highest quality in colour and sharpness. Ascertain this after using a high-quality interpolation program. It should be around 16x24in (40x60cm) for a 6-megapixel DSLR. If you are thinking of buying your first digital camera, or upgrading your kit then check out some of the websites that are listed on page 173.

Advantages

- Once set up, running costs are extremely low, as you never again have to buy or process film.

- Digital photography is tremendous fun. The fear of overspending on film has gone, so you don't feel guilty about the fun of experimenting when taking pictures.

- You get instantaneous feedback via the LCD – you can therefore retake a scene if necessary.

- There is no need to wait for processing. Because of this, an image file can be available for a customer or a friend just minutes after it has been taken, even if he or she lives on the other side of the world.

- If you buy a DSLR, you can still have access to all your old film SLR lenses.

- You can easily manipulate images to recover and even improve the quality of the original light, especially if shooting RAW files.

- As a landscape photographer, I particularly like the idea of having a relatively small digital camera and light tripod that are convenient to take anywhere, yet can produce great panoramics.

- Digital compacts offer a solution for holiday and family snappers, particularly as many can record movies.

- You can use the digital files simply and quickly in plenty of other programs, for example, to illustrate talks, in emails, in word processor documents and so on.

- Compact digital cameras make great proofing tools for subsequent shoots on large-format film cameras.

- Because sensor sizes on DSLRs are generally smaller than 35mm film, the illusion is created of increased magnification from a lens of a particular focal length compared to when it is used with 35mm film. This is an advantage if you have a passion for telephoto shots, but a disadvantage if you like taking wideangle ones. Manufacturers have addressed this with ultra-wideangle lenses for DSLRs, while there are some 'full-frame' DSLRs available. The effect depends on the size of the sensor; most create a 'focal length multiplication factor' of 1.3x or 1.6x, but some are as great as 2x.

- Although it was once a problem, DSLRs often perform better than film under low-light conditions.

Disadvantages

- There can be little doubt that for most film users, the initial costs of going digital are high, particularly as you also need a good computer and an archive capacity. Software costs can also be extremely high.

- Dust on the sensor of DSLRs is one of the biggest problems, as it can ruin a picture and require cleaning. Fortunately, manufacturers have recognized this and have implemented technology to deal with sensor dust, including antistatic coatings, vibrating sensors, more efficient seals and software solutions.

- The ease with which images can be taken can lead to a lazy, less-thoughtful approach to image making.

- The digital workflow is the undisputed downside of digital imaging. One has to spend long periods downloading and tweaking images and the truth is that it is a lot easier to view transparencies on a lightbox than it is to engage in a digital workflow on a computer.

- In some areas of photography, particularly landscapes, quality is everything and high-end digital cameras are a great deal more expensive than even some large-format film cameras.

- On the face of it, digital files should be easier to organize and archive. That is not necessarily always the case. When you end up with thousands of files, many with similar names, it can take you forever to find and open the one you really want. However, software designers are beginning to address this issue, and I discuss the option of virtual lightboxes later in the book.

- Digital cameras rely heavily on battery power and they can drain quickly compared to film cameras.

- Pro backs for medium- and large-format are extremely expensive, and are likely to remain so into the foreseeable future.

- Digital imaging is an evolving technology, while film is a mature technology. I can shoot a roll of film on any 35mm camera. With digital cameras, a degree of compatibility is required, which can be transient in the world of bits and bytes. For example, storage media is constantly evolving with media such as floppy disks and zip disks now largely obsolete; however, a film frame can always be scanned, making it relatively 'future proof'.

- Highlights can lose detail more easily than with film.

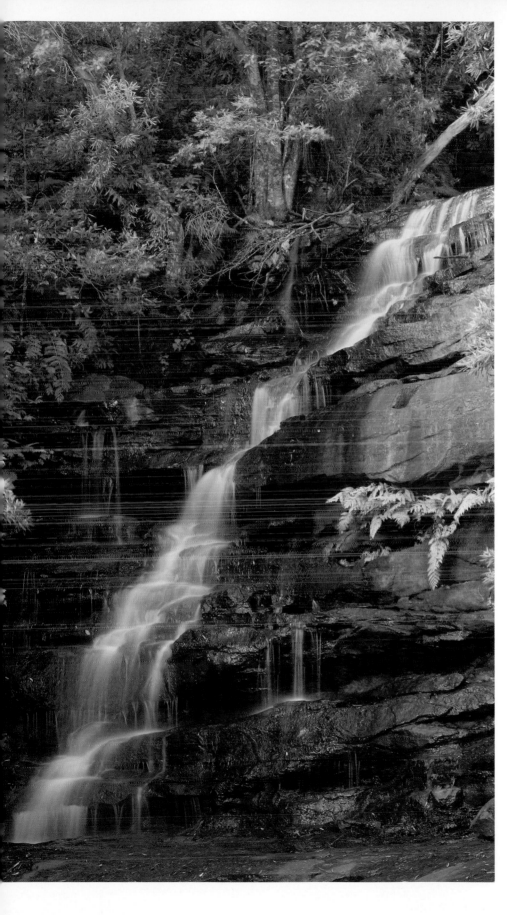

◄◄ **Bluebell woods, Yorkshire, UK.** Can you tell the difference between an image from a 6-megapixel DSLR and a film scan? This patch of bluebells growing in Yorkshire woodland was shot on medium-format film. The final file was scanned by a professional lab.

◄ **Somersby Falls, Brisbane Water National Park, New South Wales, Australia.** Taken on a 6-megapixel Canon DSLR with a 50mm lens, the quality from this shot is virtually indistinguishable from that which was captured on 6x4.5cm transparency film.

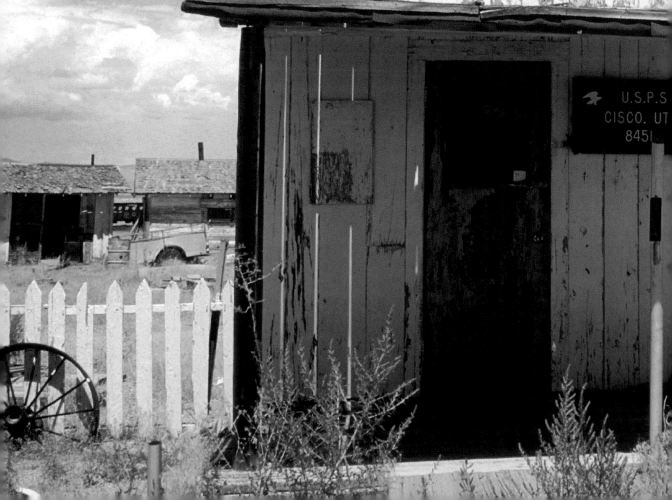

chapter 3
Digital nuts and bolts

Before you leap into taking masses of images and letting
them all pile up on your desktop, you need to understand
the nitty gritty of the digital process. Although it might
seem like a lot of jargon at first, making sure that you
understand the basics will make for a far better result at
the end of the day.

Scanning film to produce a digital file

Of course, there is more than one route to producing a digital file. Indeed, the very best prints are not always derived from digital cameras, but most often from scans of transparency film shot on medium, and large-format cameras.

My house is decorated with huge gallery prints. Three quarters of these were taken on panoramic or large-format cameras using Velvia film. They were then scanned professionally using either a Fuji Lanovia or Imacon virtual drum scanner to yield huge files. These were subsequently printed on a Durst Lambda or Theta printer using either Fuji Crystal Archive, Ilfochrome or Kodak Endura Metallic paper. The results are breathtaking. However, the scanning process, if you use an independent lab, can be expensive. For a one-off it is reasonable, but if you want to scan a lot of images, the costs can be huge. There is no doubt that if you employ a good lab, the results can be superb, but the costs can be very high, therefore you may want to have the option of scanning your own film.

Well, there is good news: in the past few years, photographers have been empowered. A range of relatively inexpensive desktop scanners is now capable of coming close to the quality that you can expect from a professional lab. Combine with that the fact that some home printers are now good enough to output saleable fine-art prints of your favourite photographic subjects, particularly with the release of modern ink sets such as Epson's K3 Ultrachrome ink set and you are now capable of producing great images at home.

▼ **Rannoch Moor, Scotland, UK.** A Fuji GX617 panoramic camera with a 90mm lens was used to capture the majesty and serene beauty of Rannoch Moor. The transparency was scanned professionally and further tweaked by making a slight change to the colour balance to better reflect the light at the time of exposure. The output is optimized to be printed at 36x12in (90x30cm) at 300dpi – once you have your final file, you can easily resize down to whatever dimension you wish. For example, I have reduced this image to a very small JPEG for use on my website.

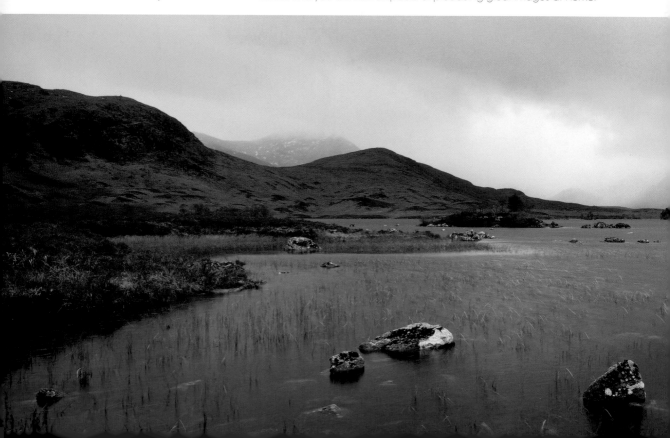

The scanning process

As with most things, a wide variety of options is available when it comes to selecting a scanner to digitize your slides. The pace of technology means that quality is fast approaching the limits of what most photographers are ever likely to need. If you work at home and demand the ultimate quality (short of professional drum scans), the choice is either one of Hasselblad's Flexlight range of scanners or the slightly more affordable medium-format film scanners from manufacturers such as Nikon. In my opinion, the Hasselblad range represents the highest quality available for professional desktop use at the time of writing, and can scan a range of formats right up to 6x17cm panoramic format. The latest generation of Nikon scanner can almost match the quality of some of the Hasselblad range, but will not scan as wide a range of film formats. However, when you realize the output resolutions that these scanners are capable of producing, you will understand the requirement for a relatively powerful computer to manage these files, particularly if you are planning to edit them in programs such as Photoshop.

To cope with the demands imposed by high resolution scanning, your PC or Mac should ideally have a minimum of 1GB of RAM (random access memory); it should have a fast, possibly even dual-processor or dual core chip with support for 64-bit instruction sets. The hard disk would benefit from having a fast rpm (15,000rpm is current at the time of writing), and a capacity of at least 80GB. A good screen is also important so that you can accurately judge your images before printing (I would recommend 17in/43cm as a minimum). A

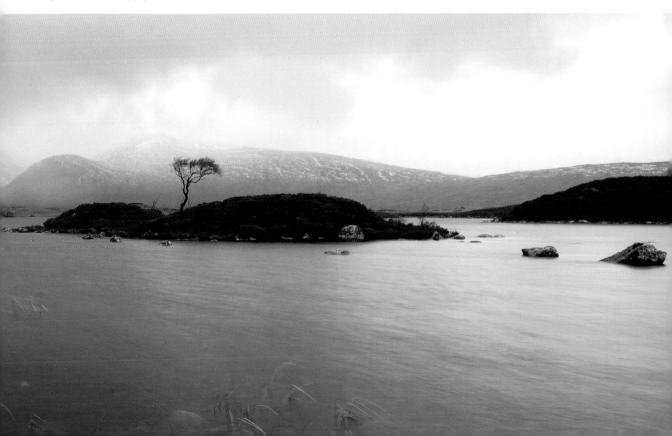

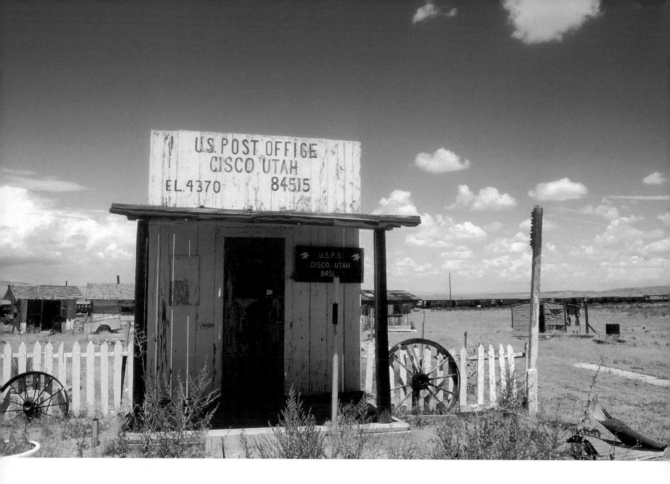

decent number of free firewire or USB 2.0 ports is vital to allow high-speed connections to a variety of peripherals. These days a good laptop can do the job admirably, and this is how I now do much of my image scanning, editing and printing. My system is built around Sony Vaio and Compaq Presario laptops. I would also recommend investing in an external hard drive to act as an archive and a back-up for what can be very large files.

When it comes to buying a scanner, you get what you pay for. At the time of writing, there are many good 35mm scanners around, but far fewer that can handle medium-format film as well. For the keen amateur or even professionals on a budget, medium-format film scanners are a good choice; however, if you want a reasonably priced solution for all formats, then you should consider some of the latest flat-bed scanners. These will scan everything up to 5x4 transparencies. It is often said that the results from a flat-bed do not match the best film scanners; and while this may be true, the very latest flat-bed scanners are pushing the envelope at resolutions of 4,800x9,600dpi, with good optical density (3.8Dmax) and Digital ICE technology for removing surface defects. These latest scanners give even high-end film scanners a run for their money.

One thing to bear in mind when scanning is the option of Digital ICE, or similar dust-and-scratch removal tools. These are a great help, but are not foolproof – I had one scan printed large, only to be confronted by a huge dust spot on a glorious flame-red setting sun. The print was a waste of money, but the scan was fine after some work in Photoshop (see page 92).

As a rule of thumb, 2,700dpi input from a 35mm frame yields an output file of around 28–30MB, and will be quite adequate for A4 reproduction. Most top-end 35mm scanners now input at 4,000dpi (4,800dpi in some cases), which will

▲ **Post Office in Cisco, Utah, USA.**
This ghost town was eerie, with a sense of the Wild West about it. I shot this image on a 35mm film camera and scanned the transparency using a Nikon Coolscan scanner. The file is fine for smaller prints, but not large wall art. It is ideal for editorial use.

▶ **Ubirr, Kakadu, Queensland, Australia.** This shot was taken as the sun was setting, and before the mosquitoes emerged. The 6x7cm transparency was scanned professionally and tweaked in Photoshop to restore the rich sunset colours that were lost during the scanning process.

▶ **West Burton Waterfall, Yorkshire Dales National Park, Yorkshire, UK.** Shot on 6x9cm film and scanned professionally, this image produces prints that have an almost monotone quality.

do very nicely up to around A3 output. Medium-format film scanned at these input resolutions will output at a size that is proportional to the increase from a 35mm frame (in other words, a 6x4.5cm frame is 2.72x larger than a 35mm frame, and therefore, if scanned to 4,000dpi, will blow up roughly 2.72x larger). Go much beyond the 4–5,000dpi range, and you begin to record grain and noise which adds nothing to the final image.

What you should look for when purchasing a scanner

There are a number of factors that are important considerations when you are thinking about purchasing a scanner, these include:

Resolution As discussed the greater the resolution, the more detail captured in the file; however, there are practical limits imposed by the size and quality of the film that is being scanned.

Bit depth The greater the bit depth, the better the range of colours and tones that can be resolved.

Density range This is a very important parameter. The best scanners have a high-density range, and will not lose much detail to highlights and shadow. This is one of the best benchmarks for selecting a scanner, although you

◄ **Grand Canyon, Arizona, USA.**
This image was taken on a Fuji GSWIII 6x9cm medium-format rangefinder with a 65mm wideangle lens. The long exposure required a sturdy tripod. The file was scanned professionally to allow very large prints to be produced. The final file was cropped slightly to improve the composition.

▼ **Menara Pavilion, Marrakesh, Morocco.** This shot pushes 35mm film to its limits. A slide was scanned on a Nikon Coolscan and cropped into a horizontal panoramic format.

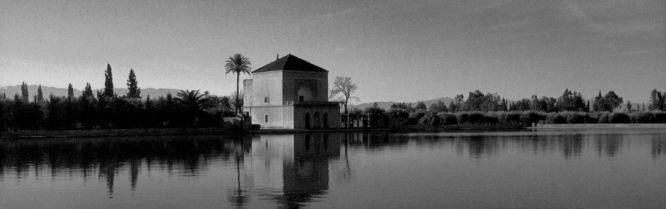

should read expert reviews on individual scanners and not take the manufacturer's numerical values for density range as set in stone. This is the area that drum scanners and Hasselblad virtual drum scanners excel in.

Connectivity When I bought my first scanner, I fitted a SCSI (small computer serial interface) card in my PC to facilitate an optimum scan speed. Today all computers come with a USB 2.0 interface. However, Firewire is fast and also very popular for hooking scanners up to computers. Older style parallel port connections are likely to be a bit slow compared to the former interfaces. The bottom line is that you should make sure the scanner you choose will not only connect properly with your PC or Mac, but also will allow high transfer rates for the relatively large files involved.

Software Like most peripherals, scanners come bundled with a variety of software programs. While you should still bear in mind the fundamental quality of the scanner, a free program such as Photoshop Elements can prove a useful tool and sway your decision between two closely matched scanners.

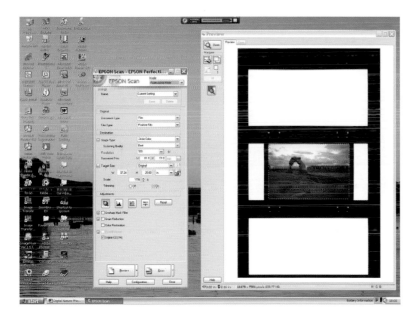

▲ **Scanner interface.** This screengrab shows the user-friendly interface of an inexpensive yet good-quality scanner. You can see how easy it is to select film type, output resolution and target print size. The image shown produces a very big file at the given settings. Even at huge magnifications, I cannot tell the difference between this home scan and a professional scan made from the same transparency.

▶ **Dinner Falls, Queensland, Australia.** Shot on Velvia film using a Mamiya 7II camera with a 65mm lens. The resulting professional scan permitted this radical crop to be made, and still allows for a reasonably large print to be produced. Cropping a 6–8-megapixel DSLR file in a similar way will not result in such a high-quality result, and the final print size will be relatively limited in comparison.

Rock pools above Somersby Falls, Brisbane Water National Park, New South Wales, Australia

This scene is 20 minutes from where I live, yet on many visits here, I have never caught the sunset as well as I did on this occasion. This image has it all. Foreground interest in the reflective rock pools acting as an anchor for the entire frame, colourful sky and a sense of wilderness.

- Taken on an Ebony RSW 5x4 view camera and then scanned with an Imacon virtual drum scanner to create a 300MB file suitable for large prints of 6ft (1.8m) and above.

- The image was enhanced by using a moderate warm-up filter in concert with a three-stop neutral-density graduated filter to balance the exposure of the sky with the foreground. As a consequence, relatively few Photoshop adjustments were required. I applied curves as appropriate, added some red via the colour-balance function, applied a little saturation and then interpolated the file slightly before double-checking its sharpness. In truth, the file required little work after scanning.

- It was tricky to decide which one of around ten exposures that I made of this scene was best – as each one rendered the sky quite a different colour.

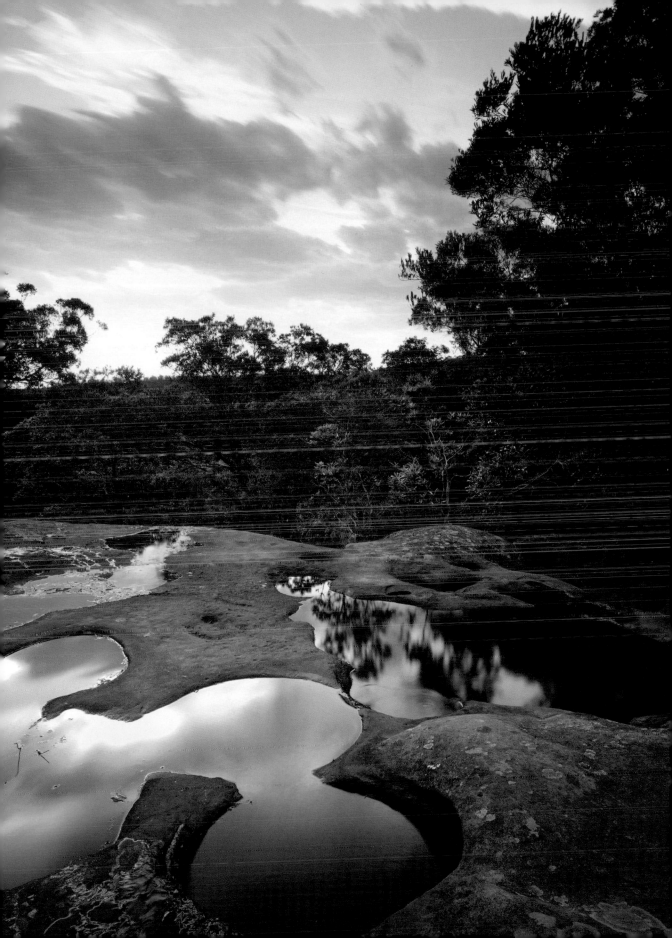

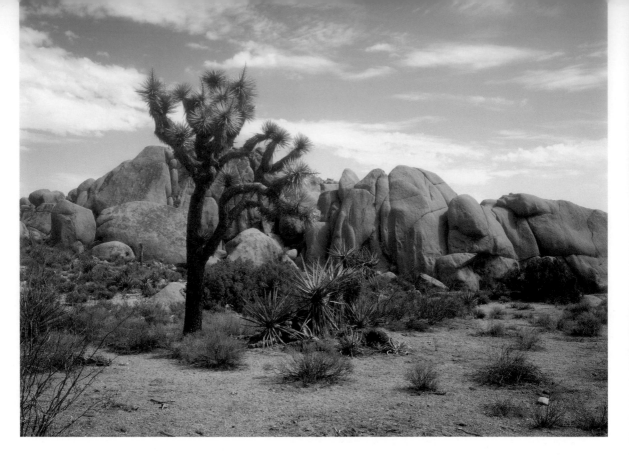

Understanding digital file formats

One of the most difficult hurdles to overcome in moving from analogue to digital photography is understanding a whole new language, and one that has more than its fair share of acronyms. This is particularly true in deciding which format to save your files in. You generally have a choice – RAW, TIFF or JPEG – but what do these mean?

If you're after the best quality output from your digital files, then the perceived wisdom is that you should be recording your camera images as RAW files. RAW is in fact not an acronym, but an apt description of the file type: RAW files are just that – raw. They are simply the data from the sensor, with any parameters (such as white balance) attached, but not applied to the data. This means that RAW files have a huge amount of flexibility, as you can alter these parameters without losing any original data.

If you shoot in RAW mode you are recording a file with a huge amount of potential, whereas a JPEG has far less flexibility. Unfortunately, there is a downside to this: a RAW file must be developed in order for it to be viewed at its full potential. Almost invariably a RAW file taken directly from the camera looks a little flat, less saturated and sharp than a JPEG. So it will need some work if you are to get the best from it.

RAW files allow you to change parameters such as brightness, white balance, picture style, hue, saturation and sharpness, while the tone curves can be adjusted within the individual red, green and blue colour channels.

▲ Joshua Tree National Park, California, USA. This 6x7cm transparency was scanned on a flat-bed scanner to create large prints. The original transparency had been used many times for commercial use, and so needed substantial remedial work in Photoshop with the clone tool and healing brush.

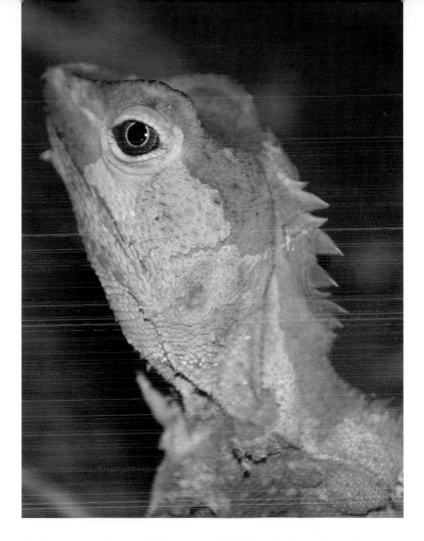

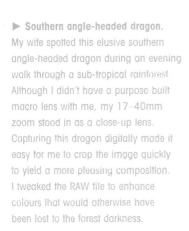
▶ **Southern angle-headed dragon.**
My wife spotted this elusive southern
angle-headed dragon during an evening
walk through a sub-tropical rainforest
Although I didn't have a purpose-built
macro lens with me, my 17–40mm
zoom stood in as a close-up lens.
Capturing this dragon digitally made it
easy for me to crop the image quickly
to yield a more pleasing composition.
I tweaked the RAW file to enhance
colours that would otherwise have
been lost to the forest darkness.

Also, because of the proprietary nature of RAW files (their file suffix and actual
format vary from one manufacturer to the next) they can only be viewed in
certain types of software (although this is becoming less of a limit, with the
new Microsoft Vista operating system). To be viewed in other software programs,
you will need to process the files and save them in a universally readable
format, generally a TIFF. When you buy your digital camera, it comes with its
own software to decipher RAW files, you can use this or third-party software,
such as Adobe Camera Raw (part of Photoshop), Photoshop Lightroom and
Apple Aperture. However, a slight problem is that newer formats of RAW file may
not be supported by older third-party programs.

RAW files are much smaller in size than the TIFFs that are created from them.
TIFF is an acronym for tagged image file format. Most cameras do not offer the
option of shooting in TIFF, but this is generally the file format that photographers
will store their images in. What really makes TIFFs so good is that they are
uncompressed and therefore lossless (although there are some compression
options, these are best not used). This means that unlike JPEGs, all information
is present in the file. This clearly produces bigger files, but also higher quality
ones. JPEG files are a common standard. Perfectionists will always ultimately
save their images as 16-bit TIFFs, but what does this mean? Well 16-bit per
channel files simply offer the finest gradation of colour and tone within your
image; this means that files are less prone to the artificial blocking of colours
that can occur. Unfortunately, choosing the 16-bit option produces more

information, and consequently much larger file sizes. Despite this, I advocate that you opt for 16-bits per channel rather than 8-bits per channel. You can select the number of bits per channel while converting your RAW files.

The other main option is JPEG, which stands for Joint Photographic Experts Group: after the organization that created the file standard. They are a 'lossy' format, that is to say, the image encoded within a JPEG file can be compressed, a process in which certain information is discarded. This means that JPEGs are of a lower quality than TIFFs, although being able to shrink file size by compression confers flexibility since they will take up less space on your memory card, and are easier to email. The other downside of JPEGs is that they degrade each time they undergo an open–save cycle. This is not the case with TIFFs.

One of the interesting, and more useful attributes of all files that originate from digital cameras is the inclusion of metadata, which records every technical aspect on how you shot that particular image. That is ISO, aperture, shutter speed, date and so on. This is a godsend if you submit your images to illustrate photo essays in magazines – I constantly struggle to remember such details. It is also possible to add further metadata in the form of captions, ratings, copyright information and so on. This is invaluable if you are thinking about making money from your photography.

Although I will discuss this in more detail in the section on the 'workflow dissected' (see page 61), the simple and logical rule of thumb in selecting which format is best for you is shoot in RAW and save as TIFF for quality; shoot in JPEG for speed and convenience.

To give you a few examples; landscape, advertising and fashion photographers will likely always use a RAW format with TIFF conversion. While a sports or news photographer may rely solely on JPEGs. Many, but certainly not all, compact digital cameras exclusively use JPEG format files. You can, however, always convert these into TIFFs at a later date using photo-editing software such as Adobe Photoshop.

If I'm shooting family and friends, in other words just fun shots, I would shoot JPEGs, since I wouldn't require more than 4x6in (10x15cm) prints, but for nature and landscape I would only ever shoot in RAW. The reason for this is that I need to produce double-page spreads and gallery prints, and RAW offers the best way of achieving this.

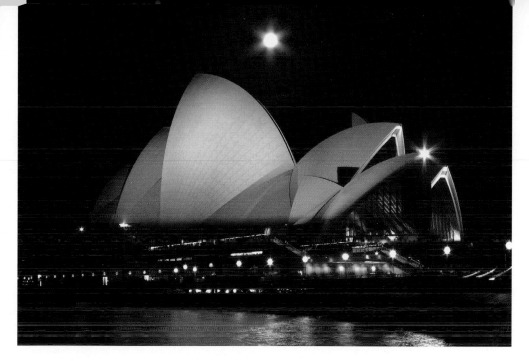

Sensor resolution and image quality

A digital SLR is in many ways just like a film SLR. The big difference is that instead of 35mm film at the plane of focus you have a sensor that converts the light falling on it into a digital signal.

Types of sensor

Without going into too much detail, there are three main types of sensor that are used for digital capture, although individual manufacturers may introduce their own variations.

CCD or charge-coupled devices are used by the vast majority of digital camera manufacturers. They have a Bayer filter of red, green and blue that overlays the pixel sites and means that each site registers as a single colour. These individual colours are then interpolated to form a full-colour image.

CMOS is the other main type of sensor and stands for complementary metal oxide semiconductor. Like CCDs CMOS technology relies on a Bayer filter to register colour. This technology is most notably used by Canon for all of its EOS DSLRs, although it is used on some other cameras. CMOS sensors generally consume less battery power, and they have received acclaim for their low-noise performance, even at relatively high ISOs.

Foveon X3 is a less common type of sensor. This sensor is deployed in Sigma digital cameras, and unlike CMOS and CCD sensors does not feature a Bayer filter. Each pixel is fitted at a different depth within a silicon wafer, which transmits different wavelengths of light to different depths. This means that instead of having to interpolate colour, each pixel site provides a full-colour signal in the first place.

▲ **Sydney Opera House, New South Wales, Australia.** Shot with a 5-megapixel point-and-shoot compact camera using nothing more than a table-top tripod that fits in your pocket. Despite the simplicity of this equipment, I produced an image that can print to 12x18in (30x45cm) and be sharp and clear. I actually think that the best compact cameras match the quality from 35mm film cameras and sometimes exceed it.

▶ **Rock pools, Brisbane Water National Park, New South Wales, Australia.** The Canon EOS 5D is a very high resolution 12.8 megapixel full-frame DSLR. It's full-frame sensor means that my 17mm wideangle lens acts as it would on a 35mm SLR. Unfortunately, the downside is vignetting with some filters attached. This image needed a bit of work in Photoshop to remove corner darkness.

What separates one sensor from another in terms of quality of image are: the number of pixels it contains, the size of each pixel and the processing circuitry associated with the chip. To repeat my earlier caveat to this statement, the number of pixels is not everything, the quality of individual pixels and the way in which they are processed is also crucial.

Size of sensor

The physical size of the sensor varies from one camera to another. Some cameras, such as models from Canon have full-frame sensors (in other words their sensor is the same size as a 35mm film frame); however, these are in the minority and represent some of the most expensive DSLRs around. Most cameras have smaller sensors.

The imperial size descriptor for sensors can be confusing. A fraction scale such as 1/1.8, 2/3 or 4/3 is often used; these sizes do not describe the sensor's diagonal measurement, but are based on a system once used to describe TV cathode ray tubes. To give you an idea of relative sensor size, the following table gives various sensors' width, height and aspect ratio:

▼ **Great Egret.** Shot on a Canon EOS 1D Mk II with a Canon 400mm f/5.6 lens. The 'focal length magnification factor' determined by the sensor size has effectively turned my 400mm lens into a 520mm one.

Sensor type	Width (mm)	Height (mm)	Aspect ratio
1/1.8	8.933	7.176	4:3
2/3	11.000	8.800	4:3
4/3	22.500	18.000	4:3
1.8 (APS-C)	28.400	23.700	3:2
Full-frame	43.300	36.000	3:2

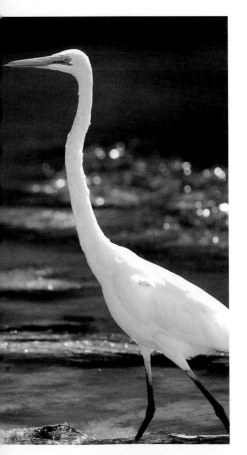

As you can see, these differences extend to aspect ratio. Most of the compact digital cameras have far smaller sensors than DSLRs, and tend to have an aspect ratio of 4:3 (width:height). By contrast, most DSLRs, be they APS-C or full-frame format have a 3:2 aspect ratio, the exception to the rule is the FourThirds open standard for which Olympus and Panasonic manufacture DSLRs at the time of writing.

The fact that there are different sensor sizes means that the same focal length of lens will have a different effect depending on the 'image circle' that is captured by the sensor. This effect is sometimes called the 'focal length multiplier' or 'focal length magnification factor'. The value for this is given in relation to the effect on a 35mm SLR; this means that as most sensors are smaller than a 35mm frame, the effect is positive, in other words the effective focal length of a lens is increased. While the effect does apply to compacts, the fact that they don't have interchangeable lenses means that their focal lengths are often given in terms of a 35mm equivalent anyway. DSLRs, however, are another matter with 1.5x or 1.6x being a common factor for APS-C sized sensors, and 2x for FourThirds size sensors.

The bottom line is the smaller your sensor, the higher the focal length multiplier, and the longer the effect of your lens. This is great news for wildlife or sports photographers, but bad news if you are into architectural or landscape photography and use wideangle lenses a lot. To be fair, manufacturers are bringing out a whole new genre of super-wideangle optics to accommodate the needs of those photographers who use the smaller sensors.

Even if you do own a full-frame DSLR, you may have problems using extreme wideangle lenses, as the sensors tend to be sensitive to the poorer edge definition exhibited by such lenses. Indeed, since smaller sensors take a central crop out of a wideangle lens's image circle, the image projected on

the sensor uses the sharpest possible portion of the image circle. It is interesting that film is less able to detect the edge image degradation resulting from wideangle lenses than is a DSLR's image sensor.

Resolution

What follows is as true for digital files derived from a film scanner as for files originating from a digital camera. The fundamental element of a digital picture is the pixel. If your resolution is too low and the image has been used too large, then you will see the pixels or dots in the picture – this is known as pixelation. You often see this effect in newspapers, where low-resolution images have been used.

Everybody is obsessed by resolution (the number of pixels), but what impact does this have on the final image. Well, a digital file has no absolute dimension in terms of resolution and size; what it has is a defined number of pixels. It is up to us to define how these pixels are distributed per unit area. We can stretch these pixels over a large area or cram them into a smaller one. In either case, the resolution will be different.

There are guidelines, however, to produce a good-quality print you need to be able to print to a linear resolution of 300 pixels per inch or ppi (ppi is essentially analogous to dpi). This means that if you want to print to A4, the original file must have sufficient resolution to maintain 300 pixels every inch over the dimensions of an A4 sheet of paper. You should note, however, that screen resolutions are typically far lower, and images can be displayed at 72ppi without any apparent loss in quality.

Let's consider this idea using some figures. If you have a target print size of 8x12in (20x30cm), and need 300dpi output quality, you need an image sensor that can input 2,400 x 3,600 pixels or a scan of a 35mm film frame that can be input at 2,400dpi. In either case you are looking at a file size of around 25MB. Bigger photos require sensors that contain more pixels and vice versa. However, as I alluded to earlier, there are considerations other than the number of pixels alone. Pixel size is also a very important factor in image quality.

There are a number of 'prosumer' compact digital cameras on the market. These have high-resolution, yet small sensors. At the time of writing, 10-megapixel cameras are the leading edge as far as this genre of camera is concerned. Most digital compact cameras use a sensor system around a quarter the size of a 35mm frame (see table on page 54). What this means is that the pixels are more densely packed than on the larger DSLR sensors and the individual pixels are consequently smaller. The larger pixels found on DSLR sensors are far better at producing low-noise images with good colour fidelity.

One of the advantages of the small sensors found in digital compact cameras is the necessary reduction in focal length needed to allow a wideangle-to-moderate-telephoto zoom lens. This reduction yields very short lenses with an almost infinite depth of field, even at wide apertures. This increased depth of field is useful for subjects that you need to be sharp from foreground to background, such as landscapes, but can prove a hinderance when you wish to separate the main subject from the background, as is often the case with macro and wildlife photography.

In addition to understanding that there is more to image quality than resolution, it is worth noting that the initial number of pixels in an image does not provide an absolute limit to print output. Basically, you can 'upsize' your image file using 'interpolation' software such as Genuine Fractals or Extensis pxl SmartScale that creates additional pixels by estimating their value.

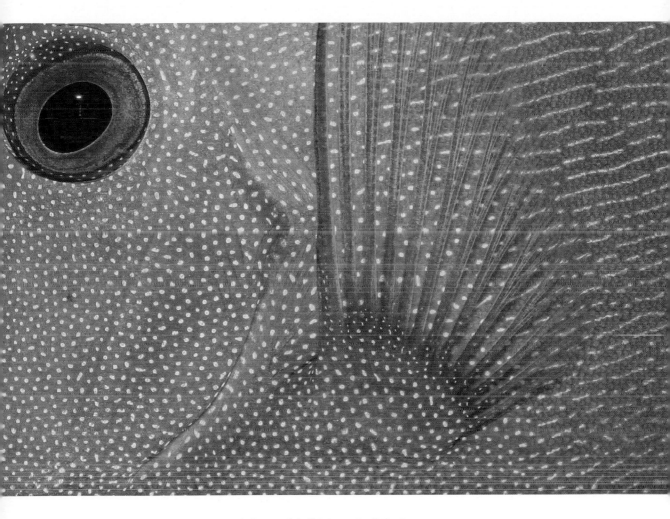

▲ **Surgeonfish.** This image is all about abstracting an interesting image from an otherwise fairly ordinary fish shot. It's not easy to home in on an abstraction such as this with fish, as they are seemingly always on the move. The secret here, and the beauty of digital capture, is that you can crop the original digital file at a later date to suit your artistic vision. With transparencies you couldn't do this so easily. The APS-C sensor may be smaller than a frame of 35mm film, but clearly there is still the capacity to crop in order to improve composition without compromising file quality too much.

For instance, PXL SmartScale allows you to 'resample' or rescale an image by up to 1,600%. The loss in quality is low relative to the increase in size, and all other image data (including brightness and colour fidelity) is preserved. Such products are typically 'plug-ins' for Adobe Photoshop, but Photoshop has its own method of rescaling images through the 'image size' dialogue.

Interpolation may seem a bit of a cheat, but chances are that the next billboard sign you see will have been produced using this technique. Even scanned 35mm film or small DSLR files can be interpolated by a huge amount using complex mathematical algorithms. The software does this by looking at how each pixel fits in relation to its neighbours. The software then adds pixels to the image to permit a bigger print to be made – something for nothing! You can use interpolation software on both film scans and DSLR files to yield massive prints. DSLR files interpolate better than 35mm scans!

While I have focused on increasing image sizes, you can shrink them down as well. For instance, you might want to reduce an image to prepare it for web use. In this case your aim is 72ppi output, which is the standard for computer screen resolution. Basically you resize your picture in Photoshop, which discards unwanted pixels, shrinking file and output size.

The industry standard for high-quality magazines and top-end printing is 300dpi (sometimes 400dpi). I use this as my benchmark when considering the sizes to which my files can be printed.

Image output quality

Much of the relevant information necessary to optimize print output can be found in the previous section. However, the following should help you understand this concept better. If you open your file in Photoshop, the 'image size' box will give you valuable pixel information.

In general terms, the larger and more prevalent the pixels, the better the image, and the larger the picture you can print; but don't set your goals in stone; you would have a very keen eye to detect the difference between a file at 250ppi versus one at 300ppi outputted at A4. Also, despite the maths, camera processors have a lot of influence on quality. I can happily produce A4 prints of supreme quality on my Canon G5, a 5-megapixel camera with a sensor smaller than a DSLR's. You won't know what's possible until you experiment for yourself.

If I want to go really big, as is the case with my gallery prints, I would scan medium- or large-format Velvia or Kodak E100VS transparencies using a film scanner. Here file sizes can really grow, and good computer-processing power is required. Further on in the book you will see how to tackle this approach. More importantly, for those of you with aspirations to sell your work, I will also deal with the various options for commercial printing that can produce gallery prints that blow your socks off!

Workflow dissected

Digital workflow is a bit of a buzz phrase at the moment, but what does it mean? The term relates to the whole process of processing, editing, archiving and retrieving digital images. Everyone has their own approach to the challenge of handling digital images, and most people have evolved their methods by trial and error. The biggest issues exist for professionals who have a large library of images catalogued by conventional means (filing cabinet and database). Because such people constantly produce a large volume of images, when they go digital they need to hit the ground running with a good

▶ **Terrigal, New South Wales, Australia.** This shot was taken on a DSLR with a 50mm lens with a polarizer and very strong neutral-density filter attached to hold back the exposure value so as to capture the ebb and flow of the sea. There was a fair breeze so I set ISO 200 (I seldom deviate from ISO 100). The rock pool provides foreground interest and provides an anchor for all the other elements within the view. The exposure took around about a minute, and produced this pleasing blue cast. The major issue was a bit of noise and hot pixels, both a product of the longish exposure. I cloned out the hot pixels; there are noise-reduction applications available, but they tend to reduce detail as well, so I prefer not to use them.

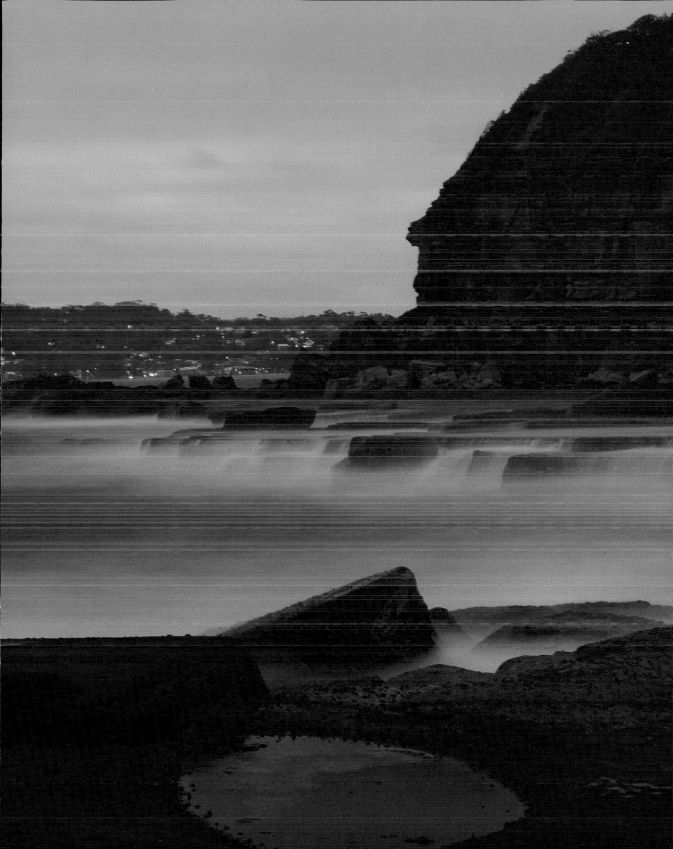

◀ **Southern leaf-tail gecko detail.**
I focused on the leg as I thought it had
a certain beauty and artistic quality
about it. I think it could sell quite well as
a fine-art print. This is a crop that has
been interpolated upwards as part of my
workflow. The final print loses little detail,
even to the critical eye.

workflow in place to smooth the transition and prevent a bottleneck in the
editing and storage of image files. The various elements of the workflow process
are shown in the flow diagram on page 25.

Just like decorating a room, where most of the work is in preparing walls
and wood, not in the subsequent painting and papering, so in digital workflow,
most of the stress and effort can be alleviated by investing up front in good
computer and archiving equipment. Think about this before you think about
buying your camera – I didn't, to my cost! I had two dozen CDs with all my best
images burnt onto them. For the first dozen CDs, I thought this was the way it
was going to be – then I woke up to the reality of it all. When I had 100 CDs,
and wanted to find one image file via some esoteric coding system that meant
something on the day I authored the CD, but nothing to me now – how would I
track it down?

Even with so few image files (two dozen CDs, with a few more containing
RAW files), it took me the best part of a week to organize the files properly with
software and hardware specifically designed for the job. What I will describe in
this book is the approach I take. It's not unique, and may not be the best way
forward for all; however, it seems to work for me, given my particular needs. My
advice is to speak to others, and get a broad understanding of the issues
involved, particularly with respect to your own requirements. For instance, you

on the
Road

Wherever possible avoid
changing lenses outdoors and
certainly in dusty or breezy
environments. This will prevent
the ingress of dust onto sensors –
the indisputable bane of a digital
photographer's life. This, in turn,
will reduce the load on your
workflow later.

may want to make your images available on the web, and want to set up your own server, or you may need to make them available quickly for printing in books and magazines, or suitable to be supplied to a stock library, the options are endless.

When you first embark on your digital workflow, don't despair. I have heard 'horror' stories regarding the trials and tribulations of some highly eminent photographers as they set about digital workflow for the first time; however, if you take a logical and pragmatic approach you will iron out any difficulties you have before too long.

Digital workflow can be broken down into several sequential elements:

- Image data is written to a memory card from your camera.

- This image file is stored as a JPEG or RAW file depending on the quality and flexibility that you want.

- The digital file on the memory card is downloaded to your PC or Mac via a USB or firewire cable. Some people, myself included, prefer to use a separate card reader.

▲ **Cascade, Blue Mountains, New South Wales, Australia.**
Cascades are a perennial favourite of landscape photographers. Highlight blowout or incorrect meter readings leading to underexposure are real problems with this subject. DSLRs have a clear advantage over film because you can experiment and bracket more without cost, and can be sure that you have the image in the bag before moving on. However, this creates a large number of similar files that can be a heavy burden on your workflow.

▶ **American alligator.** Shot on a DSLR with a 100mm macro lens and off camera TTL flash. An early DSLR image: my naivety at this time meant I didn't realize the value of RAW files and nearly disposed of them – luckily I rode the steep learning curve pretty quickly, and soon got myself organized.

◀ **Moon over Maitland Bay at dusk, Bouddi National Park, New South Wales, Australia.** Shot on an Ebony RSW 5x4 view camera with an 80mm wideangle lens. I used a 85-series filter in combination with a neutral-density graduated filter. The Velvia sheet film was then scanned at home on a flat-bed scanner, cleaned up and slightly enhanced in Photoshop. You can detect the light fall off due to the extremely wideangle lens I used. The 5x4 transparency ensures enough data to produce a huge print should I want to.

- Edit your files to remove those that are unsuitable to be kept and will just clog up disk space.

- If you shot RAW files they need to be converted into TIFFs by special software supplied with your camera or third-party software. This step isn't required if you shot JPEGs. It can take a very long time to batch process a full memory card from RAW into TIFFs, so it is time to go and mow the lawn! I always convert the RAW files into 16-bits/channel TIFFs at this stage.

- At this point I burn my RAW files onto CD or DVD. These are like original negatives – they are valuable (I discarded them at first not realizing their value). If you lose, corrupt or in any way mess up a TIFF – it doesn't matter, just go back to your original RAW file and convert it back into another TIFF.

- The decoded TIFFs are then examined one by one. They are worked on in Photoshop, renamed appropriately, and saved onto CD or DVD. The procedures that I carry out in Photoshop are listed later.

- The TIFFs and RAW files are safely archived onto separate CDs or DVDs at this point. The same files are also on the hard drive of my laptop. What I do next is to connect an external hard drive to my laptop (I have a number of different drives), and save the TIFFs and RAW files onto one of these drives in an appropriate folder. When this is completed, I then delete the corresponding files from my laptop hard drive, which I regularly defragment.

- While this workflow helps to organize your images into appropriate folders that provide reasonably easy access, it's far from ideal. When you amass a vast collection of images, how will you easily find one isolated file? Think back to what it was like with slides – you simply put clear slide wallets on your lightbox until you saw the one you were after – perhaps utilizing a database record system. Well, you can do the same thing with your digital files. There are a number of software packages available to help you. Examples include Apple's Aperture and Adobe's Photoshop Lightroom programs (which can also control a lot of the rest of the workflow). Adobe Photoshop Album is another. These 'virtual lightbox'programs provide thumbnail views of all your images in a lightbox-like environment. The beauty of such a program is that it allows you to tag every image with a category. For instance, a beautiful

sunset over a lake with trees silhouetted against the setting sun can be categorized with several tags such as 'sunsets', 'lakes' and 'trees'. A hierarchical approach means they can come under broader terms. I would have a first-tier category of 'landscape', a second-tier category of 'rural landscape', and then any one of a number of more specific categories such as those mentioned above. This cross-referencing thumbnail viewing system permits you to find any image very quickly, and certainly far quicker than the old way of filing cabinet and lightbox. When you want to view an image, or edit it, you can open it directly in Photoshop with the click of your mouse. Later versions of Adobe Elements (the cut-down version of Photoshop) offer similar functions.

- I mentioned earlier that part of the digital workflow involved editing in Photoshop. Before saving my TIFF, I would open it in Adobe Photoshop and carry out the following actions as required: crop the image; remove any dust marks; adjust curves or levels; adjust saturation and colour balance; interpolate if required; sharpen; and finally save as a TIFF. The detail of how to use these Photoshop tools to best effect is dealt with later (see chapter 4: The digital darkroom).

- When one external hard disk is full (my 160GB drives are quite small by today's standards), you can simply buy another one. My disks are the size of three or four cigarette packets – compare that to a filing cabinet! The price is also very low when you compare it to other items such as cameras, lenses, computers and monitors, so don't skimp here.

▼ **Waves breaking on a rocky section of Terrigal beach, New South Wales, Australia.** The wind was blowing quite fiercely so I used my heaviest tripod to stabilize the camera. I tried to anticipate the wave breaking and release the shutter at just the right moment. To do this I used a cable release and covered the eyepiece to prevent stray light from affecting the meter reading. I took so many images that it became a difficult job to decide which to keep and which to reject – there's simply no point in keeping too many similar copies, and so many images associated with this shoot were deleted – I kept only around four images that worked well.

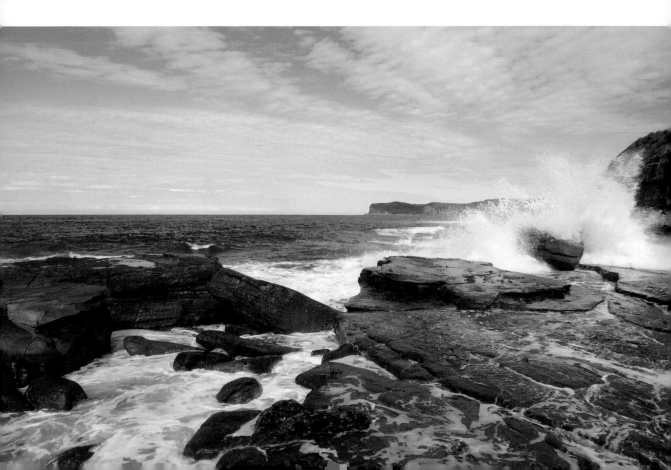

Clearly there is much more to the digital workflow than can be detailed here, and everyone will have his or her own variation on the theme. One of the big challenges is to decide which images to keep and which to erase. You can't keep everything, so learn to discriminate. Awful out of focus rejects can be deleted at the RAW file stage, others that only show their imperfections when magnified in Photoshop should be trashed at this later stage. Remember, if you change your mind after deleting a file, you can still recover it from the recycle bin. However, once you have emptied the recycle bin, the file is gone forever!

One of the great things about RAW files is that, if you wrongly entered a parameter such as the white balance, you can correct it before processing the RAW file, and it would be as if you had set the camera white balance up correctly in the first place. This is because the white balance and other parameters are stored alongside the file, and are not yet applied to the image.

▲ **Girakool in Brisbane Water National Park, New South Wales, Australia.** This image shows the power of a digital compact camera. I used the grass tree at right as an anchor point in this panoramic stitch taken on a Canon Powershot digital compact. The image was constructed using PhotoStitch, a program supplied free with Canon cameras, and one that I rate very highly. This introduced another stage to the workflow. When I have completed my stitch, I trash all the other files to avoid confusion. Also disk space soon gets used up, so it pays to avoid too many duplicate or inferior files.

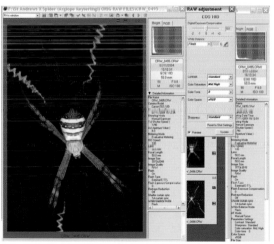

▲ **Virtual lightbox.** This screengrab shows you how to use the virtual lightbox in Adobe Photoshop Album to select, as an example, digital files of sunset scenes. Other similar virtual lightbox programs include Extensis Portfolio, Apple Aperture and Adobe's Photoshop Lightroom program.

▲ **RAW converter.** The above screengrab illustrates what the proprietary RAW converter looks like for the Canon EOS 10D. Lighting for this St Andrew Cross Spider was particularly tricky, but the camera did a good job of getting the exposure right, and no tweaking was necessary.

Image storage

Image storage can be broken down into different categories. Storage media in the form of small memory cards that slot into your camera are one category, then there are the hard disks, which you have in your computer. These are best reserved for temporary storage and image processing and enhancement. Leave too many digital image files on this disk and your computer will soon struggle to process information. Then there are the external hard drives, which act as an archive for storage and retrieval of a large volume of images. These are effectively your 'digital filing cabinets', and work well in conjunction with programs such as Adobe Photoshop Lightroom to produce a virtual lightbox. Then, finally there are optical media such as CDs and DVDs that provide a secondary back-up system that you can call upon if your hard disk (external or internal) fails.

Memory cards

Memory cards slip into your camera and are the first point of storage for your image files. They come in a variety of formats. Most DSLRs employ CF (CompactFlash) cards or SD (Secure Digital) cards. Both are solid-state technologies with no delicate moving parts. Microdrives are less common, they fit into CF slots, but they do have delicate moving parts and are considered more fragile than their solid-state counterpart. The perceived wisdom is that microdrives are delicate, require more power, and hence drain batteries quickly, and are less reliable at low temperatures and marginally slower to write. I use CF cards, preferring two 512MB cards to a single 1GB card when out shooting. My thinking is that if a card problem develops, I will only loose half my shoot.

An increasingly popular format is the SD card. Some DSLRs will take these instead of a CF card, while others can accommodate them alongside a CF card, which allows you to swap cards without leaving your camera empty at any point. The word from most manufacturers is that SD cards will increase in popularity, and overtake CF cards as the industry standard for image storage. At the time of writing, this is generally the case for digital compacts, although most DSLRs still rely on CF cards.

Memory cards come in a variety of guises, generally the two variables are the read/write speed and the capacity. It is important that you choose a card that has a read/write speed that at least outstrips that of your camera, as this will allow you to use the buffer to its maximum capacity. In terms of the capacity of the card itself there is a huge variety available; however, at the upper end of the spectrum, you can expect to pay a substantial price for your memory card.

Various digital compacts use other, less-common card types and these include MMC, xD and SmartMedia cards, so when you buy your camera, you are locked into a particular card format favoured by your manufacturer.

Full cards can be downloaded via special software supplied by camera manufacturers, or third-party software. This can be done by either connecting the camera directly to the computer via a USB cable or by inserting the card into a card reader or directly into the computer itself.

My last job of the day is always to erase and format my card in camera. Thus, the next shoot will have a completely empty card to maximize the number of images I can capture. Formatting cards also helps to keep them free from errors.

▶ **Lighthouse at Byron Bay, New South Wales, Australia.** I wanted to catch the beacon light along with some red clouds and stars to provide a different perspective on the familiar. This proved quite difficult, and this was one of only two or three decent images on my memory card – however, there was no worry about cost as there might have been with film.

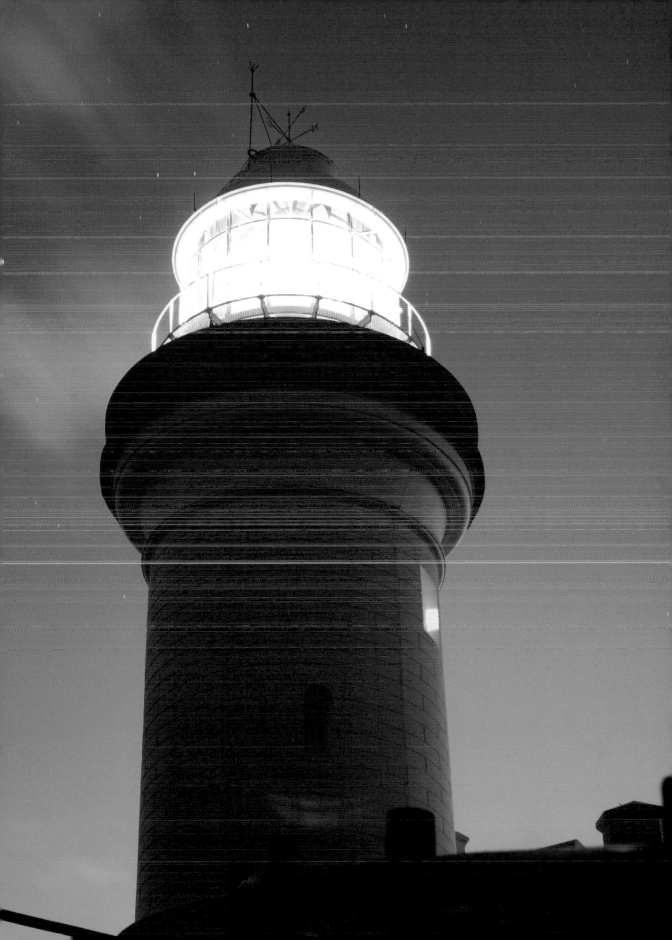

Computer drive

Once your newly created images are downloaded from a memory card to your computer hard drive, they hang around temporarily until edited out into the recycle bin, or tweaked in Photoshop, renamed and placed in a file ready for archiving. Computer hard drives are steadily increasing in size. My first PC in the early 1990s had a hard disk of less than 500MB. The laptop I'm writing this on has a 40GB hard drive. This means that I have around 28GB of free space to store images on. Despite this, I never add more than a couple of gigabytes worth of image files to the disk, as performance drops off as the disk fills up. To keep my disk healthy, and avoid problems when using virtual memory, I never store images on my hard drive, and regularly perform housekeeping tasks such as disk defragmentation. This reorganizes fragmented files on the disk, and consequently improves processing times.

External drives

As I already mentioned, my favoured long-term storage solution is on external hard disks such as those made by Seagate and Maxtor. External hard disks, like internal ones, are increasing in capacity all the time. At the time of writing, the first 'terabyte' hard drives are entering the marketplace. I'm quite happy with my 160–500GB drives though, and with the same thinking as for digital film cards, I would prefer to spread my files out on several smaller drives than one huge one. If a disk fails, it will be easier to rebuild my files from CDs, than if my one and only drive failed and I lost everything. This brings me onto the final storage option – optical disks.

Optical disks

I use a CD writer to create two types of CD – one with original RAW files on, and one with final Photoshop reworked TIFFs. These are used solely as back-up disks in case an external hard drive fails.

A clever idea to reduce time spent in front of a computer is to invest in a portable stand-alone CD or DVD archiver. These devices allow you to plug in your memory card (just about any format can be used on most models), insert a blank CD or DVD, and burn all your image files without ever switching on a computer. I use the superb Disc Steno CPx series from Apacer. These devices can run on rechargeable lithium-ion batteries, and are perfect when you're travelling, and you don't want to drag along a laptop. They also have disk-spanning capability so if you have more data than will fit on a single disk, it's not a problem.

There's no doubt that DVDs represent a huge advance in image archiving. You can store a lot more information on a DVD than a CD. Recordable CDs (CD-R) and rewritable CDs (CD-RW) can hold around 700MB of image files. In

▲ **Than Bok, Thailand.**
This image was put together from several separate images using Canon's Photostitch utility. Such large files require plenty of storage space so it is important that you are organized.

▶ **Stainforth Force, Yorkshire, UK.**
Shot on an Ebony RSW 5x4 view camera with a Rodenstock 75mm wideangle lens. I had this sheet of Velvia scanned to a very high resolution. Some people love this effect of movement on the water, others less so. Personally I really like it. Consider that you don't need too many 300MB+ files like this scan generated to start clogging up your computer's internal hard disk. It's far better to store large digital files on a separate external hard drive.

my case this amounts to 20–25 images. A DVD can hold nearly 5GB of information. In my opinion, there are some issues with DVDs though. Firstly, a truly universal format is still to be decided on (at time of writing). Different companies are pushing different variants, and I think that external hard drives have done away with the need for DVDs for image archiving. CDs are better as a back-up, because I think it is easier to access individual files. This is because CDs being smaller can be theme based. For instance, say I was to go up to the Blue Mountains for the day – on my return, after editing my pictures, I usually find I have just enough good images for one, or at most, two CDs. If I archived images onto DVD, I would end up with a real concoction of variously themed images as a consequence of being able to store the results of four or five different shoots on the one disk. For this reason I have avoided the DVD route, other than for archiving my very best, and hence very largest files that are produced solely for exhibition-quality prints. This is also what one of my external drives is dedicated to.

▼ **Somersby Falls, Brisbane Water National Park, New South Wales, Australia.** Shot on a Mamiya 7II with a 43mm lens. This image has been down-sized from a very large file, and is stored for security on both a DVD and an external hard drive with my other exhibition-quality images.

◄ **Baby long-tailed macaque, suckling, Thailand.** This shot was taken in the rainforest around a Buddhist temple in Thailand. Such a trip will doubtless not only place great demands on your storage capacity in the field, but it will also leave you with many files to organize and back-up upon your return.

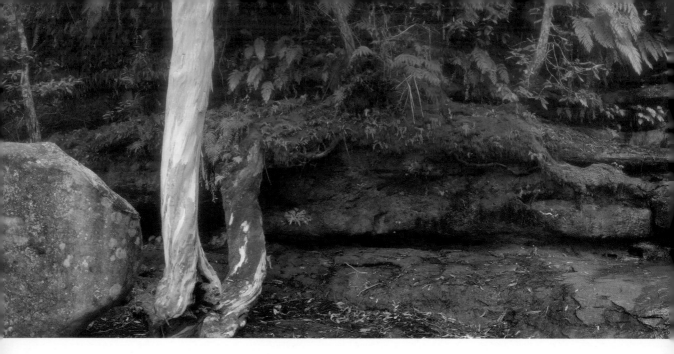

Recommended software

The good thing about digital image manipulation is that it doesn't really matter what your level of expertise is, you are guaranteed to find a software program that suits you.

For the beginner, Adobe Photoshop Elements is an ideal package. This has been designed for the novice photographer and is often bundled free with cameras and scanners. It is the smaller version of the full Adobe Photoshop program, which is the industry standard.

Other image-editing programs include JASC Paint Shop Pro (a Photoshop rival at a fraction of the price), Ulead Photo Impact XL, Arcsoft Photo Studio (often bundled free with cameras) and for novices, Roxio Photo Suite, as well as the many image-editing programs that are bundled with new computers.

An image-editing program such as Photoshop is essential, and forms the basis of the techniques described in this book. However, there is a huge array of related software and plug-ins that cannot be dealt with in a book such as this. I will therefore describe what I consider to be the most important programs:

Adobe Photoshop is a must have for serious image-makers. It offers a mass of sophisticated editing options for your images and is the basis for many useful plug-ins. It is expensive, but cut-down Elements versions are also available.

Sharpening plug-ins such as NIK Sharpener Pro, allow very accurate control of sharpening for various uses. This program can be purchased and downloaded from the web at http://www.tech-nik.com.

Interpolation plug-ins offer an alternative to Photoshop's bicubic resizing option. One of the most important aspects of my digital photography is the ability to produce large prints, and in my opinion, Extensis PXL SmartScale is one of the best interpolation programs around.

▲ **Waterfall panoramic.** To make this picture I merged two frames together using Canon's free PhotoStitch program. Each of the two overlapping frames was taken using a Canon DSLR, 17-40mm lens and ordinary pan and tilt tripod head. I used the widest zoom setting, which is usually the most problematic due to potential lens distortions. However, there were no problems on this occasion.

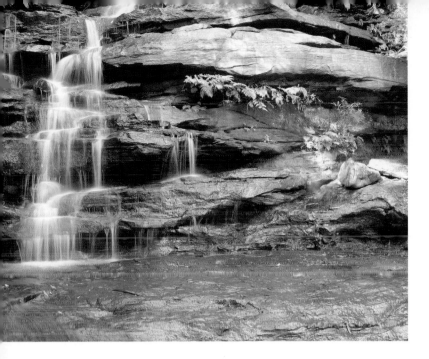

Virtual lightbox software This is undoubtedly the most important software you can have after image-editing software. A new buzz phrase has been coined for these programs – 'digital asset management' software. I use the relatively simple Adobe Photoshop Album, which is very inexpensive, and intuitive – the learning curve is very short. Although I use it as a professional, it is probably best suited to family use, and is only available for the Windows platform. Many professionals swear by Extensis Portfolio which was the standard for 'digital asset management', but at the time of writing these stand alone programs are being overtaken by all-in-one programs such as Apple Aperture and Adobe Photoshop Lightroom, which incorporate far more functions: from RAW conversion, through editing, to file organization and output. Adobe Photoshop also includes Adobe Bridge, which is an incorporated file-management system.

RAW conversion software This is available free in the form of the proprietary software supplied with your camera or at a cost as third-party software, it is also included within larger programs such as Adobe Camera RAW within Adobe Photoshop and the built-in converters for Photoshop Lightroom and Apple Aperture. RAW conversion and RAW conversion software is discussed in greater detail on page 80.

Panoramic software Although not a panacea for all panoramic requirements, photostitching software is amazing. I have tried many types, but have settled on two programs for my use: Canon's free Photostitch program and Realviz Stitcher Express; however, there are plenty of other options out there.

Other programs to consider are Corel Knockout, for professional cutouts, Extensis Intellihance for batch corrections and Extensis MaskPro for complex masking. Take care, there are many programs out there of little use.

chapter 4
The digital darkroom

Making good pictures with a digital camera is very much a two-stage process. Most of us are familiar with image capture – little differs here from when we used film, but fewer of us are familiar with the subsequent image-editing techniques that can be used to bring out the best in our pictures.

Basic image-editing techniques

This section will look at some of the basic enhancements required as part of a routine workflow. It will also delve into some of the more dramatic processes that can be performed in the digital darkroom, and finally we will consider the printing process.

Understanding colour

Before proceeding into some of the key elements of Adobe Photoshop, I want to spend a short while talking about colour, specifically 'colour spaces'. Photographers, and indeed anyone involved in the graphics industry, need to have at least a rudimentary understanding of colour, and how it can change between devices such as camera, monitor and printer.

With some digital cameras recording in sRGB and others Adobe RGB 1998, and printing performed in CMYK or RGB colour modes, how does one understand all the jargon? Well, fortunately, simplicity is the key and the International Color Consortium (ICC), which was created by Adobe, Agfa, Apple, Kodak and other big-name companies, seeks to ensure that standardization is possible. This organization has made it much easier to understand and achieve effective colour management.

In essence, colour management is all about understanding where colour originates from, where it is going, and how it will make that journey. To undertake such a journey – from camera or film scanner to an image-editing space, to various types of output such as printing or web use – is fraught with potential difficulties. The problem is all about preserving the colour of an image file as it is transformed from one device's colour space to another. Whenever you go from one device to another, a Profile Connection Space is used. So, for the journey from digital camera to, for example, the printer that has produced this book, the journey would be:

File from digital camera

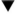

Profile connection space

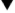

Image-editing space

Profile connection space

Printer output space

It is clear from this diagram that the image file is transcribed in two separate processes. One transformation takes it from device (camera) to the edit space, and another from the edit space to the output (printer) space. There are a range of colour spaces available; these include Adobe RGB 1998, sRGB,

◀ **Sydney Harbour Bridge, New South Wales, Australia.** This view of traffic trails approaching the Harbour Bridge in Sydney was taken from a footbridge that is one of the best places that I've discovered for shooting these trails. This image was shot in sRGB and then converted into Adobe RGB 1998 in Photoshop to comply with the requirements of the printer that I use.

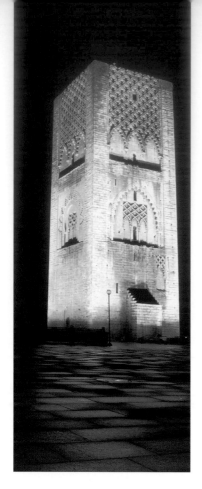

▲ **Unfinished Minaret of Hassan Mosque at night, Rabat, Morocco.**
Shot on 35mm film this was scanned on a Nikon Coolscan, then cropped to emphasize the building's height and character in Photoshop. That means a colour profile had to be assigned at the scanning stage and then converted into the monitor profile for editing.

DIGITAL DETAILS

Always keep your RAW files somewhere safe – these are your most important asset. Back-up your image files in a separate location.

ProPhoto RGB and Apple RGB. In essence these act as maps that describe what colour a set of digital coordinates will translate into. When you move between one device and another the colour information needs to be translated from one colour space to the next, so that a sudden shift in colours does not occur.

Colour printers have different gamuts; for instance, you might have a broader colour gamut on a typical inkjet printer than an offset printing press would offer. Similarly, the colour space of your camera varies in size. The smallest is sRGB, which is really designed for screen/web use, while Adobe RGB 1998 is larger, and considered better for general use with digital cameras as its larger colour gamut allows a more accurate colour rendition. If you want to sell your pictures to the publishing media, use this Adobe RGB 1998. If you have the money, and own a pro digital back, the chances are that you will be using ProPhoto RGB, which is a much larger space still.

The objective of colour management is to ensure conservation of colour between one colour space/profile and another. The best advice on colour management is to keep it simple – avoid too many conversions. If you are a DSLR user, shoot in the colour space you will follow through with – this might be Adobe RGB 1998 if the media are your target clients, but bear in mind that many sensors are designed for sRGB, as are monitors and many home printers. Although a smaller gamut exists in this colour space, results in sRGB are generally more vibrant and impressive at first look, while Adobe RGB stands up better when being subjected to editing.

I convert my images to Adobe RGB, so that they are suitable for the printing company that I use for my final output; it ensures they do not have to alter the colour profile to suit their print process, and means that the colours I see on my calibrated computer screen are 'precisely' what will appear on the final print. In other words, the fate of my prints is in my hands rather than my printers'.

In general terms, computers work in RGB (red, green, blue) colour mode, and the spaces mentioned above are variants of this. An alternative colour mode, used extensively in the publishing industry is CMYK (cyan, magenta, yellow, black), which renders images so that they can be printed using the separation process that is common to the media – where different colours are laid down on different plates.

If you want to get the most out of colour space management, then you should consider calibrating your equipment. This means setting up your monitor and home printer if you use one so that they give consistent results. It is possible to do this using the cheap tools that are free as part of a Mac or Windows system – through system preferences in the case of a Mac and through Adobe Gamma in the case of a Windows-based PC.

More advanced tools exist that perform these functions automatically and give more consistent results by feeding back information from a screen or print-reading device; however, these more advanced tools can be expensive. You need to make a judgement between how much money you waste on disappointing prints and how much a calibration system will cost.

What follows is a worked example of how I treat most of my digital files once they have been committed to a memory card. It aims to cut through any mystery, and provide a whole new dimension to your photography. Success in this area is actually all about gaining confidence and better understanding of the whole editing/manipulation/enhancing process. When you have confidence, you will be willing to explore the almost limitless possibilities offered by programs such as Adobe Photoshop.

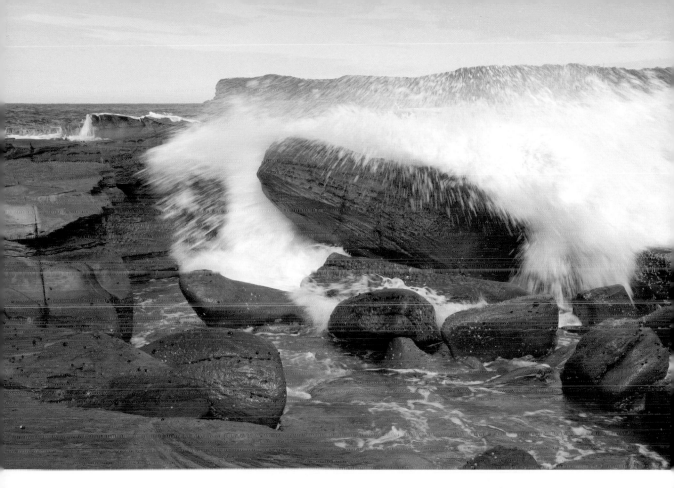

▲ **Waves breaking on Terrigal Beach, New South Wales, Australia.** The wind was blowing quite fiercely so I used my heaviest tripod to stabilize the camera. I tried to anticipate the wave breaking action and depress the shutter at just the right moment. Accurate colour rendition is particularly important with the amount of highlights in this image, otherwise detail may be lost.

▶ **Rural Cyprus.** Subtle warm tones such as those on the side of this building are particularly vulnerable and poor colour management can lead to them becoming lost.

Basic enhancement as part of routine workflow

▲ **Original RAW.** To illustrate the workflow process, I have selected an image of Somersby Falls in Brisbane Water National Park on the New South Wales Central Coast. The image above shows the nascent RAW file in Canon's own proprietary RAW converter. As you can see the image is very lackluster. It was taken on a tripod mounted Canon 10D with 50mm macro lens at ISO 100, f/16 and the exposure was for 3 seconds.

▲ **Converted TIFF.** The above screengrab shows the converted TIFF that has a bit more punch than the RAW file due to extra saturation and altered white balance for the RAW file.

Everybody has their own perspective on editing image files. If you are an architectural or landscape photographer for instance, you will likely always endeavour to render pictures so they reflect a true version of the original scene. At most adding a little extra saturation to a scene, but no more than would have been generated had you used something like Velvia slide film.

In most cases you will seldom alter colours other than to warm them slightly. Perhaps looking for an effect that equates to having an 81B or C filter over the lens. In other words, you aim to record scenes as they are, and not change a scene beyond that which you would once have done with film and subtle color filters. However, if you are an advertising, social or fashion photographer, you might well dive in and start changing things quite dramatically to stylize your image. Chances are you will tweak tone, colour and apply repair tools to remove unsightly or distracting elements. Although I wrestle with my conscience on the issue, these days I apply repair tools more and more to my landscape images as well – cloning bathers from beach scenes etc. Although this might be questionable on an ethical standpoint, no one would argue the merits of removing red eye or flash reflections from the eyes of a bride and groom for instance. Let's examine the various enhancement processes that I am likely to apply to a typical scenic shot:

RAW conversion

If you are serious about your photography, you will probably always shoot RAW files. At the time of writing, I tend to use Canon's own proprietary RAW converter on the premise that they are likely to have evolved the optimal algorithms to yield the best results. I do not produce hundreds of images a week like social photographers might, and so batch processing efficiency is not so important to me – I prefer to process one by one and spend time on my image files. Where out of necessity throughput is high, photographers often elect to use third-party software to perform RAW conversion. Some of the leading third-party software for RAW conversion includes: Capture One Pro, Breezebrowser Pro, Bibble, Adobe Camera RAW, Adobe Lightroom and Apple Aperture. Many of these programs offer more advanced functions than can be accessed via proprietary software, and the whether the results of conversion are better or worse than from proprietary RAW converters is a hotly debated topic.

Perhaps the two best-known RAW conversion programs are Capture One Pro and Adobe Camera RAW. Capture One does away with the tedious need to process one file at a time. Instead, RAW file adjustments are saved in a cache and can be applied later as a batch process, or in the background while you continue working on current files. Many other RAW conversion programs have now adopted this feature. Capture One also offers multiple file output, in other words you can generate a variety of files for different purposes all at the same time, for example a full-resolution TIFF for printing and a JPEG for web use. Increasingly popular are 'all in one' programs such as Adobe Lightroom and Apple Aperture, not only do these offer browsing, editing and archiving modules, but also powerful RAW conversion modules. The integration of various other functions into the RAW conversion stage has made these relatively new programs increasingly popular.

It is also worth noting that Adobe Camera RAW is incorporated into more recent versions of Adobe Photoshop and Adobe Photoshop Elements. Adobe Camera RAW is a superb product with great features, and even allows the use of curves on RAW data to better control highlights – great for wedding photographers faced with white dresses and landscape photographers confronted by bright or snowy landscapes. Note that the full version of Photoshop ships complete with Adobe Camera RAW as well as Adobe Bridge, which is a program that aids workflow and allows batch processing in the background.

In the conversion process I set 16-bit output whichever program I work with. I always work with the biggest possible 16 bits per channel TIFF. This means I retain tonal range and native detail in the final print. The conversion process then yields a 16 bit TIFF that can be viewed and worked on in the image editing space of Photoshop.

▲ The above screengrab shows how to assign the Adobe RGB 1998 profile in Photoshop CS.

Colour space

The next step of the workflow for me (because my printing company requires Adobe RGB 1998 files – you may not need to do this if you're printing on an inkjet printer at home) is to convert the 16-bit TIFF from sRGB to Adobe RGB 1998. I always shoot in sRGB and convert to Adobe RGB 1998 in Photoshop.

The crop

The second thing I do to any image is to crop it to what I perceive to be the most aesthetically pleasing composition. The more competent you become in the field the less you will need to use the crop utility. Indeed, the waterfall in this worked example needed no cropping, as I framed it carefully at the time of exposure. This provides a salutary reminder that a good photographer produces his or her art in camera, and does not use Photoshop to compensate for a lack of creativity in the field. Photographers are artists, and the way we execute our field craft has not changed, even if technology has moved on. Also, remember that there is a downside to cropping, in that as you lose file size, so you lose flexibility in what you can do with the remaining image in terms of print size.

Tonal balance

There are many ways in which tonal balance can be optimized. I always try to reproduce colours as I remember them when I made the exposure. Clearly, a level of subjectivity is involved, and my personal goal is always to aim for the attributes of ISO 50 Velvia film, for which the words 'pizzazz', punch and saturated come to mind. Fine, so most photographers may go that little bit beyond the attributes of nature in their augmentation of nature. Personally, I would be unhappy to take Photoshop saturation of my image tiles beyond what would be seen if shot through an 81B warm-up filter. Regardless of your personal preferences you should consider what a viewer is likely to believe. If he or she is likely to stare at the colours of a sunset in disbelief, then this reaction will, in itself, detract from the desired effect of the image. Another point to bear in mind is that too much colour enhancement can induce technical issues, where colours block up and tones look flat and unattractive.

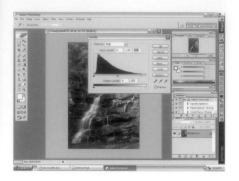

▲ **Levels.** Play with the levels adjustments on your 16-bit image file until you are happy with the results, as I have done for the shot above.

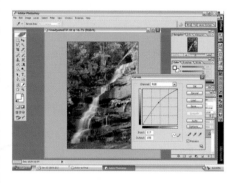

▲ **Curves.** The above screengrab shows the use of curves to achieve essentially the same effect as the levels histogram, but with more subtlety and flexibility. The upward pull on the curve has lightened the image substantially giving more detail in dark areas without blowing out lighter areas.

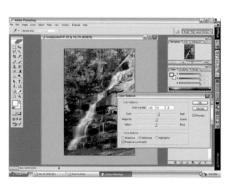

▲ **Colour balance.** The dialogue box for changing colour balance. Here the midtones have been boosted in the red channel by +10.

The first step is to correct levels. This is usually done in one of two ways:

Levels histogram

By taking the following route in Photoshop; Image>Adjust>Levels, you can pull up the levels histogram. This is a graphic illustration of an image's colour range. It's an easy matter to interpret and then adjust the histogram. On the horizontal axis you have a scale of brightness, and on the vertical axis you have the number of pixels at a given level of brightness. The thing to remember in using this utility is that the dark end of the histogram is to the left, and the bright end to the right. If you pull the adjustment arrow on the left towards the centre of the horizontal axis the image darkens. Conversely, if you pull the adjustment arrow on the right towards the centre of the horizontal axis the image lightens.

A typical histogram may show a range of tones, in an ideal world this would not have any pixels lost to the extreme right or left and shown as a vertical line at either extreme. If the curve is shifted too far to the left, the image may be too dark, and appear underexposed. If the curve is shifted too far to the right, the exposure may become overexposed and suffer from blown out highlight areas.

Before moving on, I should make it clear that levels is an extremely useful tool for quick, basic adjustments, and is invaluable in improving picture files. A similar effect can be achieved using the curves tool, which although more advanced is perhaps not quite so easy to control.

Curves

Curves is a more versatile version of the levels histogram. I often use it to pull a very slight S curve to add punch (Image>Adjust>Curves). I find curves particularly useful for washed out woodland scenes. It is easy to add a bit of punch and colour back using this tool – see left:

The figure is self-explanatory; drag the line (pull a curve) to make a picture darker or lighter. Use the bars on the axis as a guide to the effect you are after. The curves adjustment rather than the levels histogram correction provided the best effect that I continued on to the next step of workflow with.

It is worth noting that the latest version of Photoshop at the time of writing (Photoshop CS3) has combined the levels and curves tools into a single tool to improve ease of use.

Colour balance

Getting the colour balance right comes down to personal taste. Since most of my shots are all about getting a warm, saturated effect, what I tend to do is move the colour balance slide control three to five units to the red side of the scale for highlights and midtones, and one or two units for shadows. See screengrab left. Sometimes I may add a slight touch of yellow. This addition of red works great for forest scenes in particular. This control is accessed via Image>Adjust>Colour Balance. Clearly use of this control is subjective, and similar attributes can be applied during the RAW conversion stage. I always err on the side of caution otherwise it will spoil the outcome of the next step – adding saturation.

Saturation

This is where you really start to see a change. Increasing the level of saturation really gives your image a bit of punch (now you truly start to see a digital ISO 50 Velvia beginning to unfold). Go to Image>Adjust>Hue/Saturation. My advice to you would be never go beyond 30%. Indeed, my average saturation boost would be between 10 and 20%. Try to have integrity and just recreate the level of colour you remember seeing through the camera viewfinder at the time of exposure, a little extra is fine, but people will detect too much saturation and start muttering digital manipulation under their breath when they walk around a gallery hung with your work! Yes, digital manipulation is still a dirty word in some quarters – the public likes to see work that reflects reality, so don't stretch the truth too far. It is also worth noting that saturation, and sometimes an 'intelligent' version of saturation called vibrance, can be applied at the RAW conversion stage.

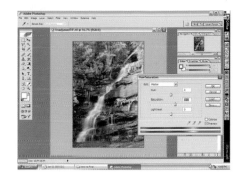

▲ **Hue/Saturation.** The addition of saturation to the image shown in the above screengrab shows a large degree of difference in terms of adding eye-catching vibrance.

Interpolation

The next step is to upsize your masterpiece so that it can be used for large print reproduction. However, before you start this process its time to change your 16-bit TIFF into a smaller, more manageable 8-bit TIFF. The benefits of the 16-bit waterfall file were realized in the earlier levels/saturation enhancements which provided a wider range of colours and tones to work with. Now we can safely convert into 8-bit mode prior to interpolation. You simply follow the path Image>Mode>8 Bits/Channel.

Now you can 'upsize' the resolution of the image. In the case of the waterfall shown in the screengrabs, I elected to use Extensis PXL SmartScale to interpolate the image. There are limits to how much you can enlarge an image file. You need to play about and learn what works best for your particular camera sensor. Some subjects that lack fine detail (skin being one example) can be interpolated more than a detailed landscape with lots of texture in the foliage. To give you my view of this software's capability, I have standardized on 24x16in (60x40cm) at 300dpi as the final master file size for images taken on my 6.1 megapixel DSLR fitted with a professional lens. 30in (76cm) on their longest side seems quite acceptable as well and they will go larger, but beyond 36in (90cm) on their longest side, I can see early signs of pixelation on some images at this size. For my 12-megapixel DSLR 30x20in (76x50cm) is the standard I work to, but files will go larger and retain sharpness in the detail.

You should remember that as clever as interpolation software is, you don't really get something for nothing (it is more like stretching the truth). So, for example, if you heavily crop an image down to improve composition, you cannot replace the lost pixels through interpolating back up to the file's original size. You might simply be better expecting a smaller print.

▲ **Interpolation.** These screengrabs show the file before and after being interpolated by Extensis PXL SmartScale to create a 99MB 8-bit TIFF at 300dpi. You can also interpolate an image using the bicubic resizing facility.

◀ **Crested pigeon.** These are a common sight around my house. They are far more endearing than their urban counterparts. They make a strange whining noise when they take off. I shot this specimen using an 8-megapixel DSLR with a 400mm telephoto lens with the help of a flash gun. The image reproduced here was cropped and then interpolated slightly using the PXL Smartscale plug-in for Photoshop.

▼ **Sydney Harbour from Milson's Point, New South Wales, Australia.** DSLRs like the Canon EOS 1D Mark II used for this shot are far superior to film when it comes to undertaking twilight photography with manually timed exposures. They are also better able to withstand the effects of interpolation; furthermore, there was little need to add much saturation to this image, as it was vibrant straight from the camera.

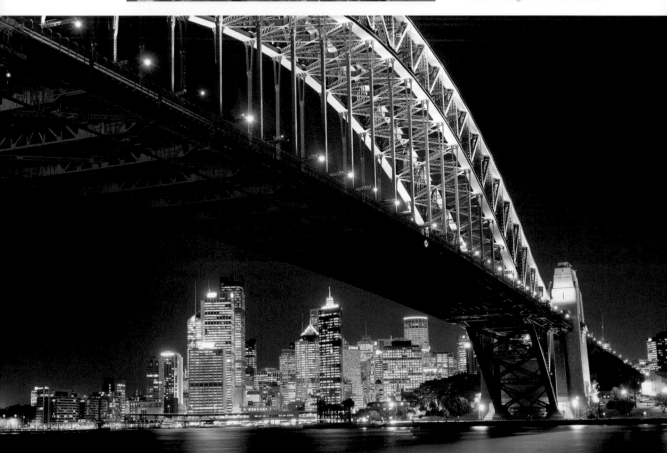

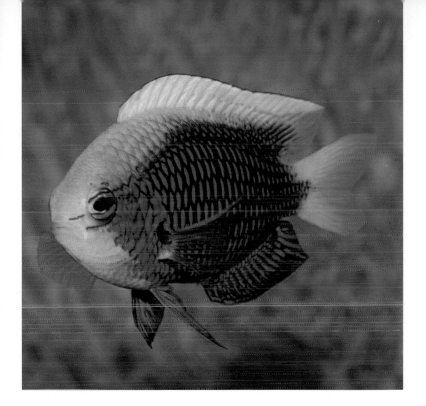

◀ **Blue Damselfish.** Bright colours are always a good selling point – a dynamic composition as here also works well. This digital photograph was cropped in Photoshop, and then enlarged to a moderate 300dpi print size using Extensis Smartscale.

▲ **NIK Sharpener Pro.** The above screengrab shows the NIK Sharpener Pro plug-in for Adobe Photoshop.

Sharpening

The next step is to sharpen the interpolated image. Never sharpen first, then interpolate, as you will simply magnify any artifacts of the enhancement process and the sharpening process. Always make sharpening the last job that you do. Sharpening, like some other enhancements, can be performed in the RAW-conversion software, however, I prefer to carry out these processes in Photoshop, as sharpening in particular is best carried out as the last step in the image-optimization process.

I have three mechanisms I sometimes use to achieve sharpening.
Adobe Photoshop – Unsharp Mask;
Adobe Photoshop – Lab Colour – Unsharp Mask;
Adobe Photoshop – NIK Sharpener Pro plug in.

Another, fourth method that some people use is called 'high-pass sharpening'. This is ideal for images that contain both smooth tonal areas and detail. By using this approach, it is possible to minimize any increase in noise within the smooth tones that might otherwise occur when using Unsharp Mask. In essence, it retains edge details where sharp colour transitions occur, and suppresses the rest of the image. Because the filter removes low-frequency detail in an image, it is useful for extracting line art and large black-and-white areas from scanned images, but is not a method that I use.

 Most people, myself included, are happy to use Adobe Photoshop's Unsharp Mask utility to sharpen their images (but try not to overdo it). I usually use around 300% sharpening. Go to Filter>Sharpen>Unsharp Mask and enter your value. This approach won't improve a hopelessly soft or out-of-focus image. I tend to use 300% sharpening with a radius of 0.3 pixels and a threshold value of 0 for most of my digital camera files that approximate to 8x12in (20x30cm) at 300dpi. For larger files following interpolation or derived from high-resolution scans of transparencies I increase the pixel radius. So for a

typical 99MB interpolation from one of my Canon DSLRs to yield a 24in (60cm) to 36in (90cm) print I would typically set 300% sharpening with a radius of 0.7–1.0 pixels.

What the sharpening tool does is to increase contrast along edges within the picture. Basically, each pixel in the frame is compared to surrounding ones to compute the level of contrast that exists. If the differential in adjoining pixels achieves a certain threshold, the program determines the area to be an edge and a predetermined level of sharpening is applied. The sharpening or increased edge contrast produces a slight 'halo' effect, which can become visible if too much is applied.

In controlling the sharpening algorithm, the radius slide control is particularly important. It determines the size of the halo in pixels that will be added at each contrast edge. If like me quality is always your first concern, you should select a radius of around 0.3–1.0. For lower resolution files you can increase radius further, perhaps up to three or four pixels.

The 'amount' slider ascertains how much contrast is added to the halo. That is, it will control halo intensity. As a rule of thumb, for a small radius select an 'amount' setting of between 150% and 350%. However, if you have applied a large radius, your 'amount' setting should be below 100%.

The threshold scale allows you to set the difference that must exist between adjacent pixels before it is considered as an edge that requires sharpening. For the highest resolution images, you should select a threshold between zero and five. Only go higher with lower resolution files with less inherent detail.

All your camera files will need some sharpening – but let me repeat myself; to avoid artifacts, sharpen your image after all other manipulations and enhancements are complete. Always make sharpening the last job.

This TIFF is now the master file. The very last job is to downsize this file to a range of potentially usable print sizes. I would take the long edge down to 18in (45cm), 12in (30cm), 5in (13cm) and 3in (8cm) and file these five 300dpi TIFFs away in a folder with the original RAW file that produced them.

As they say: 'the proof of the pudding is in the eating' – I have this image hung in our spare room at home, and I don't doubt that my efforts in Photoshop have improved this image beyond anything I would have shot on Velvia film, and viewed on the lightbox.

▶ **Lord Howe Island, South Pacific.** This shot was taken using my Mamiya 7II and 43mm lens. Although shot on film, its success depended very much on digital enhancement. I scanned the transparency at home, cropped it down to a panoramic, and carefully (using Photoshop) minimized the impact of smoke coming from the island's incinerator, which very nearly spoiled the picture. As this was an unusually grainy crop from a 6x7cm transparency, I had to work hard to ensure the appropriate balance between reproduction at a useful size and the correct level of artifact-free sharpening.

▶ **Owl Butterfly.** Sharpening works by increasing the contrast at edges. Subjects that have high-contrast edges to start with can be vulnerable to over-sharpening, where the effect becomes too obvious and a halo appears around the edge.

DIGITAL DETAILS

Learn to examine your RAW images prior to conversion into TIFFs. This way you will save time, and only need to convert and optimize the very best photographs. This also saves valuable space.

◀ **Before and after.** To prove that this whole lengthy process is worth the effort, examine the left screengrab, which shows Somersby Falls as the original unadjusted TIFF versus the final adjusted one.

Chameleon-Laona Plateau, Cyprus

This chameleon was in the perfect pose for a peek-a-boo style photograph. This picture is completely natural, and was not posed, just a few very minor adjustments were required in Photoshop.

- I shot it at around f/11 to increase depth of field, but not ruin the picture by increasing diffraction as is often seen at small apertures.

- Minor cropping was carried out along with some curves adjustments in Photoshop. A little bit of saturation and some minor alterations via colour balance were followed by interpolation using the Extensis Smartscale plug-in to produce a file suitable for a moderately large print. The image was then sharpened using Unsharp Mask.

Magic of the digital darkroom

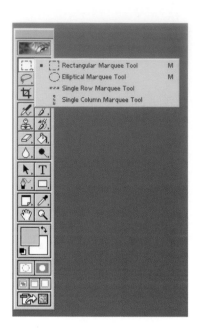

I'm sure you will have fun exploring Photoshop and similar image-editing programs with all they have to offer. However, you need to come quickly to terms with the following basic editing principles if you are to make the most of these programs. To deal comprehensively with Photoshop alone would require a huge tome, and as space is at a premium, necessity dictates brevity. However, with the information here you should gain sufficient skill to begin an intuitive process of learning how to make the most of Photoshop for your nature and landscape photography:

Selections and layers

When you have learned everything there is to know about layers, you will have passed the test and earned your wings. Even then, it's a steep and long, not to mention winding road to achieve true excellence in Photoshop. By true excellence, I'm talking about a level of expertise reserved for the few who produce the finest artwork for the advertising industry. We see this work every day; yet mostly take it for granted. Next time you see an amazing photo composite in a glossy magazine advert, examine it to see if you can identify the Photoshop skills that went into creating it.

I will briefly mention selection tools and layers. The toolbox contains icons that permit various ways of selecting areas of an image to edit them. These are shown to the left for Adobe Photoshop 7, but are similar in all versions.

The marquee tools can delineate an area for editing or copying. The same thing can be done in several other ways, for instance by using the magic wand or lasso tools shown to the left.

If you select part of an image from one file and paste it into another, you create a layer. Each time you paste, you create a new layer. Layers allow you to create Photoshop composites, or to apply subtle exposure changes to an image by merging layers of the same view that have been exposed for different elements of the scene. You can see all your layers stacked up in the layers palette, and so can keep on top of your artwork. When you finish, you should flatten the image, which simply means that all the layers are merged into one.

One of the most common uses these days for layers is as a substitute for ND graduated filters used to counter high contrast in a landscape scene. One can do this by double processing a RAW file – once for highlights and once for shadows. Each TIFF can then be saved separately. The two files are then opened and one copied and pasted onto the other to create two layers. Layer masking is then used in combination with a brush tool to reveal shadow detail and achieve a suitable harmony in the contrast range. There are other methods available to achieve a similar effect.

All that is left is for you to experiment – however, be prepared for as much frustration as reward. Remember, though, all the effort will be worth it as you can do some truly amazing things in Photoshop.

▲▼ **Magic wand.** The marquee tools shown in the screengrab above can delineate an area for editing or copying. The same thing can be done in several ways, for instance, by using the magic wand or lasso tools, which in themselves come in several different forms as shown in the screengrab below.

Panoramic software

As a keen panoramic photographer, I have collected together many superb Velvia 6x17cm transparencies over the years. One of the best attributes of digital cameras is their ability to generate 'photostitched' panoramas by using clever software that is often supplied with the camera. Even cheap digital compacts (by comparison to a DSLR) can yield breathtaking panoramas. They don't go as big as a 6x17cm transparency scan from an expensive Fuji GX617, but they can yield commercially viable fine-art prints that anyone would be proud to hang on their wall. Indeed, the shape of the frame that a digital panoramic yields is often more interesting than what a film panoramic camera can produce. The screengrab shown below shows one of my favourite photostitched panoramas at a strangler fig in a subtropical rainforest very close to where I live.

There are many programs around that permit photo merging such as this. The latest version of Photoshop is one example. I prefer to use either Canon PhotoStitch or REALVIZ Stitcher Express. The Canon program is easy to use and works well for most subjects. It's best to shoot subjects using a tripod with a good pan-and-tilt head designed for QTVR imaging, and to avoid moving subjects (such as rough seas). Try shooting a turbulent sea, and you will soon find out the limitation of photostitch software.

I possess three types of stitching software; Canon's free PhotoStitch program, REALVIZ Stitcher Express and Ulead Cool 360. Each has its advantages and disadvantages.

Digital capture offers new ways of tackling panoramic views. Specialized film cameras were, and indeed still are great for capturing panoramas, but digital can do the same thing using special stitching software. However, beware of moving subjects, particularly choppy seas, as they don't stitch together too easily.

▶ **Panoramic composition.** You can see that the main picture is a composite of five separate JPEG files, each one slightly overlapping the next. Aim for around 20–40% overlap in the individual elements of your panoramas. The final merged picture was adjusted using saturation of around 20% and a slight curve was pulled to darken the scene, and make colours more distinct. The final step was to sharpen the image. It's clear from the screengrab how profound the effect of subtle colour adjustments in Photoshop can be when you compare the colour rendering of the final panoramic shot with the neutral, almost washed-out appearance of the individual JPEGS.

Monochrome

Digital cameras obviously record images in colour. However, the digital route does provide you with the option of converting your image files into black & white at a later date. As with so many things in Photoshop, there are many ways to achieve your artistic goals.

The most obvious route to producing a monochrome image from a colour one is to follow the route Image>Mode>Grayscale in Photoshop. When you have converted the file into a greyscale image, you can then adjust the levels histogram and or curves to get the effect you want.

While this method is quick and easy, other people prefer to use the greater control that the Photoshop channel mixer confers. Follow the menu path: Image>Adjustments>Channel Mixer then in the resulting dialogue box select the monochrome tick box and adjust the red and blue channels until you get the result that pleases you most. The total value of the channels should equate to 100 unless you want to change the overall brightness.

There are also increasing numbers of ways to convert from colour to black & white during the RAW-conversion stage, this allows you to apply the various RAW-conversion functions and see their effects.

While I'm sure there are many photographers who will welcome an ability to do away with their cramped darkroom and noxious chemicals, I personally feel nature and landscape images are always better when viewed in colour. Some people will feel this is heresy given the seminal work of Ansel Adams and his followers, others will agree.

Repair work

The two most significant tools for applying a cosmetic fix are the healing brush for removing small blemishes, and the clone tool for more radical correction. However, the cosmetic fixes that are possible with Photoshop are almost limitless, and are thus only really determined by a photographer's imagination. Perhaps

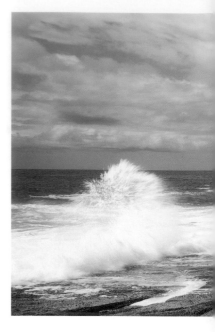

▲ **Skillion, Terrigal, New South Wales, Australia.** My Fuji GX617 panoramic camera with a 90mm lens was used to capture this coastal vista. Film is still a better choice than digital stitching for coastal panoramics due to frequent problems with the registration of seams when merging files with a lot of turbulent water movement.

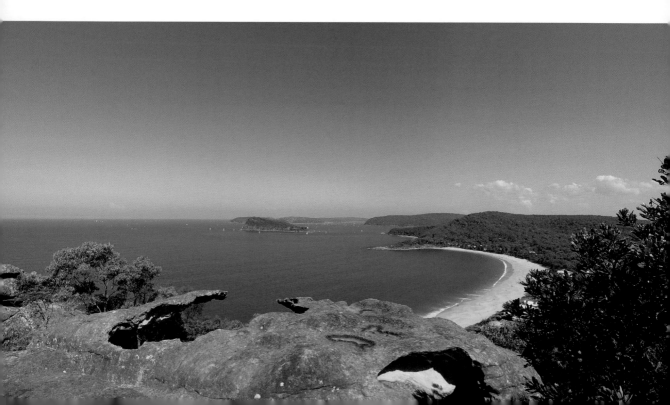

The most common example I tend to employ after the healing brush and clone tool is a digital version of a neutral density graduated filter (ND grad) to hold back the sky in a scene. If I shoot film or digital I would often use a Neutral density graduated filter to achieve this in camera. However, there are times when I omit to do this and only realize the error of my technique during post-production. Fear not, if you too do this, it's a relatively easy matter to put right. Consider the storm sky I shot on Lord Howe Island in the South Pacific (see page 94). This image was shot digitally without an ND grad. When I arrived back home I was disappointed to find that the dark brooding sky was far weaker than I remembered (who said the camera doesn't lie?). I soon put this right by making a background copy (Layer > Duplicate layer). Next I used the polygonal lasso tool to select the sky area and then selected quick mask. To blend the selected area smoothly the next job on my list was to feather the masked off area. Do this by choosing Select>Feather. Start at around 50–60 pixels and alter according to need. The final job was for me to make the necessary adjustments. In my case I chose Layer>New layer>Curves. I pulled the desired curve to darken the sky and flattened the image before saving it (Layers>Flatten).

◄ **Looking across towards Lion Island and Palm Beach, New South Wales, Australia.**
This grand panoramic view was created using a DSLR in vertical format set on a tripod with a panoramic head. This is a well-known local view, and I'm so pleased with this digitally created picture that I have a matted and framed colour metallic print of it hung in my house. Most people think it was taken on my film panoramic camera rather than digitally originated – which shows that many people still perceive film to be superior.

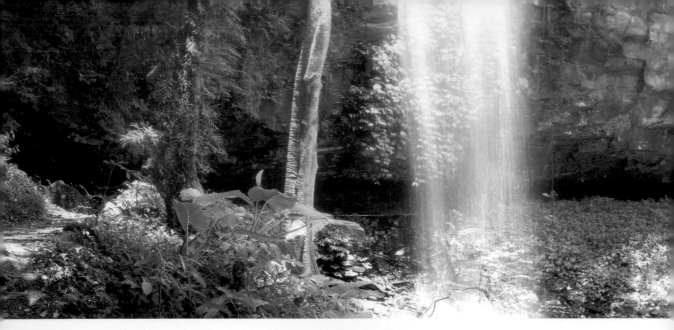

▲ **Lord Howe Island, South Pacific.**
Storm clouds over Lord Howe Island.
A last shot grabbed just before a storm
hit. I wanted to capture the menacing
Pacific sky juxtaposed with the palms.
I shot this on a compact camera in RAW
mode, and used masking in Photoshop
to recreate the sky's contrast that I saw
at the time (it's not really possible to
use ND grads on a small digital
compact). The method I used is
explained on Page 93.

▲▶ **Crystal Falls in Dorrigo National
Park, New South Wales, Australia.**
These images show you the true power
of a DSLR. However, while the first
shot shows a great vertical image of
this cascade, the second shot wins
hands down in terms of perspective
and potential maximum print size.
 It represents the merging (stitching)
together of two discrete images that
overlapped by about 30%. Obviously
you need a sturdy tripod with a decent
pan-and-tilt head. I could never have
dragged my heavy and cumbersome
purpose-built panoramic head all the
way down to this cascade (and even
less so back up to civilization), however,
this was taken with a lightweight tripod
that has a built-in pan-and-tilt head. It
worked beautifully for the production of
this panoramic stitch which prints as
well as any 6x17cm film scan that I
have produced in the past. It will print
to 36in (90cm) comfortably, which is
the typical output I worked to with film.
Digital capture can certainly compete
with film in many different ways.

The printing process

My first inkjet printer printed at a very low resolution and the pictures were terrible. Today I use 1440dpi output that is 100% photo quality when I use glossy paper. A 28MB scanned image file will output at A4 with no interpolation necessary, and yield pictures far superior to those that I obtained from commercial labs just a few years ago.

DIY archival inkjet prints

One of the biggest issues with inkjet printers was always the problem of colour longevity; it isn't worth hanging an inkjet picture on your wall if within a few months it fades away to a washed out shadow of its former glory. Fortunately, the latest generation of printers from manufacturers such as Epson, Hewlett Packard and others solve this problem by employing archival pigment-based inks that claim to outdo good-quality photographic paper in terms of longevity. These printers can even print onto roll paper for full-width panoramic prints. With the array of paper media around today, this is a serious option for turning out professional quality prints. Until recently one of the major drawbacks of these archival prints was that they were not available in the high-gloss finish that picture buyers tend to prefer. At the time of writing, Epson has corrected this, and now you can have a high-gloss archival-quality print easily produced at home using its Ultrachrome Hi-gloss pigmented inks and latest K3 ink sets, which at the time of writing represent the state of the art for home printing, and virtually remove all artifactual bronzing (known as metamerism) where colours appear to change under different light sources. They can produce panoramic images that established artists can sell directly. The same company even produces a range of inkjet printers that are (if you are very keen) just about affordable for home use, and can produce huge, gallery-quality images that are lightfast, and will outlive many traditional photographic prints. Hewlett Packard now also offers large-format printers, which use dye-based inks, but which have 70+ year longevity. Undoubtedly other manufacturers are also constantly updating their technology in this field.

▲ Monument Valley, Utah, USA. Taken using my Mamiya 7II and 65mm lens. The film was scanned and an extreme crop taken to emphasize the character of this iconic vista. Panoramics like this are great for printing at home with roll paper on your inkjet printer.

▶ **Strangler fig, Mt Warning National Park, New South Wales, Australia.**
This is one of the best strangler figs I have seen. They often make great rainforest photographic subjects, but this is probably the easiest one I've photographed. It is not far from the beaten path and you don't need to walk far from your car to shoot it, which is good, as there is little light so you most definitely require a tripod which can be a pain when summer humidity builds up. This was taken on a DSLR, and has a reproduction size that won't exceed 30in (75cm) on its longest side.

▲ **Green python.** Colour fidelity can be a problem over time, so you should consider the archival quality of inks and papers before you buy into a system.

▲ **Praying mantis.** Macro subjects are great for large prints, where the scale of the creature on display and the sense of seeing something out of the ordinary adds huge impact.

Top-end laser/LED output

No matter how nice it is to have your images published in books and magazines, there is little to beat seeing a huge gallery print depicting the best of your work. However, this can be a confusing area for those first entering the digital output arena.

The Lambda output prints that I sell have been produced from digitally mastered images using fibre-optic-LED technology exposing directly onto continuous tone photographic silver halide material. The prints represent the ultimate in fidelity, colour, clarity and tonal range available on any photographic paper.

Today, there are many options open to buyers of photographic art. Prints are available on a range of premier media, often using special chemistries or ink sets, but how does the process work? First select a reputable lab, and liaise with the lab regarding their requirements for resolution, file size, colour profile and so on. Basically, having got the best quality file possible from your digital camera or DSLR, you need to transcribe the digital bits and bytes you have archived onto a CD or DVD into the highest quality output that is possible. In my opinion (others may disagree), Kodak Professional Endura Metallic Paper or Fuji Crystal Archive prints produced from master image files using fibre optic-LED or laser technology is the best route to take.

Among the most popular mechanisms for producing photographic art in this way are; LightJet, Chromira and Durst printers. LightJet prints seem to be de rigueur in the US, where they are often used to produce high-quality nature and landscape photographic art. With this technology, the digital file guides lasers to expose the photographic emulsion. Chromira uses an array of LED exposure modules that print directly onto photographic paper from digital files. I commonly use a Durst Epsilon fibre-optic-LED printer (baby brother of the Durst Lambda). It is limited in print width to 30in (75cm), but uses rolls that permit a length of up to 100ft (30.5m) to be exposed. This process uses proprietary three-colour (RGB) fibre-optic-LEDs to produce high-quality, continuous-tone exposures (boasting 16 million colours), with perfect edge-to-edge clarity. It avoids screening and dithering, and thus picks up on the finest details. It supports TIFF, JPEG and BMP images.

I have yet to do any kind of comparison between these high-level printers, and such a test would be very difficult to carry out away from a lab situation, but my guess is they will all satisfy the most demanding of us nature and landscape photographers. My choice is as much to do with geography as anything else. My lab in the UK was literally around the corner, they did my E6 slide processing and were a dab hand at turning out sympathetically rendered Epsilon prints from either scanned slides or digital camera files. I now live near Sydney, and so have sought the services of a local lab who are simply wonderful at producing consistently excellent work using their Durst Lambda.

Remember, once your precious slide has been digitized, you need never risk its loss or damage again. This sparing of original slides is one of the big plus points of this kind of printing from slides. Of course, image files taken on a DSLR are easily cloned, and therefore less physically vulnerable.

For me, digital output is more consistent than optical methods of exposing photographic paper. Some of the finest Ilfochrome prints I have seen from scanned slides are those of Australian panoramic photographer Ken Duncan. I wandered around one of his galleries on the New South Wales central coast, and was absolutely mesmerized by his captivating natural landscapes. If you ever get the chance, visit one of his galleries.

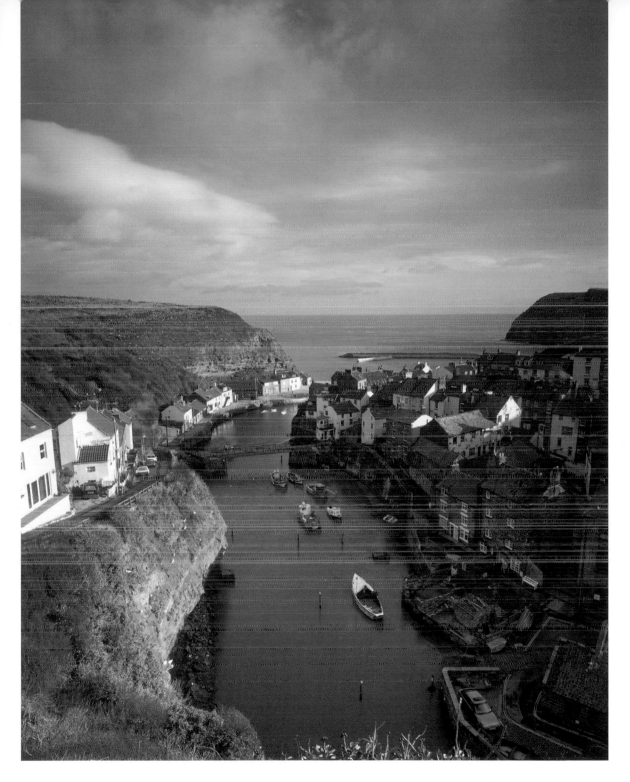

▲ **Staithes near Whitby, North Yorkshire, UK.** This slide combines the best of analogue and digital technologies. It was shot with an Ebony RSW 5x4 view camera with an 80mm wideangle lens. I used a neutral-density graduated filter and an 81D warm-up filter to enhance the lighting. I had this sheet of Velvia scanned professionally. As seagulls were in flight all around me, I then took the professional scan and cloned out a very long white seagull trail that I had inadvertently caught on film, and which runs right through the foreground.

chapter 5
The photographic basics

While the digital revolution has changed an awful lot about photography, there are plenty of things that have remained the same. These photographic 'basics' underpin all good photographs.

The basics of exposure

Mastering exposure is a keystone of the whole image-making process and is dependent on three variables:

Shutter speed The duration that the camera shutter is open during the actual image-taking process. The longer the shutter is open, the more light will reach the sensor.

Aperture This is denoted in f-numbers and is a measure of the size of the lens opening relative to the focal length. Small f-numbers such as f/1.8 or f/2.8 represent large apertures and large f-numbers such as f/22 or f/32 represent small apertures. Obviously progressively more light reaches the sensor as the f-number is reduced.

By balancing the shutter speed and aperture equilibrium according to need, one controls the amount of light hitting the sensor (or film emulsion).

ISO This determines the sensitivity of the material being exposed: a low ISO setting requires a greater intensity of light than a high one in order to record a digital image. This can be varied with digital cameras to enable different combinations of shutter speed and aperture.

▲ **Green python.** Shot on a Canon DSLR with a 100mm macro lens. Macro lenses are often used stopped down to their minimum aperture to maximize the depth of field which drops dramatically when shooting close up.

▲ **Waterfall in the Blue Mountains, New South Wales, Australia.** One of the best things about a professional DSLR is that they are so well made and substantial, but this means they weigh a lot. The hike to this fall on a summer's day was long and hard, not the least because I also had my tripod strapped to my shoulder. I got several excellent pictures such as this one, but decided that lighter consumer and semi-pro DSLRs have much to commend them, as indeed do lightweight tripods. The moving water in this shot has been blurred nicely by selecting a small aperture and consequently a long shutter speed. Note the difference in effect between the moving and the still water.

In order to communicate the various aspects of exposure theory, we should talk in terms of stops. A stop is either double or half of any value. For instance, shutter speeds range from many seconds down to 1/8000sec. A typical sequence being 2sec, 1sec, 1/2sec, 1/4sec, 1/8sec, 1/15sec, 1/30sec, 1/60sec, 1/125sec, 1/250sec, 1/500sec, 1/1000sec and 1/2000sec (1/250sec often being the maximum speed of flash synchronization). You will note that this sequence represents a series in which each shutter speed is half the preceding value and twice the subsequent value. Each doubling or halving of shutter speed represents one stop; for instance, 1/125sec to 1/250sec is a one-stop decrease in exposure. Shutter speed is used for two purposes: to balance the amount of light reaching the sensor and to control the appearance of motion, the slower the shutter speed the more likely motion is to blur (it depends on how fast the motion is). So for example you can render a waterfall a milky haze by using a shutter speed of around a second. It is also worth noting that slower shutter speeds also make your shot more vulnerable to the blurring effects of camera shake if it is not tripod mounted.

The f-numbers that define aperture are also a progression of one-stop changes in which the amount of light admitted through the lens is either doubled or halved. However, the arithmetic change is not obviously reflected in numbers of the typical f-stop series which runs f/1.4, f/2, f/2.8, f/4, f/5.6, f/8, f/11, f/16, f/22 and f/32. Nevertheless, f/4 lets in twice as much light as f/5.6 and represents a one-stop increase in exposure as does opening the aperture from f/16 to f/11. Your f-number dictates depth of field, or the extent of the zone of apparent sharpness from foreground to background. Small apertures are therefore ideal for ensuring near-to-far sharpness in wideangle landscapes while large apertures suit telephoto wildlife shots in which you want to blur everything apart from the subject, making it stand out.

The two variables, shutter speed and aperture, exist in a reciprocal relationship: if you halve the shutter speed and open the aperture by one stop you are providing the sensor with the same quantity of light as if you had doubled the shutter speed and closed the aperture by one stop. Although the amount of light is equal in each case, the effect in terms of depth of field and action freezing potential will vary.

The ISO sensitivity dialled into the camera also plays a role in determining the correct exposure. In fact ISOs, like f-numbers and shutter speeds, also work in stops, in this case represented by a halving or doubling of ISO number. Examples of a low ISO would be ISO 50 or 100, while high ISOs might be 800 or 1600. This means that each doubling in ISO requires half as much light as the previous number in order to record an equivalent exposure. In other words high ISOs are useful when you wish to shoot with high shutter speeds or in dark situations. However, there is a problem in that higher ISO films tend to exhibit more grain structure, while high digital ISOs exhibit more noise (randomly coloured pixels). This can detract from fine detail, or prove distracting in areas of continuous tone, but some people consider them to be atmospheric.

It's important to understand these basics even if you only ever use your camera in a semi-automatic mode such as aperture- or shutter-priority. I use aperture-priority more than manual mode or shutter-priority, but select my aperture according to need – it will be a small aperture if I want a slow shutter speed to blur water or need the extra depth of field for a landscape shot, but will be a wider one if I need a faster shutter speed. With time, these kinds of consideration will become intuitive and you can consider them alongside other aspects such as composition.

RAW files are certainly more forgiving than film when it comes to exposure errors. Moderate under- or overexposure of a RAW file can be corrected easily before conversion into a TIFF, and again can be tweaked using the levels command or curves in Photoshop following conversion. Even before downloading a RAW file from your camera you can get a good idea of how well exposed your image is. The histogram on the camera LCD will indicate the distribution of tones and any likely problems you will have later on. If the curve abuts the right-hand side, then you will lose detail in the highlights, if it abuts the left hand side, you will lose detail in the shadows. However, there is a little flexibility in RAW files beyond the range shown by the histogram, but don't rely on it.

▼ **Abstract of tropical fish.** Cropping an original file at a later date to suit your artistic vision is a simple matter; this was not the case with film. This image is quite bright, and actually fooled the camera's meter into underexposure. I corrected this underexposure in Photoshop using curves.

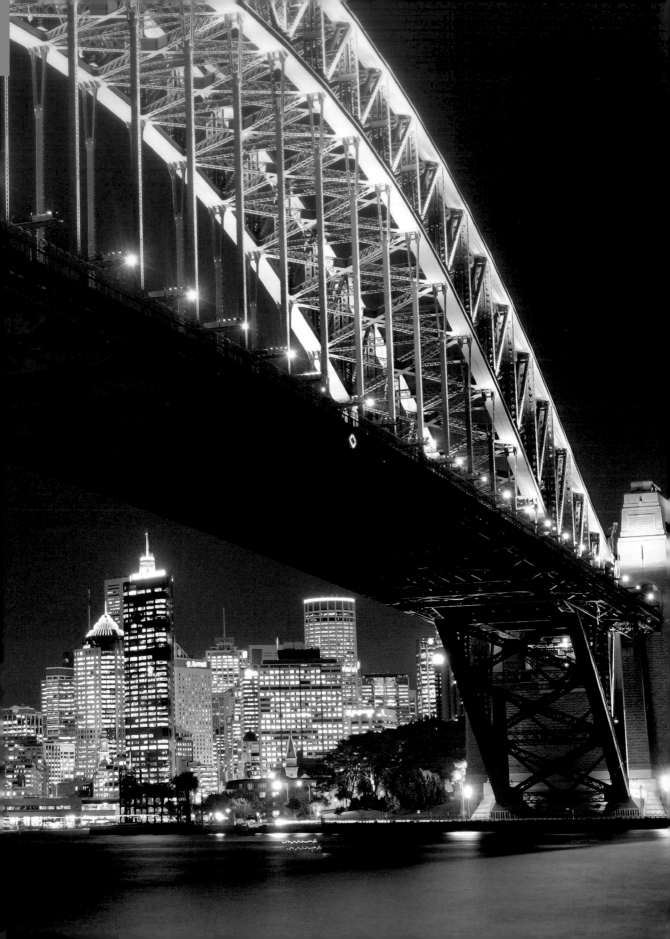

Sydney Harbour from Milson's Point, New South Wales, Australia

DSLRs like the one used here are far superior to film when it comes to undertaking twilight photography with manually timed exposures as was the case with this image.

- The best time to shoot evening cityscapes is when there is still some colour in the sky, but when all the city lights have been switched on. Pick scenes that have merit regardless of the time of day, such as here where the Sydney Harbour Bridge provides an ideal subject for this style.

- Curves and levels were applied as appropriate, followed by a little extra saturation and then interpolated with the Extensis PXL SmartScale plug-in and sharpened. It's necessary to scroll over the canvas at 100% in Photoshop to find and clone out any hot pixels that invariably show up in night scenes – I make this the very last job.

- I always shoot at f/5.6 or f/8 with this particular lens (17-40mm zoom) as it is at these apertures that it provides the sharpest images.

Composition

Digital cameras are just like film cameras in one way in particular, no matter how sophisticated they are, both technologies will produce images that are underwhelming if you don't develop an eye for a picture. Here are some of the visual elements that you need to inject into an image to give it impact, and hence sales potential:

- Look for strong, bold colours and/or distinctive patterns. Avoid chaotic detail and arrange complexity in a way that appears as organized as possible – always seek harmony.

- Landscapes require lead-in lines that draw the viewer into the scene and direct their gaze. Some landscapes require foreground interest that can anchor a distant vista within the camera frame.

- When composing in the viewfinder, never position the horizon too close to the top of the scene, and check for sloping horizons, especially with seascapes. Make sure you avoid cutting off the bottoms of trees in a woodland scene.

- In general, don't place the major point of interest slap bang in the middle of the frame (it's worth noting that occasionally, subjects do actually benefit from this particular rule being broken).

- Never shoot a scene where the major interest lies in the distance, and allow an out-of-focus foreground to creep into the frame (to make sure this doesn't happen, use a tripod, cable release and stop down to f/16 or narrower).

- Always present the primary point of interest in a way that reflects maximum impact – go in close if you're shooting flora or fauna, or let it hold a strong, but balanced, relationship with its surroundings. When shooting animals always focus on their eyes, particularly if you focus close, or crop tight.

- Make animal portraits strong or quirky – never indifferent.

- Don't be afraid to add a person (friend or family), or animal to give a sense of scale when shooting grand landscape scenes.

- Learn to apply the 'rule of thirds', as when used properly, it generally gives the most satisfactory and powerful composition. Divide the frame up with two imaginary lines dropped down a third of the way from either edge of the frame and again run two lines laterally, a third from the top and bottom of the frame. Now place your primary point of interest at any of the line intersections, and you will have a composition that should work well. Which of the intersections you select will depend on the nature of your subject and the secondary features that are also contained in the landscape. Strong vertical features also work well if placed on the vertical lines a third of the way from either edge, while horizons look best when placed on the horizontal line a third of the way from the top of the frame. Again, feel free to break the rules – the rule of thirds is not necessarily always best practice.

▶ **Creek, Daintree Rainforest, Queensland, Australia.** This was taken on Velvia film with a Mamiya 7II and a 43mm super-wideangle lens. I had the 6x7cm transparency scanned professionally, and the final 300dpi print has sold many times as a 40in (100cm) print. This scene is full of things to see, but is well ordered, that is harmony exists between all elements.

◀ **Carpet of bluebells growing in a Yorkshire woodland, UK.** This image sums up springtime in Britain. It was taken on an Ebony 5x4 view camera using a wideangle 80mm lens and Velvia film. The exposure was quite long, and the need to bracket in these sorts of difficult conditions makes shooting 5x4 sheet film an expensive proposition. Although a good scan of sheet film permits huge large-format prints to 5ft (1.5m) or more, the reality is that I have never printed this image beyond 24in (60cm), and even a 6-megapixel DSLR can achieve this with careful post-production enhancement. This scan was performed by a professional lab. Why did I take this shot? Quite simply for the swathe of blue that contrasts with the green to convey the beauty of spring.

on the
Road

Always carry a compass to predict where the sun will set or rise so you can find good vistas to catch at either end of the day.

◀ **Yellow Waters sunset, Kakadu National Park, Northern Territory, Australia.** Taken on a 35mm film camera and scanned. There is little detail in this shot, which is all about colour, so a scan of this kind of subject might print slightly larger than one full of detail.

Strong colours

At school, we all learned about the spectrum of colours that comprise visible light and saw how white light can be split into its component parts by a prism. As future photographers, this was a valuable exercise in understanding how rain can generate a beautiful, yet transient, rainbow. Just as important is understanding the transition from red to violet through orange, yellow, green, blue, and indigo in terms of colour temperature, a scale that is expressed in degrees Kelvin (K) which gives midday sunlight a value of 5,500K, a reference value to which all daylight-balanced films are calibrated. RAW files can also be tweaked according to colour temperature in K to provide a different level of warmth in a scene. At the orange red end of the spectrum, the colour temperature is low (3,000–3,500K), and is the range favoured by most landscape photographers who have the choice of shooting late in the day.

Many photographers, myself included, sometimes attempt to simulate nature's warmth with software or filters. 81A and B filters provide subtle amber enhancements, while 81C and D filters add even more warmth – indeed, care is required with these latter filters, as well as with software, to avoid an over-the-top effect. However, special care is needed with 85 series amber warm ups, which really are obvious in their filtration effect. Most nature and landscape photographers would agree that if two images of the same subject were placed side by side, the warmer of the two would sell first.

At the other end of the spectrum, blues evoke a sense of coolness. The blues of nature can be augmented with 80-series filters (a cloud-laden blue sky will be around 9,000–10,000K). Personally, I don't like too much blue in an image; however, I have seen some magical dusk seascapes enhanced with 80-series filters.

Colour preference is highly subjective and plays a pivotal role in the overall ambiance of a picture, but as well as creating mood, it can also play a role in the graphic design of an image. For instance, the blaze of bluebells in a lime woodland, or the juxtaposition of gaudy flowers vibrantly set against a whitewashed Mediterranean wall, perhaps with a crudely painted blue chair in the scene. If you come across such arresting graphics, don't hesitate to photograph them as they impart real sales potential.

Much of what I have written so far would seem to be more important in landscape photography, but colour is one area that is important in all aspects of nature photography. It is easy to shoot and isolate strong colours with a telephoto or macro lens, for instance. Personally, I find the easiest way to exclude extraneous distracting details from colourful compositions is to shoot close-ups, as it is far easier to isolate colour within a scene using a macro lens. You can do either of two things to isolate the subject: focus really close or employ flash to produce a black background due to the rapid fall off of flash illumination. With a black background, dazzling bright colours really stand out – for example the electric hue of flower petals, butterfly wings or tropical fish.

Colour is just one of the elements that contributes to the whole. It is a blend of factors that makes a picture succeed. The following are some of the more important factors for landscape photography in particular.

▲ **The Tasman Sea.** Afterglow bathing the Tasman Sea in pink and vermilion hues, looking across Soldiers Beach, New South Wales, Australia.

St Andrew's Cross spider. Spiders in webs are notoriously difficult to photograph with flash, as their small size relative to a large open background is a recipe for overexposure. Digital capture takes away a lot of the guesswork in getting it right.

Lead-in lines

What you need to look for in a photograph is a visual thread that provides a lead-in line to a scene. This could be a wall, hedgerow, palisade of trees, watercourse or range of hills.

There are so many ways to achieve this visual thread. Such lines, be they roads, paths, rivers – whatever, add a three-dimensional illusion to the overall image. They carry the viewer's attention into and through the frame – it is a thread that attracts the viewer into the scene from the fore to the distant – if you like, it is a three-dimensional journey into the two-dimensional image.

▼ **Buttress Roots on a rainforest tree, Daintree Rainforest, Queensland, Australia.** Taken on ISO 50 Velvia film with a Mamiya 7II with a 43mm wideangle lens. I scanned the 6x7cm transparency at home so it would print large at 300dpi output. The picture works because the roots lead you into the frame.

When you buy a new lens, make sure you also buy a filter to protect the front element. However, rather than purchase a UV filter, try an 81A or B to add some warmth to your images – particularly if landscapes are your forte. Don't ignore lens hoods – they reduce lens flare, and are often important at the beginning and end of the day.

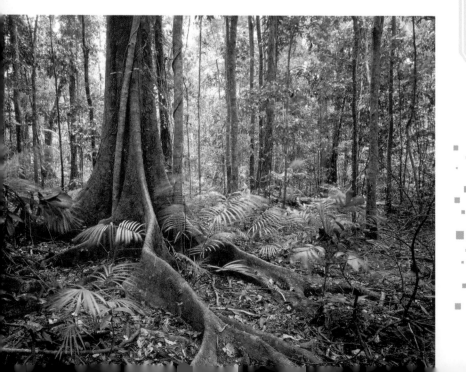

DIGITAL DETAILS

Experiment with white balance settings. I most often shoot with this set to auto, but frequently change it later in the RAW conversion software. The effect can often improve a drab shot, perhaps by changing it to the cloudy or shade setting.

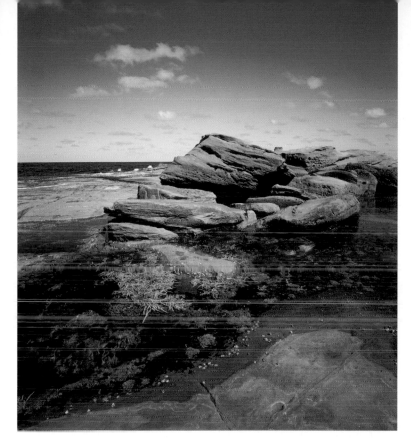

Foreground interest

The best landscape pictures offer some kind of anchor point in the foreground. This could be pretty much anything: a rock, flowers, or a decaying log. The anchor point is not usually the primary subject, but does provide a conduit between foreground and distant subjects so that they work together to complement the overall scene; it is not usually a good idea to make the foreground interest too dominant.

Near-to-far focus requires a relatively wide lens, as does including disparate foreground and background elements, but given the issue of the so-called 'focal length multiplier', it is not always easy to achieve a truly wideangle perspective on a DSLR. You really need the equivalent of a 24mm lens on the 35mm format. In other words, if your sensor size provides a lens magnification factor of 1.5x, your DSLR lens focal length that equates to 24mm on the 35mm format would be 18mm. The reason you need such a wideangle lens is to provide the depth of field required to hold near and far subjects in focus simultaneously. This isn't such a problem with smaller sensors and short focal length lenses typical of compact and prosumer digital cameras. With these you have tremendous depth-of-field, even at fairly wide apertures. This is because depth of field is proportional to focal length.

If you are a view camera user, you can employ front or rear tilt to overcome this problem, and then scan your 5x4 transparency to digitize it and get it into Photoshop for editing.

If your DSLR has a depth-of-field preview button, you can use this facility to evaluate the envelope of sharpness to ensure sharpness from foreground to background. Unfortunately, it is difficult to use this feature in low light.

When it comes to positioning the point of focus, placing it roughly a third of the way into the frame will give you roughly the greatest depth of field; you can usually rely on a DSLR to get it right, but I often use manual focus.

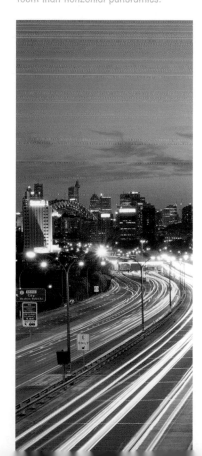

◄ **Tasman Sea.** I wanted to go all out with foreground interest in this wideangle image, so I got down low, and selected a smallish aperture on my DSLR, and used a wideangle zoom.

◄ **Rock pools above Somersby Falls, Brisbane Water National Park, New South Wales, Australia.** Shot on an Ebony RSW 5x4 view camera and with an 80mm wideangle lens. I used a neutral-density graduated filter to enhance the sunset colours. The Velvia sheet film was then scanned at home on a flat-bed scanner, cleaned up and enhanced slightly in Photoshop at a size suitable for large-format printing at 300dpi. This image is just packed full of foreground interest (and colour).Plenty of foreground interest anchors the frame.

Patterns

Nature is simply jam packed with exquisite patterns of all types; for example, ferns exhibit beautiful fractal designs that depict a perfect Mandelbrot plot. (The Mandelbrot set is one of the most intricate and beguiling images in all of mathematics. Benoit Mandelbrot discovered it in 1980, and most mathematicians, and others familiar with the concept marvel at its geometric intricacy.) On a grander scale, large stands of trees can form a graphic repetitive pattern if you focus on a group of trunks. Undulating sand dunes, as well as ripples in sand or water also form repetitive patterns. Also look out for the geometric patterns of crops in fields or of dry stonewalls. To emphasize these patterns, a telephoto lens is ideal, as it isolates the pattern, excluding any superfluous elements, and the distance from which you can use one compresses perspective, crowding foreground and background elements closer together. You can also seek out the pattern caused by textures in bark or the striations in wind-blown grasslands. Two of my favourite pattern abstractions, and the easiest to shoot, are the reflection of sunset in gently rippling water, and clouds that are bathed in the sun's afterglow. There is really no limit to the number of possibilities.

Although patterns are important in nature photography, when it comes to landscapes, I must say that I personally prefer to see lots of detail in my photographs. To me, this is preferable to strong graphics and a simple composition. I like something to examine – to run my eyes over. For me, a landscape image should contain enough information to avoid boring me. If a lot of detail is included in frame, I like the elements to be arranged in harmony.

Where much detail is held in a landscape photograph, I always make a concerted effort to orchestrate the various elements to produce a pleasing composition. For instance, I like scenes to be sharply focused from close-up rocks to far-off cliffs. I try to remove any incongruity – tarmac, walkers and so on, without recourse to later using the clone tool in Photoshop.

▲ **Water lilies.** I took this shot because I liked the wavy pattern they created. I used various Photoshop tools to enhance the contrast between the vegetation and the murky water.

on the Road

Keep it simple. I find I get better results if I travel light – often a single camera with a zoom and tripod is all I take hiking. This way you don't tire so quickly and most importantly are freed from making decisions as to which lens or camera would be best. If I want a choice, I'll take two cameras, each with a different lens as opposed to one camera and two lenses. This avoids the problem of sensor dust and speeds things up in the field.

chapter 6
Understanding field craft

What is nature? Well, from a nature photographer's viewpoint, it's everything that has life, or which plays an important role in life processes. This is a huge repertoire of subjects, and in order to capture them effectively, you need to understand field craft.

Creating context

As nature photographers, we all have our reasons for tripping the shutter on our cameras. Some of us have a passion for recording landscapes, others a love of bird photography, or mammals – I'm sure I could carry on this list to the bottom of the page. The point is that whatever your angle (scientific photographers aside) for a picture to have merit, and hence guarantee a sale it must have impact, or an evocative appeal. It is often necessary to show the human world in harmony with the natural one.

I always have a vision in my mind when I commit anything to my memory card. Indeed, it is having this preconceived vision of how to interpret nature that sets the best photographers aside from the rest of the pack. My vision of nature is twofold: firstly to produce something that works from an artistic standpoint and secondly to generate something that will sell. Clearly, these two attributes are inextricably linked.

If you have a burning desire to succeed as a photographer specializing in creating fine-art images of the natural world, it is not enough to love the great outdoors, nor is it sufficient to possess technical expertise on digital cameras, computer hardware and software. To a certain degree you need it all, but above all else you need a passion about the whole process, particularly what is required in the field. Such passion will invariably breed an intuitive response to the aesthetics of a potential picture. Armed with an eye for a good picture and technical prowess, mediocre pictures will become a thing of the past. You will graduate to become a maker of pictures and no longer simply a picture taker. Let me elaborate on this latter point: Like most people I can go out with my 'auto-everything' DSLR, see a nice view, point and shoot. A process that takes a few minutes if you need to pull over and get out of your car, just a few seconds if all you need do is stop walking, frame and fire. This is taking a picture. To make a picture takes far more effort. The whole process is about a patient wait until the elements of nature conspire to yield the image you are after. This may be the elusive appearance of a rare animal, or a singularly extraordinary display of light for a landscape scene. Whatever it is, you need to catch it at just the right moment to produce a masterpiece of photographic art. This is where good field craft comes in, being ready to take the opportunity when it arises.

◄ **Rainforest, Thailand.** This rickety old bridge in a Thai rainforest creates a real sense of atmosphere. This might not be the view that you would expect to see from a rainforest, but the combination of human and natural elements gives the image context.

Hardware considerations

In essence, using a digital camera in the field is similar, if not identical in many respects, to using a film one. There are some differences, and we will examine these, but we will also briefly address some of the common ground between these two different types of image capture technology.

LCD monitor in the field

One of the great strengths of digital capture is to know that a shot is safely in the bag. Digital cameras have an LCD on the back so you can review an image immediately after exposure. If it's not up to scratch, you can simply reshoot it. With film, you didn't know if you had been successful until several days (or weeks) later, when you got your slides back – hence the need to shoot multiple frames to be on the safe (and expensive) side.

The other great thing about the LCD screens on DSLRs and certain digital compacts is that they can help you tweak an exposure by paying attention to the histogram. This is a graphic illustration of an image's luminosity. It's an easy matter to interpret the histogram; on the horizontal axis, you have a scale of brightness, and on the vertical axis, you have the number of pixels at a given level of brightness. The thing to remember in using this utility is that the dark end of the histogram is to the left, and the bright end to the right.

Under optimum conditions, you would have a histogram that looks roughly like a mountain range across the levels of brightness. If this curve is hard up against the left hand side then you will have lost detail in the shadows, while if it is hard up against the right-hand side you will have lost detail in the highlights.

It is one of the weaknesses of current digital sensors that highlights blow out easier than on film. To avoid this make sure that your histogram does not abut the far right-hand side. If you are pushed for time, for example if you are shooting a fast-moving animal, then you can ensure this in the majority of cases by leaving some negative exposure compensation set, for every shot, which should keep the highlights from blowing out. A better solution, but one that you can only practically carry out if you have plenty of time, is to apply fine adjustments to the exposure so that the histogram is as close as possible to the right-hand side without actually touching it. This will ensure that you make the most of your camera's available range of tones.

When reviewing images on your LCD screen bear in mind that although you will be able to spot obvious flaws it can be tricky to see fine detail or assess colours, even though you are able to zoom in. Also bear in mind the fact that LCDs burn up battery power, therefore, once you are sure you have the shot, proper editing is best left until you are in front of a proper computer screen. A further problem with LCDs is that they can be difficult to view in sunlight or from an angle – but you can buy or improvise shades that alleviate this.

Although you can only review images on the LCD screens of most DSLRs (at the time of writing Olympus, Panasonic and Canon have introduced live-feed LCDs on their DSLRs), digital compacts show a live image. Combined with the ability to move the LCD screen, which is possible with some models, you can compose a shot using the screen rather than the viewfinder. I find this particularly useful for really low shots in muddy, wet conditions where I would otherwise have to lay flat in the mud to get the picture.

LCD screens are also the main interface that provides access to the parameters that control camera operation.

ISO in the field

One of the main advantages of a digital camera compared to a film one when used in the field is the ability to vary ISO (sensitivity) from frame to frame. With a film camera, you would insert a film cassette offering say 36 exposures at ISO 50, but if the light changed or you switched subjects you might wish that your film was ISO 200. With digital cameras you can simply change sensitivity from frame to frame according to your need. If you increase the ISO, however, the resulting increase in sensitivity means that all output from the sensor is amplified, this makes it more vulnerable to signal noise – the generation of false values from certain pixels. The lower the ISO setting, the lower the signal noise and vice versa. While this is similar in certain respects to film grain, the effect is less structured, and can be particularly distracting in large areas of continuous tone areas. The effect of noise also depends to a certain extent on the quality of the sensor and the size of the individual pixels, the larger the pixels the less vulnerable they are to the effects of noise. To reduce noise shoot between ISO 50 and 200, avoid JPEGs, the compression of which can exacerbate these effects, and avoid very long exposures. Some cameras offer noise reduction algorithms to help iron out the wrinkles in long exposures; these can be useful as they simply take a dark frame and subtract the noise present from that in the actual frame. If you choose to use noise-reduction software on computer, then you should consider that this will also sacrifice a degree of detail. This should be done at a similar stage to sharpening so that you can balance the degree of detail and noise.

Tripods in the field

To get the best quality from your digital camera you will need to shoot at relatively low ISOs. This means that a tripod is necessary whenever possible. They are particularly important for landscapes as they will permit the use of small apertures, and the correspondingly long shutter speeds, to provide good depth of field for near-to-far sharpness. If you are shooting wildlife, however, you may prefer to use a monopod, which gives greater flexibility of movement.

Most tripods come in two parts: the legs and the head. As far as the legs are concerned there is a balance to be struck between stability, weight and cost. Today it is possible to buy carbon fibre tripods that are both lightweight and extremely robust. These are a lot easier to lug around in the field than solid alloy tripods, but are generally more expensive.

When considering a head there are two main types: ball-and-socket and pan-and-tilt head. A ball-and-socket head consists of a socket that moves around a sphere, and which can be locked in place. A pan-and-tilt head allows separate movement in three planes: forward–backward tilt; left–right tilt; and horizontal pan. Many people prefer ball-and-socket heads for their simplicity, but pan-and-tilt heads are better suited for demanding tasks such as creating panoramas. Certain more-advanced heads designed specifically for panoramic photography allow precise movement of a lens around a nodal point to make later stitching more effective. In addition to a tripod head, a quick-release plate that is attached to your camera will allow you to switch between tripod-mounted and hand-held photography at will.

The rule of thumb is to use a tripod when the reciprocal shutter speed value drops below the equivalent focal length value of the lens being used; in other words use a tripod at shutter speeds below 1/50sec, 1/100sec and 1/200sec for 50mm, 100mm and 200mm lenses respectively. This photographic tenet has been around for many years now, but I would recommend using a

tripod whenever practical. Not only will a tripod help counter camera shake, it will also encourage you to think a little bit more about the composition of your shot, improving it in the process.

Some digital cameras and relatively new lenses, incorporate anti-camera-shake technology. This is built into the sensor on some cameras, but is more commonly found in lenses. This stabilization detects camera shake and compensates for it by moving either the sensor or lens elements in the opposite direction. This allows you to shoot at lower shutter speeds without an image suffering the effects of camera shake than would otherwise be possible.

This technology is a real innovation, but should be considered a fall-back rather than a first resort – nothing will improve your image sharpness more than using a tripod, it's the most important accessory for the nature photographer.

Storage in the field

Image-storage capacity is a problem specific to digital capture. With film, you would simply fill your bag or pockets with as much as you could carry, but with a digital camera you have to take a very different approach to things. Memory cards are what you need, as we've already covered, and you should strike the balance between having cards that are large enough to be practical, but not putting all of your eggs in one basket. A useful addition to your kit can be a portable downloader, which is simply a portable hard drive, sometimes with a colour screen and certain editing functions. You can plug your memory cards directly into one of these devices to download the images, before transferring your card back to your camera. When you eventually get home, you can download, sift, edit and archive your images.

Your needs obviously depend on how you shoot: if you shoot small JPEGs, you will get an incredible number of files on a decent-sized memory card. However, if you're recording images as RAW files, you'll fit far fewer shots on each of your memory cards. In this case downloading in the field will be a far more useful option.

Of course, many people will be taking their laptop with them on an extended photo shoot. In this case all you have to do is either connect camera (with card) to the USB 2.0 or firewire socket of the laptop and download at the end of each day. Alternatively, and often quicker, pull out the camera's memory card and insert it into a cheap card reader to download image files to your laptop. Personally, I never travel with my laptop. It's a magnet for thieves, and a time-consuming distraction from the task in hand of shooting images of new and interesting places. Save the editing until you get home.

on the
Road

If shooting long exposures with a tripod-mounted camera always use a cable release to minimize camera shake. Don't waste money on good lenses and then skimp on your tripod. The secret to consistently sharp images is a decent, sturdy tripod as much as it is high-quality optics. This means finding a tripod that is robust, but not so heavy that you can't carry it long distances. Consider buying two: one heavy duty and one lightweight. A strap to carry your tripod over your shoulder will also make a huge difference when you're out and about in the field.

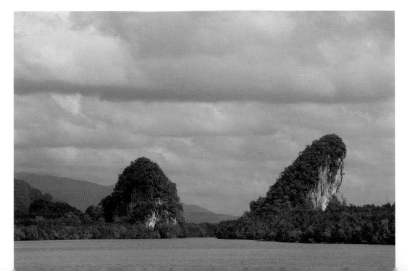

◄ **Khao Kanab Nam, Krabi River, Thailand.** Image storage in the field is always an issue with digital photography, particularly when you are photographing in remote locations.

Batteries in the field

Battery use is one of the major issues cited by photographers for not wanting to go digital. Professional wilderness photographers perceive this to be a real problem. True, batteries don't last as long in a DSLR as a film model, but you can easily work around this. I had an old digital compact that went through two AA batteries every 30–35 images; this was hopeless, but now battery life has been vastly improved. Despite this, it is prudent to carry a spare, just in case. I can honestly say I have never yet run out of battery power on a shoot. Having said that, if I were going to certain extreme environments without any electricity for days or weeks on end, it would be film, and not a digital camera that accompanied me. You should be aware that cold environments in particular can markedly reduce battery life.

Lenses and dust in the field

My advice on lens selection is to make it before you get out into the shooting environment. The reason for this is to avoid getting dust onto the camera sensor. If I'm out shooting landscapes, I will fit my 17–40mm lens to my DSLR at home in a controlled environment rather than in a dusty outdoor situation. Obviously, you may suddenly have the need to shoot another type of subject requiring a completely different focal length lens. Because of this, I use a back-up body fitted with a different lens attached. Obviously this isn't possible for everyone, but you should still fit the lens that you are most likely to use before you head out. When changing a lens you should point the camera down so dust doesn't fall into the chamber.

Manufacturers have also begun to appreciate the problem more keenly and incorporate anti-dust coatings, and sensor-vibration technology to remove the effects of dust, as well as weatherproof seals to keep dust out in the first place. Software solutions, other than the usual heal/clone approach in Photoshop are also becoming more widely available.

If you need to clean your sensor, there are many tools available for you to use yourself, but occasionally it will not hurt to treat your camera to a professional clean.

Flash in the field

Flash photography is key to my brand of nature imaging. I have a predilection for macro photography. Using film, even with advanced flash guns, the success rate was pretty low. When you consider the issues of exposure in close-up being more critical than in the normal magnification range, and the much reduced plane of focus in the macro range leading to likely focusing errors, it's not hard to see why I was happy to have one great shot out of every ten to twenty macro exposures. This is not a problem with DSLRs, as exposures are free and this freedom to experiment helps get flash right. If you want to learn all about the fundamentals of flash for nature photography, read my previous title: *Photography for the Naturalist*.

▶ **Empusid Mantis.** Sometimes it is necessary to use macro flash (normally in the form of a ring flash attached to the front of a macro lens) in order to add punch and vibrancy to the colours in a close-up image.

Medium- and large-format film photography

Why would anyone be interested in film cameras in this age of digital photography? Simple, if you shoot landscapes and you want to produce big prints, large-format film is, for the time being, still king. However, the gap is certainly narrowing with amazing digital camera backs that approach, if not quite equal, the quality of a 5x4in sheet of Velvia film. Because of the expense, I think that most of us who are after the ultimate in quality will simply stick with the best DSLR we can afford and perhaps invest in a view camera and good film scanner.

Medium-format cameras

Medium-format equipment represents quite an eclectic mix of camera types compared to the 35mm genre. However, with the advent of digital technology, there has been an erosion of the market in this area, with fewer and fewer options available. Having said that, there are still many good cameras around for landscape enthusiasts. All employ 120/220 roll film, but the shape of the frames that are exposed varies from 6x4.5cm (645 format) through 6x6cm, 6x7cm, 6x8cm, 6x9cm to three panoramic formats: 6x12cm, 6x17cm and even 6x24cm.

The size of these cameras and consequent need for a tripod introduces a more considered approach to photography. This in turn helps develop a rigour in both image composition and timing. This extension of the thought process definitely helps produce better pictures, as does the fact that their size allows very high-resolution scans to be created, suitable for large prints.

Which aspect ratio is best for you?

Larger medium-format transparencies require less magnification for a given reproduction size – that is, it is easier to attain high-quality reproduction. This trait is very important, and is why medium-format landscapes have the potential for

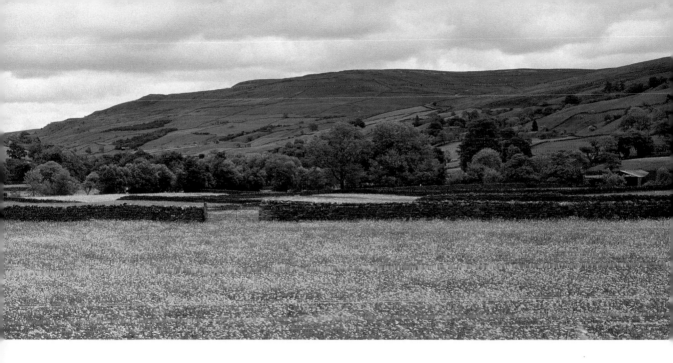

sales in advertising, upmarket publications and for making gallery prints.
The first question you need to ask yourself when considering purchasing this
kind of camera is what aspect ratio best suits you as a creative nature and
landscape photographer? The next question you must ask is whether you
will ever need to upgrade from a film back to a digital capture back?

As far as size is concerned, a 6x4.5cm frame from the smallest medium
format aspect ratio yields an image 2.72x the size of a 35mm frame, while a
6x7cm slide is 4.50x the size of its 35mm counterpart. My favourite aspect ratio
is definitely the 6x7cm option, and I still very much enjoy using my Mamiya 7II
rangefinder film camera for potentially important shots, choosing this over even
my DSLR on occasion.

If you decide that one day you might well add a digital back to your
camera, then there would be little point in buying a Mamiya 7II like I use.
You would be better off with a Hasselblad 6x4.5 or 6x6cm or Mamiya 6x4.5 or
6x7cm reflex camera, which are served by several existing digital backs from
various manufacturers.

Size is not everything – select a film format that best suits your artistic vision.
I really like the 6x7cm aspect ratio when used in portrait format – it is like
a perfect door on the world and I find I can control the appearance of the
image a lot more easily. Foreground detail and sky just seem to fall into place
with a minimum of conflict. At the end of the day, the roll film format that you
choose to work with must simply fulfil the creative vision that you personally
have for your brand of nature and landscape photography. In my case, this
is now 6x7cm, or the 6x12cm or 6x17cm panoramic formats.

However, before opting for a film camera, a caveat that is worth bearing
in mind is that if you are going to produce large prints, it takes a lot longer to
clean up and finalize a large scanned transparency than it does to finalize a
large interpolated DSLR file.

▲ **Muker in Swaledale, Yorkshire, UK.**
Meadows rich in buttercups are
commonplace at Swaledale in Yorkshire
and this image was taken with a Fuji
GSWIII rangefinder. The original 6x9cm
Velvia transparency was then scanned
and cropped down to produce this
panoramic suitable for printing.

Panoramic and large formats

If you think that the satisfaction and buzz you get from seeing your first medium-format images is justification enough for the move to this larger format, just wait until you see your first 6x17cm roll film panoramic image – the impact on your lightbox will be unforgettable and you will likely be swept away by the sharpness and intense colours on the celluloid.

In the right hands, a 6x17cm camera can produce images that are second to none when it comes to producing saleable wall art. The format is incomparable to images taken on any other camera system, perhaps with the exception of photostitched DSLR files. Some of the world's best photographers who shoot using this format include Colin Prior, Peter Lik and Ken Duncan.

My Fuji GX617 and 90mm lens is a heavy camera that can only ever be used with a tripod, and generally only after I have scouted for suitable viewpoints without the disadvantage of being heavily laden down with kit. I have come to love the 3:1 aspect ratio passionately, and frequently leave the camera at home taking only a cardboard mask with a cut out 6x17cm aperture with me to evaluate new locations for a possible shoot. It is far easier to do this than to lug this behemoth of a camera around in the hope of finding a shot by chance.

Fuji had become the major name in panoramic photography. Its GX617 body and 90mm, 105mm, 180mm and 300mm lenses provided a large and popular system. However, the company no longer makes this format. Fortunately others do, and it's possible to buy 6x17cm (and 6x12cm) panoramic film systems from Linhof, Horseman, Fotoman, Noblex (rotating lens cameras in 35mm and roll film formats) and others.

The 90mm lens I favour on my 617 body is an extreme wideangle lens, equivalent to around 20mm on the 35mm format. To compensate for the light fall off that is inevitable at such a wideangle, I use a centre-spot neutral density graduated filter that evens out exposure across the viewing frame. Unfortunately in doing this I lose a stop of light.

With this format you only get four frames per roll of 120 film. As you need to use a hand-held meter to gauge exposure, it is prudent to bracket exposures anyway, so the chances are that you will dedicate a roll to each subject.

In general, I try to have foreground interest that leads into the subject from the left side of the frame, creating a three-dimensional effect as the viewer's eye moves across the frame to ever more distant elements – not an easy task to achieve, but always worth the effort given the pleasing effect that can be attained if you work at it.

▲ **Stainforth Force, Yorkshire, UK.**
A Fuji GX617 panoramic camera and 90mm lens were used to capture. The sheet of Velvia was scanned to a very high resolution professionally. Unfortunately the slide contains a wide dynamic range with some blow-out of highlights. Digital capture tends to be more forgiving than film when it comes to exposure extremes.

Some subjects that occupy a single image plane, such as the distant landscapes you might come across in the American West, also lend themselves well to this format. Whatever landscape you select, a well-executed 6x17cm image of it will look awesome when blown up as a large fine-art wall print. Editorial use cannot do justice to this format as you really need to see it large to appreciate the full effect. If you want perhaps the ultimate in panoramic film cameras, consider the Seitz Roundshot. This camera will yield a full 360-degree panoramic image. However, extreme is not always the way to go: it is quite common for photographers to opt for a 6x12cm panoramic format over the 6x17cm one. This aspect ratio is generally easier to compose than a 3:1 ratio and allows greater magnification for editorial use.

If you are a view camera user, the 6x12cm format is also an economical introduction to panoramic photography. A 6x12cm roll-film back that attaches to a 5x4 view camera allows roll film economy and the panoramic format on a camera type that permits a wide range of movements to give extreme depth of field, and which allows the use of some of the highest quality optics available today. Although some 5x4 view cameras give full-frame coverage with both 58mm and 47mm lenses, these wideangles optics have such a limited image circle that little or no movement is available to correct perspective or alter the plane of focus using the Scheimpflug principle (see page 128). The 35mm lens will simply not cover a 5x4 sheet of film. I tend to take a lot of 6x12cm panoramic formats using a 6x12cm Horseman roll film back on my Ebony SV45 TE 5x4 field camera. However, my preferred film-based system for panoramics is definitely the Fuji GX617 with 90mm lens – it is a landscape photographer's dream, and it's a shame that it has now been discontinued. Any stock library will tell you that the 6x17cm is a popular and much sought-after format; and when you see a huge print hung on a wall, you can see why.

The area of a 6x17cm transparency is not so different to that of a sheet of 5x4 film. The potential of both is therefore to produce truly large and impressive prints, be they Ilfochromes, Endura Color Metallic or Crystal Archive prints from

▲ ▲ Two panoramics of the same scene. However, they were produced in very different ways. The first was produced by merging together several discrete DSLR images in Realviz Stitcher Express, while the second was produced on film using a Fuji GX617 panoramic camera with a 90mm lens and then scanning the transparency on an Epson 4870 photo scanner. In either case 3ft (90cm) prints are excellent and no one of these prints is better than the other.

Lightjet, Durst or Chromira printers. In fact, of the many reasons for opting to use a 5x4 view camera, there are two that stand out: one is that a huge sheet of film taken with a modern lens design will be so sharp and large that it can be printed up to a huge size without losing clarity; the second reason for opting for a 5x4 view camera is that you can control perspective and the plane of sharpness. This means that you can alter the lens's axial position with respect to the film plane until depth of field extends from near to far irrespective of aperture, which, in itself, is still used in the conventional way to extend depth of field even further. Thus, large prints retain sharpness because of a large original transparency as well as an extended depth of field via camera movements such as front or rear tilt. These pictures can be so good that when you view them you feel you can just walk into the landscape. The 5x4 view camera is the smallest of the large-format cameras commonly encountered. 5x7 and 10x8 cameras are the other major examples of large-format equipment, but are less popular than the former – something I predict will change in the near future as digital capture approaches the quality available from a 5x4 transparency.

Camera movements that are critical in landscape photography

We've already covered the issues of quality as far as large-format goes, but if you are considering a move into large format, then a brief explanation of camera movements will help you to make your mind up.

Rise and fall shifts the front and back standards up and down relative to each other. This avoids the problem of converging verticals, which most people have experienced when tilting the camera backwards to shoot tall buildings. It is, however, also useful to nature photographers who may wish to shoot a stand of trees, yet keep all the trunks parallel. To deal with this situation on an ordinary camera, you would angle the camera upwards to include the whole scene. However, on a view camera, by placing the camera back parallel to the trees, and employing front rise, you can avoid the problem of converging verticals, not that I dislike this converging effect at times with some scenes.

As a landscape photographer, front tilt is beyond any doubt the most important movement available to you. If you want to photograph a scene with foreground to background sharpness and keep it all in focus, you must select a small aperture (f/22-32 or smaller) and tilt the lens forward. The result is an extended depth of field. The effect of this tilt phenomenon is explained by the Scheimpflug rule which states that subject, lens board and film planes must either be parallel to one another, or meet at a common intersection along their planar axes. Similarly, enhancement of depth of field can be obtained if the back is tilted (front and rear tilt can also be combined for even greater effect). By using rear tilt you also exaggerate the size and shape of foreground objects.

▲ **May Beck near Goathland, North Yorkshire Moors National Park, Yorkshire, UK.** Shot on a Fuji GX617 panoramic camera with a 90mm lens. This image has been professionally scanned to produce output capable of 300dpi 3ft (90cm) prints.

▶ **Stainforth Force, Yorkshire, UK.** Shot on an Ebony RSW 5x4 view camera with a 75mm wideangle lens. Front tilt has been used to maximize near-to-far sharpness.

Focusing, exposure and image circle

One of the trickiest aspects of large-format film photography to master is without question how to focus the camera. There are several methods you could use, although the one I tend to use is as follows.

Set the aperture to one stop narrower than its widest setting and use front axial tilt, as opposed to front base or rear tilts to control the plane of focus. This involves focusing the camera using the most distant subject in the field of view. Establish critical focus on the ground glass screen using a loupe. Then use forward axial tilt until the foreground is in sharp focus. Then use the camera rails to refocus on the distant subject. Repeat these steps a few times until both near and far subjects are in focus.

Before exposing the film, I then shut down the aperture to at least f/22. This further increases depth of field along the new plane of focus generated by front tilt. This is quite important, since it allows tall elements in the scene to remain in focus. Having said this, very tall elements can extend beyond this and appear soft in the final image, so the utmost care is required in your preliminary assessment of a scene.

Clearly, even before erecting your camera on its tripod, the considerable effort involved in correctly exposing a sheet of film means you have stopped to evaluate the picture you are after. Such a considered approach is not a necessity when shooting digitally, but it is mandatory on sheet film – not just because of processing costs, but because of the time involved in setting up a large-format photograph.

Fortunately, some of the effort involved in this process can be eased by replacing traditional double dark slides with the Fuji Quick Load or Kodak Ready Load systems. These allow you to easily and conveniently load sheets of Velvia or Kodak Ektachrome E100VS in daylight without the need to load and unload dark slides in a light-tight changing bag with all the hassle and risk of dust contamination (yes dust isn't only a problem in digital photography).

The large image circle of large-format lenses is what allows them to be used in conjunction with camera movements. The image circle is the diameter of the total area focused at the film plane. The larger the diameter of this circle, the more movement that will be available.

Lenses

My favoured lenses are definitely wideangle ones. These have a focal length less than the diagonal dimension of the film in mm. For a sheet of 5x4 film this would be 161mm. Actually, I personally think of any lens with a focal length of below about 120mm as wideangle for landscape work (above this I would call them wide–normal). In selecting a lens, one should also realize that any lens with an image circle of 161mm will not permit camera movements, since the circle is only just sufficient to cover the film area. An image circle below 161mm is not suited to 5x4 sheet film at all, but might still be fine for use with a 6x12cm roll film back. Because ultra-wideangle lenses (75mm focal length or below) exhibit significant light fall off in the corners, it is sensible to use matched centre-spot neutral density graduated filters to counteract vignetting. These are pricey and often in landscape work you can get away without one. Indeed, a little darkening in the corners of a blue sky often enhances an image as it removes the flatness from the sky. Problems could potentially arise if you add a filter system holder, leading to possible vignetting. However, this can be a problem for all formats of camera, particularly full-frame DSLRs, so it is not just an issue for large-format cameras.

▶ **Corkscrew trunk.** The high-resolution Canon 5D tends to vignette with some filters attached to my 'bread and butter' 17-40mm zoom. For this reason I now tend to shoot with a fixed 24mm lens on the 5D. Photoshop was used to remove corner darkness in this image shot at 17mm and f/11.

A normal lens for 5x4 landscape work would be a 135mm, 150mm or 180mm lens. These are cheap and offer excellent image circles and hence lots of camera movements. They are much easier to focus on the ground glass than their wideangle counterparts, since they produce a much brighter image for focusing. My standard lens is the 150mm Schneider Apo-Symmar. Telephoto and all manner of specialist lenses are also available for the 5x4 format, ranging from flat field to macro lenses. As a point of reference, a 90mm lens on a 5x4 camera is roughly equivalent to a 28mm lens on a full-frame DSLR or 35mm camera. Also look at filter sizes – smaller diameters are cheaper – some of the Schneider Super Angulon XL series (90 and 72mm) have a huge 95mm diameter thread – which can prove expensive when buying filters.

Although a 5x4 outfit is a tricky system to use, the cost and weight are not that different to a DSLR outfit. In fact, often the cost is less. It really all comes down to how important quality is – if this matters to you, large format may be what you're looking for (especially if you can't afford the latest digital back). This may change, but at the time of writing, a drum scanned 5x4 transparency currently has the edge on the best of the current crop of digital backs, but who knows what is around the corner?

Mandatory accessories

Remember, view and panoramic cameras require a large solid tripod, a hand-held lightmeter, loupe and a grey card to meter from in tricky lighting. I use a meter that permits incident and spot metering. Remember, when you shoot panoramic or sheet film, the cost of each exposure increases significantly compared to the smaller formats and digital. For this reason, it is important to obtain consistently accurate measurements, particularly for exposing transparency film, which has less latitude for error than negative film or indeed a digital sensor.

I tend to use a reflected spot meter reading these days. Reflected metering reads the intensity of light reflected from the subject, and will bias the meter according to variability in tone colour and contrast because all meters see their subject as an 18% neutral grey. Thus subjects lighter than 18% grey reflect more light and result in exposures that render them darker and vice versa. Therefore in landscape photography where you are often metering distant objects over a wide area of view, highly reflective surfaces and extreme contrast including backlit situations, a reflected spot reading can be very useful for picking out an area that represents mid-tone. I use an 18% neutral grey card for some tricky situations that I find hard to evaluate. However, what I generally do whenever possible, is use a very narrow angle of view on my meter to target any green foliage – leaves, grass and so on – and take the reading given as being near on perfect. When I can target green foliage in this way, I never bracket my exposures, as I am sure they will always be accurate for exposing Velvia. I will, however, attach one caveat, and that is you should always extend your exposures in low light to compensate for reciprocity failure – details of which are supplied with the film itself.

▶ **Silhouettes, Northern Territory, Australia.** For images that are to be reproduced at large file sizes the quality from a 5x4 transparency is yet to be matched by anything that digital has to offer.

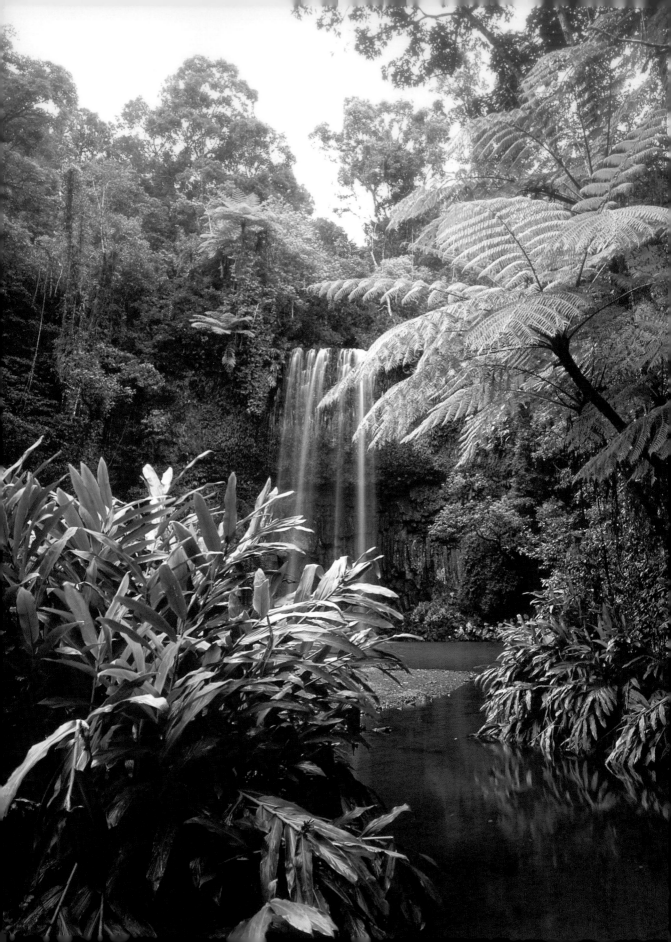

The intimate landscape

What do I mean by an 'intimate landscape'? Well, I suppose I'm referring to an enclosed world where the glory and beauty of nature is all around, but where there is no grand scenic element. Such enclaves generally have limited dimensions. I must confess my greatest passion in landscape photography is to record intimate landscapes. Until recently, these were invariably taken on panoramic and large-format film cameras. The intimate subjects that I am most enamoured by are secluded woodland scenes. Such scenes are all the more captivating if there is a small stream or river involved. I shoot a lot of these sorts of scenes and, if at all possible, will only ever shoot under cloud cover using soft, diffused light.

When I lived in the UK, temperate woodland, literally at my back door, offered me so many wonderful possibilities for intimate landscapes. Today I live in Australia, and my intimate landscapes are now mostly of subtropical rainforest scenes, which are again only five minutes from my back door. All the principles of shooting temperate woodland still apply; I just have to avoid sunny days, which are more prevalent than in the UK. A classic example of an intimate rainforest landscape is given by the digital photostitched image of a strangler fig tree among palms and other rainforest vegetation on pages 14 and 15.

While larger film formats produce the ultimate quality for wood/forest scenes, they are heavy and slow to use, and exposure issues associated with low light make the whole photographic process a bit hit-or-miss – a real issue with expensive sheet film. Rainforests in particular have their own peculiar problems. The humidity in rainforests combined with high temperatures makes this kind of film photography very difficult. Try lugging a view camera, tripod and all the associated paraphernalia through a rainforest in summer – you'll soon get my point. Digital cameras are a revelation in this respect.

To add foreground interest to an intimate landscape, you need a good quality wideangle lens on a DSLR, or the extended depth of field conferred by compact digital cameras. The equivalent of a 24mm lens on the 35mm format is ideal. I also use a 43mm lens on a medium-format camera and a 75mm one on 5x4 formats as these will give a large depth of field when stopped down to f/22–32, although digital compacts will achieve this depth of field at much wider apertures. It is important to remember that depth of field is related to focal length. While a 24mm lens on a full-frame DSLR gives the same wideangle

▲ May Beck near Goathland. North Yorkshire Moors National Park, Yorkshire, UK. Fuji GX617 panoramic camera and 90mm lens. I shot this from underneath a footbridge giving me some protection from the elements. This image has been scanned professionally and outputted to produce an amazing 7ft print. This image has sold many times, and hangs in my living room at home. It was taken in overcast conditions, perfect for reduced contrast.

◀ Millaa Millaa Falls, Atherton Tablelands, Queensland, Australia. An intimate landscape, and undoubtedly one of the most photogenic locations on the planet. However, on the day I visited, it rained profusely, so I had to work quick to get the shot I was after. The Velvia transparency was scanned at home to yield a large print, and then cleaned and tweaked in Photoshop to get the exposure and colour spot on. This scan is as good as any professional scan I've had done. Unfortunately, producing final scans for a large print is very time consuming, and a strong case exists for farming your key images out to pro labs for guaranteed high quality.

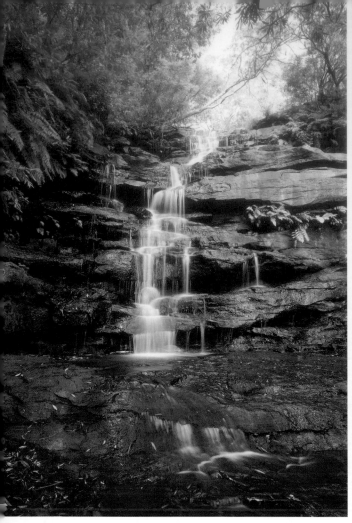

perspective as a 75mm lens on a 5x4 camera, the depth of field is dramatically less on the larger format. Fortunately, it is possible to get around this by employing front or rear tilt on view cameras.

The biggest problem I have with ensuring near-to-far sharpness is with my 90mm lens on the 6x17cm format. This procedure is tricky for intimate landscapes, and some compromise may be required. However, I usually do reach a satisfactory compromise with good overall sharpness. Perhaps one day someone will invent a 6x17cm panoramic camera with front tilt – now that would be a step forward in camera design! Actually, this is why I like the 6x12cm panoramic format, and continue to use it despite having a 6x17cm camera; the 6x12cm back on a view camera does permit loads of front tilt, as well as other camera movements that help control perspective.

With the coming of age in digital photography, the convenience and quality possible even with digital compacts place these as my overall favourite cameras for 'intimate landscapes'. One of the other reasons that puts digital cameras ahead of film for this kind of photography is the better response under low-light conditions. Digital takes the 'hit or miss' out of such challenging photography. This is because the sensors respond well to prevailing exposure conditions found even in dim rainforest interiors and you can see immediately on the LCD review facility if the image you shot was successful – no more wasted film! The best rainforest pictures I now have are, for the most part, taken on my DSLRs.

◀ **Somersby Falls, Brisbane Water National Park, New South Wales, Australia.** The portrait format is ideal for capturing intimate natural scenes.

▲ **Epiphytes in Border Ranges National Park, New South Wales, Australia.** It was this clothing of other plants that attracted me to this potential image shot on a DSLR with a wideangle zoom.

The other thing that a digital camera permits is 360-degree panoramics. These are difficult to achieve with accuracy, but rainforests make superb places to hone your skills. Only expensive, and very specialized film cameras such as those made by Seitz can achieve this effect otherwise.

UK woodlands and Australian rainforests do not have a monopoly on intimate landscapes. They can in fact be photographed almost anywhere – you just have to avoid harsh light that generates too much contrast. It's not always easy to succeed in this type of photography though. In Florida I tried to shoot jungle hammocks – a week passed and the sun was unrelenting. I never managed a single satisfactory shot that had low contrast, and provided a muted rendition of the jungle interior with the detail needed to make an image stand out from the crowd.

▲ **Bird's nest fern.** Epiphytes such as this bird's nest fern bedeck many rainforest trees. They make excellent photographic subjects in their own right. With film, backlit subjects were always hit-or-miss, with the need to bracket. Digital capture does away with all the angst. You can see when you have caught the character of the backlit scene and leave knowing that the shot is safely in the bag.

Swamp forest, Thailand

This swamp forest and its aquamarine waters provide an evocative image of a secret place that beckons swimmers. When presented with beautiful scenes like this, it's not hard to see what it is that attracts nature photographers to their craft – to take a wonderful piece of nature and immortalize it.

- The site was visited early in the day, before locals or other tourists were likely to appear on the scene, in order to ensure a clear shot.

- Curves were applied as appropriate in Photoshop, some red added via the colour balance, along with 10–20% saturation. The whole image was then interpolated with the Extensis PXL SmartScale plug-in to produce a file suitable for a 24in (60cm) print. The image was then sharpened using Unsharp Mask.

Nature's broad canvas

I love my digital cameras for shooting grand scenics. The best lesson to learn for success in this area is to use a tripod. Even if you think the light is sufficient to hand-hold your camera, you will get a sharper picture if you use a tripod. Not only that, but by using a tripod you tend to think about composition more – the effort of employing a tripod engenders a more thoughtful approach to photography.

If I resort to film, say because I have used a 6x17cm camera to catch a panoramic scene, I often scan it and retouch it in Photoshop. The final result is a 300MB file that I might resize to 300ppi at A4 for editorial use, or leave at 300MB for a large fine-art print. By comparison, the big advantage of shooting digital is that you can choose your format via a photo-merge option either during exposure or later on computer. The bottom line is that a digital camera gives me more options and avoids the need to employ a scanning step in the image-making process.

Even with film, the post-exposure digital option of scanning does allow you to change format later. I shot Monument Valley in Utah on my Mamiya 7II using Velvia and a semi-wideangle 65mm lens. A mediocre shot was turned into a great one by scanning the transparency and cropping the resulting file down to a letterbox shape in Photoshop. This also allowed me to pep up the desert colours a bit as well (see pages 96–7).

This is perhaps a good place to emphasize that although digital photography has usurped 35mm film photography, it provides a complementary approach to medium- and large-format film photography, where image files from scanned slides still offer the ultimate in picture quality. Such image files can be enhanced in Photoshop in exactly the same way as digital camera files. The big difference is file size. A 300MB file takes a long time to improve in Photoshop compared to a smaller DSLR file, even one around 50MB in size. So, despite the issues surrounding pros and cons of film versus digital, it would be a mistake to consider them as mutually exclusive technologies – it's all about horses for courses.

I shoot more grand scenics on digital than film cameras these days, but I know that if I want the very best; I still need to catch it on large-format film. Also, if my grand scenics are in truly wild and remote locations, there are still advantages to film because of a digital camera's reliance on power. To put it in perspective – a 24in (60cm) print at 300dpi from my DSLR will have taken 10 minutes or less to shoot at any given location on average – post-production work will be about 25 minutes at most. A 5x4 transparency I shot at Frazer

▲ **Pearl Beach from Mt Ettalong Lookout, New South Wales, Australia.** This view was created using a DSLR in vertical format set on a Manfrotto 755B tripod with the company's bespoke QTVR 303Plus panoramic head (17-40mm lens). Usually water stitches very poorly, but here, the high angle removes this problem. I stitched this panorama together using Realviz Stitcher Express, which is simply brilliant.

Beach near my home took one hour to shoot on large format – and nearly 10 hours post-production to clean up the scan which was sized at 60in (1.5m) at 300ppi. Clearly a lot more went into the print, but the quality is stunning, and the effort was worth it.

Grand scenic shots come in many forms: some benefit from using wideangle lenses, others suit telephoto lenses from a distance to compress perspective. When you find your canvas, don't rush the exposure; place the camera on a tripod and use your zoom to select the best perspective. Also, scout around the scene using the viewfinder to assess the optimum composition – use some of the previous tips on composition to achieve this.

▲ **Pelican Beach, New South Wales, Australia.** Pelican Beach is a very pretty spot, but is not particularly easy to photograph in a way that conveys the best of the place. This is one location that I have found film produced a better image than digital exposure. However, a lot of work went into the image after scanning. The reason for this is that my flat-bed scanner can cope with a 6x17cm transparency, but does not have bespoke holders for this size of film, so rings caused by diffraction needed to be removed – a painful process!

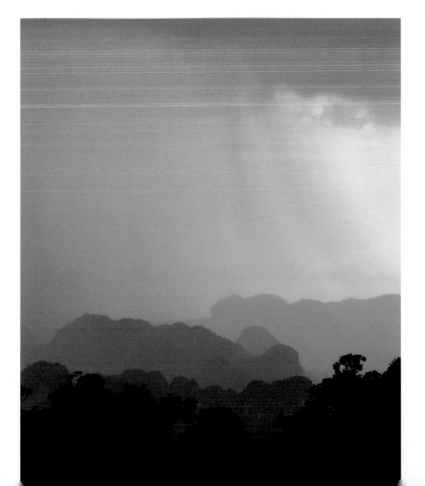

◄ **Rain over Karst, Thailand.** While you might initially think of bright blue skies and fluffy white clouds for your grand vistas, do not eschew the chance to shoot in stormy weather. Storm clouds and indeed rain itself can create some powerful images.

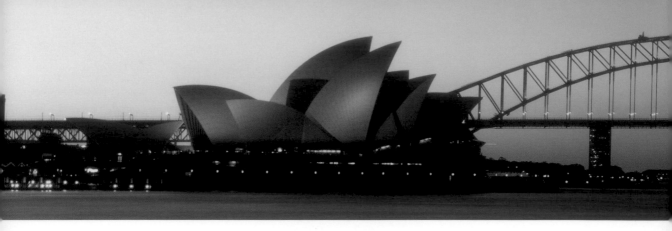

The human landscape

As a keen naturalist, it probably comes as no surprise that I prefer not to be in an urban setting whenever possible. However, I do like shooting night scenes in towns and cities. I seldom find urban landscapes appealing during the day, but at night the gaudy neon colours transform things into a kaleidoscope of visually arresting detail. Low-light photography during the twilight hours provides the best time to record city scenes. Ideally, there should still be some colour left in the sky, but with all the city lights lit up at the same time.

The beauty of DSLRs is that they respond wonderfully to low-light and evening photography in the city. Even many compacts do an admirable job of shooting city nightscapes. As a rule of thumb, I try to keep as low an ISO as possible. I seldom go above ISO 200 for any type of photography, as I dislike too much grain/noise. Clearly, for this type of photography, there is no other option but to employ a tripod.

One of my most saleable images is of Sydney Harbour at sunset. The original image was taken on a 6x17cm Fuji GX617 with a 90mm wideangle lens. I then scanned this at a high resolution and produced two crops from the original frame. This means I have made three distinct images out of one slide; an extreme panoramic, a 3-to-1 panoramic and a colourful crop of the opera house. Sydney is a colourful, vibrant city, and living close by has allowed me to collect some marvellous images of this capital city at dusk using a variety of techniques including photostitches.

Of course, there are many more forms of the human landscape that you can capture, it is just that I prefer to shoot at dusk. In fact you needn't be in a city or a town to add a human element to your landscape, you can position people in shots of wildernesses, or grand vistas to add a sense of scale and an additional point of interest.

▲ **Sydney Harbour Bridge, New South Wales, Australia.** This view of the Sydney Harbour Bridge and Opera House is a classic as it permits shooting towards the west, and is hence ideal for capturing sunset. During the summer you will be vying for tripod space with many other landscape photographers so find your spot early. I took this on my Fuji GX617 panoramic camera and 90mm lens shortly before I bought my first DSLR. My fellow photographers were shooting on DSLRs and I was very impressed by the shots they were catching and showing around via their LCD screens. I, by comparison, had no idea whether I'd caught the subject as I saw it in my mind's eye. The transparency was scanned at home, cropped to emphasize the scene, and cleaned up prior to applying the usual Photoshop enhancements.

▶ **Sydney Opera House, New South Wales, Australia.** My favourite time to shoot is during the crossover light at dusk. The Opera House and Circular Quay are a great place to hone your skills in this genre of photography.

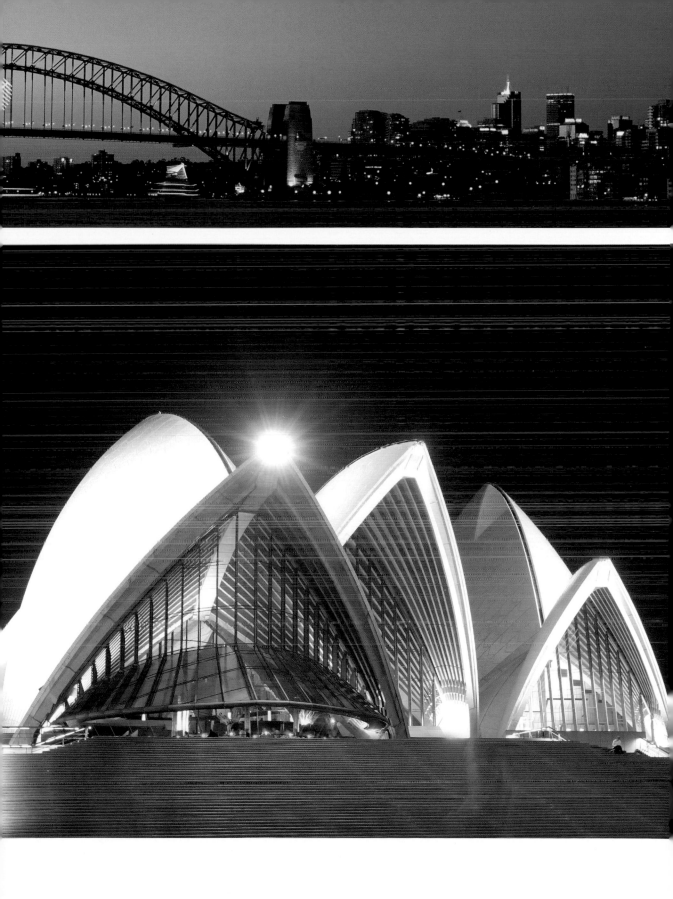

Traffic trails at night, Sydney, New South Wales, Australia

This vertical crop of traffic trails approaching the Harbour Bridge in Sydney was taken from a footbridge that is one of the best places that I've discovered for shooting car light trails. Vertical panoramics are becoming increasingly popular for wall art as homes become progressively smaller. This is because they take up less 'useful' room than horizontal panoramics.

- The exposure was for 45 seconds at that all-important point during dusk when crossover lighting occurs.

- Crop, curves or levels as appropriate in Photoshop, given 10–20% saturation, followed by interpolation with the Extensis PXL SmartScale plug-in and then sharpened using Unsharp Mask.

- A constant wind and the awkward angle of view could only really be tackled by the unusual design of my heavy Benbo tripod.

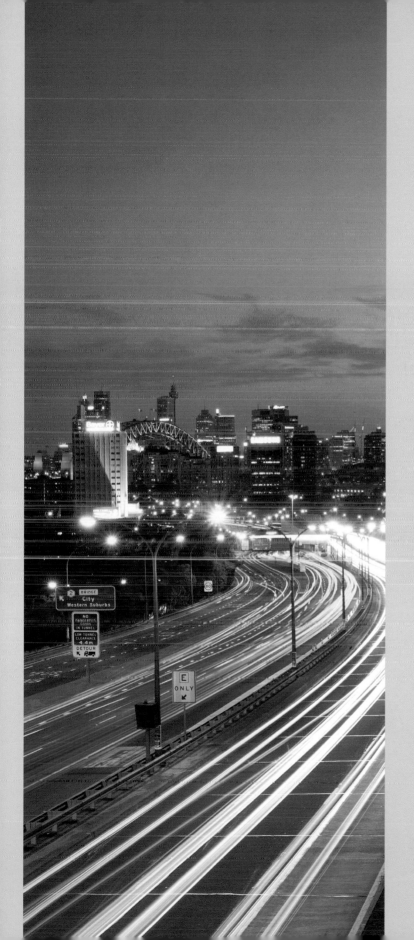

Wildlife

Wildlife photography was one of the first areas of nature photography to turn digital, as advantages in being able to shoot hundreds of frames at no extra cost made DSLRs a financial must for wildlife photographers. Sure, this didn't happen as quickly as it did for news and sports photographers, but by the time you read this almost every professional wildlife photographer will be shooting digital.

Many wildlife photographers capturing an image on a DSLR use an almost identical process to that which they formerly used when employing film. There are certain differences of which you need to be aware.

The opportunity to shoot without cost can lead to a fall in standards; however, in the case of moving subjects like wildlife, you may not have the chance to reshoot your image, even if it would cost you nothing to do so. This means that you should bear the advantages of digital technology in mind, but not use them as an excuse to let your standards slip.

Another aspect of digital photography that you have to be particularly disciplined about is the exchange or downloading of memory cards. If you blaze away without regard to how many shots you have left on a card, you may find that you miss the perfect shot as 'full' blinks in your viewfinder. The same applies to the burst depth. The lesson is twofold: not to waste frames just because you can; and to take every opportunity to download and clear cards as you simply do not know when the opportunity may arise again. This has a knock-on effect at the workflow stage, and means that it is important for you to be disciplined in the way you work with your images, otherwise they can become chaotic.

▲ **Eastern dwarf tree frog.** Shot on a DSLR with 50mm macro lens and a ring flash. A wide aperture was used to place a narrow band of focus where it matters most – on the eyes.

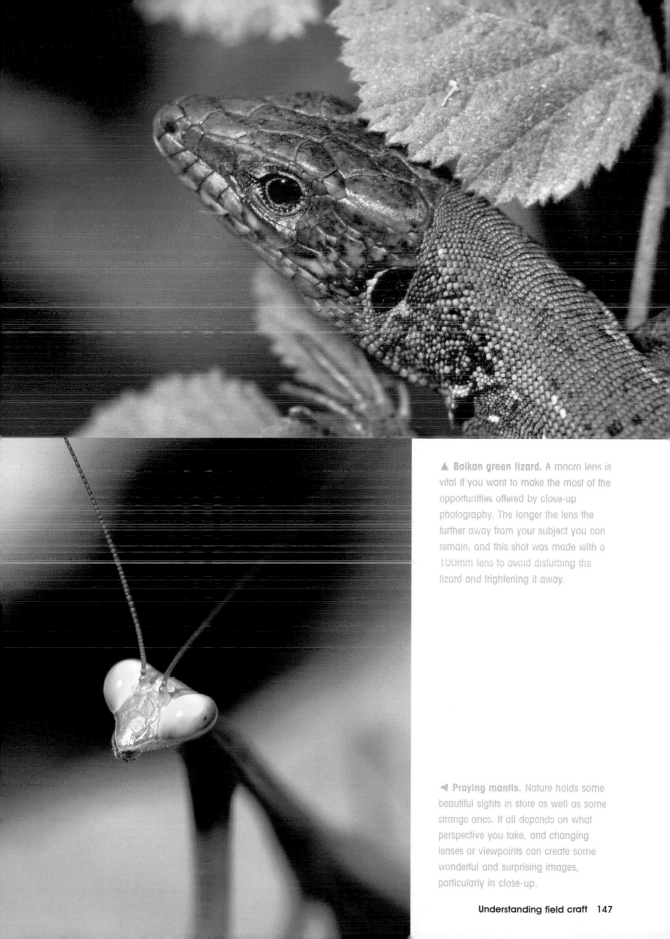

▲ Balkan green lizard. A macro lens is vital if you want to make the most of the opportunities offered by close-up photography. The longer the lens the further away from your subject you can remain, and this shot was made with a 100mm lens to avoid disturbing the lizard and frightening it away.

◄ Praying mantis. Nature holds some beautiful sights in store as well as some strange ones. It all depends on what perspective you take, and changing lenses or viewpoints can create some wonderful and surprising images, particularly in close-up.

Some digital cameras suffer from slight delays between pressing the shutter release and the shot still being taken. This does not afflict more recent cameras to the same extent, but it is something to be aware of, particularly if you are using a fairly basic compact model.

Instant feedback on a DSLR's LCD screen provides an immediate indication of success or failure. Beware though, I find this useful for assessing landscape shots, but a poor indication of how good my wildlife shots are. In fact, on a recent shoot, before returning to my car, I reviewed all my shots on the LCD screen. The one that looked best was awful viewed on my laptop, while some that looked pretty poor on the camera screen were outstanding on the laptop. Use this LCD screen as a guide only. It is also worth noting that you can miss out on shots if you spend too much time reviewing images, and excessive use of the LCD screen will run your battery down.

Sensors are now so good that they can show up an inferior lens much better than film can. For this reason, buy good glass! Cheap lenses and quality sensors simply do not go together. In wildlife work, it is inevitable that you will want to buy a telephoto at some point. I decided that 300mm wasn't enough for many wildlife subjects. For this reason, I opted for a 400mm lens; however, prices of wide-aperture 400mm lenses were beyond my budget, so I went for an f/5.6 lens. This is still a good lens, and razor sharp, but simply not capable of as wide apertures and therefore as fast shutter speeds. For most of what I do it is quite adequate, and probably produces better images than a wide-aperture 300mm lens with a teleconverter. This is one area that cropped-sensor DSLRs have advantages as their so-called 'focal length magnification factor' makes the lens behave as if it were longer. For this reason, it is well worth considering, if you have the cash, using a full-frame DSLR or a medium- or large-format camera for landscapes and a cropped-sensor DSLR for wildlife.

on the
Road

If you are shooting wildlife, and don't want to be loaded down with a tripod, use TTL fill-in flash to add punch to your image and also to freeze motion. It works well in macro photography and with long lenses in particular, although the subject obviously has to be close enough.

◄ **Great cormorant.** Capturing good wildlife shots is often about capturing an animal's behavioural traits. In this example a great cormorant is shown in its characteristic pose.

The final and biggest change for the wildlife photographer swapping from film to digital capture is the workflow that follows exposure. This is going to be the sticking point for many. I am just now beginning to adjust to the extra time I must spend in front of a computer to make the most of my photography. To those daunted by this aspect of digital nature photography, I say to you, the extra control you have over exposure (especially RAW files), and the immediacy of the process will win you over eventually.

Macro and close-up

My greatest interest in wildlife photography is macro. I simply love to explore nature in close-up, and to render images that people rarely see with the naked eye. My two concerns about going digital were that I might not be able to produce good-quality landscapes using wideangle lenses, and that I might have problems combining a 100mm macro lens with TTL electronic flash to capture small creatures on my sensor as effectively as I did on film. These fears were totally unfounded.

If you are considering investing in some macro kit, then there are several tools that you might be interested in to enable you to capture your subjects at high magnifications. A specialist lens is the best, although in many cases most expensive option, this will allow you to get in close to your subjects and reproduce them large. Extension tubes (sometimes called extension rings) are another option, and these can be fitted between a lens and camera to allow you to focus your subject closer and therefore reproduce it larger. These can be particularly useful when used with longer lenses to allow you to capture relatively shy or flighty subjects. Bellows perform a similar function, but while they offer a great deal of flexibility, they are too cumbersome to use effectively in the field in the majority of situations. Close-up attachment lenses are a fine starting point for anyone on a budget, but they are comparatively low quality and your results may be dissapointing.

▼ **Saw-shelled turtle.** Shot on a DSLR with a 100mm macro lens and off-camera TTL flash.

◄ **Troodos lizard with earwig.** Good wildlife photography is often about capturing the moment, and in particular the behaviour of an animal. In this shot I struck lucky managing to capture this lizard as it made off with its lunch – an unfortunate earwig!

▶ **Silver studded blue.** At large magnifications the depth of field can become very shallow. This can influence your compositions and here the subject is kept parallel to the sensor in order to keep it in sharp focus.

▼ **Southern leaf-tailed gecko.** This lives in my garage. Most often he can be found under my potting compost bags, sometimes behind the blinds. I carefully moved him on to a piece of rock to shoot him with a DSLR and a 50mm macro lens before returning him to the safety of my garage.

chapter 7
Professionalizing your photography

If you're thinking about a career in nature photography, then digital capture offers so many advantages over film. Many photo libraries have had to invest a fortune in both equipment and time to digitize their slide collections. This process is necessary in order that clients can download images directly from the library server. Make no mistake, the world is going digital, and if your photography doesn't join it, any professional aspirations you have will be left behind.

An overview

If your images are already digitized, you can save your library and yourself the hassle of scanning. This is something you would not be able to avoid if you had shot on slide film. Your digital file can be copied at the click of a mouse; the clone being identical in every respect to the original. When film held sway, duplicating a slide meant an inevitable loss in quality and an additional expense.

This ability to duplicate your images without limit means that you can send your files to established or potential clients without worrying about possible loss or damage. I still have sleepless nights worrying about my existing slides getting lost in the post or being damaged by the client or agents (it has happened to me on many occasions). It also means that you can send the same file to different customers at the same time, or create a version for your website while creating another for print, this flexibility is of crucial help to both aspiring and existing professionals. However, while digital technology has enabled

DIGITAL DETAILS

One area that digital excels at is low-light and dusk photography. This was always a bit hit-or-miss when using film, but digital cameras help create far more saleable shots.

professionals to take huge leaps forward, the fact that it has democratized the imaging industry means that there are now far more photographers in competition than ever before. So the challenge remains: how to make sure that you succeed where others fail.

In a sense, with film we all participated on a level playing field. The camera made little difference; the defining character of an image came down to the type of film and your good technique. Today, that is not the case, however, you do not need the latest and greatest camera to succeed. This point is crucial: when submitting images to clients, or displaying them on your website, quality is of paramount importance. Out-of-focus or poorly exposed images are simply unacceptable and all they will do is create a bad impression of your abilities.

I do not say this to put you off selling your images, rather by way of encouragement. If you and your images are good enough, and you are determined enough then you will be able find a market and succeed.

◀ **Gunnerside, Yorkshire Dales National Park, UK**. This image was taken on a Fuji GSWIII 6x9cm medium-format rangefinder with a 65mm wideangle lens. The image file is large and was tweaked in Photoshop to boost saturation as the professional scan was very neutral relative to the original transparency.

on the
Road

Carry a note book and pen in your camera bag to scribble down thoughts that might help in future photographic endeavours – don't bother with exposure information though, as this EXIF is already tagged to the image file as metadata. You may need to note the length of any bulb exposures though (in excess of 30 seconds on most cameras).

The options for selling your digital images

It really doesn't matter if you are a professional or amateur, to succeed you must be a driven individual with a deep and enduring passion for the photographic process, and possess the inner vision to create consistently good, and sometimes brilliant imagery. You need to have absolute focus and a desire to succeed.

As I've already mentioned, digital imaging has made selling your photographs at once easier, and at the same time more competitive. It's up to you whether you market yourself or use an agent in the form of a photo library. Although going it alone means you don't have to pay an agency any commission, the chances are you will miss out on additional sales that a good agency can offer. This is because successful photo libraries have a far wider client base than you are likely to compile. You also need to recognize that your work will be viewed alongside that of other photographers contributing to the library, so your work must stand out if it is to sell.

The world is a much-changed place from a decade ago. If you have a talent with computer systems, or know someone with reasonable technical skills, you could set up your own website and server providing access to anyone wanting to download an image for commercial use. This isn't as difficult as it sounds. Make it a long-term project to learn a web-authoring program

▲ **Dyeing vats, Medina, Fez, Morocco.** Travel images that show aspects of life that are unique to a culture are often good sellers.

◄ **Blue Gate and Mosque Sidi Lezzaz, Fez, Morocco.** Including people in your travel shots often makes them more saleable, as they have a human element that can be used in a variety of situations.

such as Front Page or Dreamweaver. Then buy one of the programs that allow you to organize your images in a searchable online database. There are costs involved, but from little acorns...

Your endeavors may be particularly successful without an agent if you have a particular expertise, and choose to photograph aspects of this interest. This is particularly true if few other photographers can supply your type of work. Also, if you decide to go it alone, you can increase your sales potential by putting together a package of words and pictures. These sell far better to the editorial market than either can on its own.

There are many sources available for you to research potential markets. Obviously the Internet is a great place to start, but lists of prospective clients are also published in various tomes such as *The Writers and Artists Year Book*, the *Photographer's Market* and *The Freelance Photographer's Market Handbook*. Various newsletters are also available such as that produced by the Bureau of Freelance Photographers in the UK.

Putting these 'all-in-one' sources to one side, it is always worth looking in your local newspaper/magazine store for inspiration. Browsing magazine stores should give you some really good ideas for likely articles and prospective markets. As I write this book, there has been a phenomenal explosion of magazine titles covering the field of digital photography. Make the most of this, and send off some speculative submissions of your digital work.

If there is one piece of advice you should always remember, it is to find out what a particular market requires in terms of images. What format and size they require, how much work you should carry out in Photoshop, what media you should supply you files on, what lead times are for seasonal stories and so on. The only other thing I would say to you is good luck!

◄ **Golden python.** When shooting wildlife subjects, remember that images with strong eye-contact are often more saleable than those without.

Working with a professional lab

In recent years things have changed as much for photo labs as they have for photographers. In a world where photographers can now capture, enhance and print their images at home, one must ask why would anyone ever need to use a professional lab. The answer is twofold: firstly, if you have a high throughput, there simply aren't enough hours in the day to do everything yourself; secondly even if your throughput is fairly low, and if you have a good printer at home, things can still go wrong and you can waste time and money trying to rectify problems. I have given up printing at home except for occasional proofing. All my printing is handled by a professional lab that does a consistent and exemplary job. The cost is not so much higher than that of home printing, but the quality is better and the worry and all that extra time taken is no longer required.

Labs have had to adapt, many offer a variety of print finishes, mounting, framing, web services, high-resolution scanning, archiving and so on. With the adoption of standardized protocols, the hit-and-miss results of yesteryear are gone forever. Today the best labs will ask for work prepared in Photoshop using accurately calibrated monitors. The chances are that the TIF files will need to be named in a logical manner to reflect the file resolution, dimensions and finish that you require for the final print. So for example, if I have two images needing printing, possible examples of the file-naming system a lab might require are: 01_48x36_MDL_Q1_CM_300.TIF or 02_12x36_MDL_Q3_CM_300.TIF – where the print number, dimension in inches, your initials, the quantity required, the finish (CM = colour metallic) and the resolution are all descriptive elements within the file name.

I supply my files on CD, and am never disappointed with the results, which are usually returned within a week. It only takes half an hour to prepare an order of multiple prints on CD; by contrast it can take many long and frustrating hours to produce the same prints yourself at home using your own inkjet printer. I know which method I prefer.

The chances are that at home you will be producing inkjet prints. Take care when framing inkjets – if you don't let the ink and paper cure for a sufficient time period before framing, they can release chemicals that settle out on the

▲ **Sydney Opera House, New South Wales, Australia.** This is a photostitch of the Opera House that I took to try and emphasize the drama and activity that occurs around this popular area at dusk.

▲ **Wyrrabalong National Park, Bateau Bay, New South Wales, Australia.** Five miles along the coast from where I live is a small area of coastal heath set aside as National Park. Each spring the wild flowers are a riot of colour. This shot could have done with less contrast, but still, my Canon Powershot G6 and photostitch software has done a good job in piecing together this panoramic. The path provides a critical element in holding the picture together.

DIGITAL DETAILS

Work closely with you're lab – develop a good rapport with the staff and listen to their advice. In this way you will get the most out of your image files, and they will look spectacular when printed up.

back of the framing glass. This is often referred to as gas-ghosting. I must confess that I prefer photographic prints to inkjets, even to the latest generation of ink sets. Part of the reason for this is that almost anyone can produce a decent inkjet print these days, but a quality photographic print is not such a common commodity, and I feel more comfortable selling a photographic print than I do an inkjet.

The other major role that a lab might play is in scanning your transparencies. Large-format and even panoramic slides can be scanned at home these days, especially using competitively priced flat-bed scanners. However, if a slide is really special, I might still ask my lab to drum scan it rather than do it myself. The reason being that the lab is then responsible for cleaning the slide up. It can take forever cleaning a scan up at home. I never scan with the software dust removal option activated as the scan never seems as good – I prefer to clean it manually at 100% with the healing brush and clone tool – a time-consuming job, especially if fine scan lines are present.

Working with a lab is certainly the best way to achieve optimum results for use as fine-art prints, and the chances are that you will also learn something from their accumulated wisdom in the area of image input and output. If you use a lab regularly, its quite possible that you will be entitled to a preferential rate that reflects your level of use.

On-demand publishing

No author forgets the thrill of seeing the proof copy of his or her first book. Unfortunately, not everyone is lucky enough to be published and to have this experience; at least not until recently.

There are now several companies that you can work with to produce illustrated books that are of outstanding quality. The company I have used and which produce printed images to a standard beyond anything I have experienced previously is Asuka Books. Although this kind of limited print-run self-publishing is probably a better and more profitable route for social photographers – particularly wedding photographers – it is still worth considering if nature and landscape photographic art is your forte.

There is a huge scope for personalizing your books. Not only will they contain your own images, but you can also select a style and finish that you are happy with.

Natural Bridge National Park, Queensland, Australia

This picture was taken in southern Queensland at Natural Bridge National Park, Australia. Most people take the classic shot from inside the cave looking out and through the cascade. I wanted to be different and found this view which I think is actually a superior vantage point. I'm very pleased with this image and it looks absolutely magnificent as an 18 x 24in (45x60cm) matted print.

- Like so many good scenes I was presented with a dilemma. The contrast was high – do I expose for highlights or shadows? The broken-up nature of the high-contrast areas meant a neutral-density graduated filter would be inappropriate. In the end I decided to expose for the mid-tones, and metered from an area of green vegetation, which produced an acceptable compromise in my opinion.

- I applied curves and levels as appropriate in Photoshop, tweaked the red channel in the colour balance, added 10–20% saturation and then interpolated with the Extensis Smartscale plug-in, before sharpening it using Unsharp Mask

Design, author and publish your own website

What is the point of taking beautiful images of the natural world if no one else has the opportunity to enjoy them, and even better, the opportunity to buy them? The Internet has changed the world in which we live. From a photographer's perspective, it has democratized the business of image making and marketing, the two core facets of earning a successful living from photography.

There are two basic approaches to developing a website of your own: let someone do it for you, or do it yourself. There is much written on the subject in the photographic press, with several magazine articles each year listing the numerous companies that offer this service for photographers. There is generally little other useful information provided outside of the obvious points: a web presence provides you with access to a global audience; it provides a mechanism to 'professionalize' your operation; if a sophisticated site is set up, it can act as a 'virtual shop', permitting customers to buy prints or reproduction rights for images. It is cheaper than actually renting premises, and if you do own or rent premises, it is, in this day and age, an absolutely necessary adjunct to your business.

A good site should be kept 'fresh' in order to help to promote a photographer's reputation, and develop follow-up trade from previously satisfied customers, and their contacts. Put your web address on a business card, and it allows prospective customers to consider making a purchase at their leisure.

There are downsides, everyone is getting in on the act these days, and simple sites put together by third parties are so commonplace, impersonal, and prosaic that they often don't warrant a second glance. The secret is to have good interaction with your host server, and regularly update your site. Perhaps with new pictures, or planned expeditions, or even a blog that keeps people up to date with what you are doing or a forum to allow a discussion on topical photographic issues.

For this reason, I want to spend some time talking about setting up your own website from scratch without the intervention of a third party, except your chosen host. This is the route I chose, and I believe it to be the best way forward. I taught myself FrontPage, which is a web-authoring software that comes with the Microsoft Office suite, and is fairly simple to get to grips with. After learning the rudiments, so you can slowly move forward with your web-development skills. When I became confident in FrontPage, I then learnt Dreamweaver, which is probably the industry standard analogous to Adobe Photoshop in image-editing circles. Once I had designed and built my website, I selected a host to look after the site. Using the information they provided, I selected my domain name – www.marklucock.com – chose 3GB of server space and coughed up around $200 AUD, for two years' hosting. That was the total cost, other than personal time taken to build the site.

I'm pleased with my site, although it lacks e-commerce capability, which is something I hope to put right in the future. However, I have designed it in a way that still permits commerce to take place, albeit in the old-fashioned, personal way. You should be very wary of setting up an e-commerce facility yourself,

▶ In making this image I took several shots of surfers with the aim of trying to bring together the surfing action and a good landscape composition that contained plenty of sunset colour in the sky. I used a polariser attached to my 50mm lens in order to create the greatest interest in the sky. It was taken on a Canon DSLR.

DIGITAL DETAILS

Before employing a third party to set up your website – have a go yourself, you will be surprised how simple it can be.

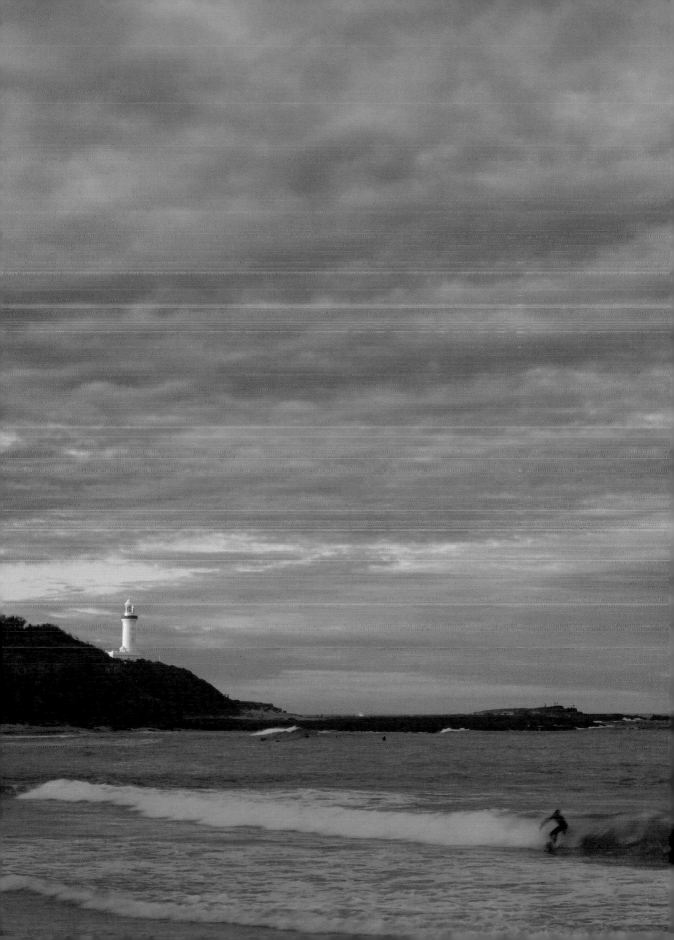

▼ **Web gallery.** One of the galleries I created on my website to facilitate viewing of the prints that I sell.

▼ **Windows Explorer map.** To illustrate how easy FrontPage is to use here is a simple Windows Explorer map of my website.

▼ **Underlying HTML.** The screengrab below shows the underlying HTML code for the biography part of my website. It may look daunting, but you don't actually need to understand HTML to create your site.

unless you are fully aware of what the legal implications are in the case that problems with transactions should occur. My advice is definitely to seek third-party help on this issue.

I hope this brief resume of how I set up www.marklucock.com will encourage you to have a go at learning how to build your own site – it takes time, so cater for a month or more, but is well worth the effort. Although I live in Australia now, I selected a UK based host and a '.com' URL, rather than a '.com.au' or '.co.uk' URL, so don't think that you are limited to local or national providers – you're not.

The one thing you should be aware of is that professional site developers can be extraordinarily expensive, or if competitive, they may offer only simple template solutions to your problem. What I would suggest to you is look over my site, then look at the bespoke sites of other professional nature and landscape photographers, and compare these with some of the more generic sites out there. I know which kind of site I prefer.

Before you start building, you should understand certain rules. Recognize what information you are trying to convey, and why. What is it that is special or unique about your site, in other words, why will people be visiting your site? It may be that all you want to do is 'vanity publish', or it may be a way for friends, family and other interested parties to keep in touch with your work on a holiday, expedition or work-related project. Of course for many, it will be a portal for people to view and purchase your art. Whatever your angle, ensure that your audience can immediately experience why your work is so special.

Cardinal rules include avoiding overly busy web pages and avoiding too much garish colour. Don't go overboard with your mix of font sizes, and absolutely do not upload excessively large files (especially images). Large files take forever for viewers to download, and as a consequence, they will get bored and move on to the next site; its sad I know, but you should cater for an audience with a short attention span.

Try to avoid a poorly organized page structure. This can't be emphasized enough. Remember to make a simple home page that, is easy to navigate around – your first thoughts should be on this issue of organization.

When you've created a couple of web pages, say your home page and a biography, you link them together by selecting a word, image or icon and inserting a hyperlink. It's really very easy. You can even link word documents, slide shows and pdf files to hyperlinks.

Once you've learnt the rudiments, there can be a tendency to go overboard with colours, borders, backgrounds and things like animations and sound. My preference is to keep it simple, and make it professional. Avoid serif fonts such as Times Roman, sans-serif fonts such as Arial fonts look 'cleaner'. Keep pages short; don't make your audience scroll down the page too far. A good rule is to keep everything consistent – background colour, font, borders, navigation bars and so on. Study other sites you think look good and think about what it is that makes them work.

When you have finished designing and building your site, and you have acquired a domain name and host, you can then use your web-design software to upload your files to your host's server. There are two possible protocols for uploading files to your server: HTTP (hypertext transfer protocol) and FTP (file transfer protocol), which is what I use. It's an easy process, and shouldn't pose to much of a headache. When you have mastered the basic utilities, you can begin to explore all the other possibilities that web authoring

offers. It's not rocket science; so don't be scared to have a go. When you gain a bit of confidence, you can buy one of the many books out there, and take your skills to the next level, creating a more advanced website that enables you to better display your photography.

▼ **Preview page.** Below is a preview page from the FrontPage editing interface that I used to create the biography page for my website, this highlights just how simple and intuitive web-design programs can be.

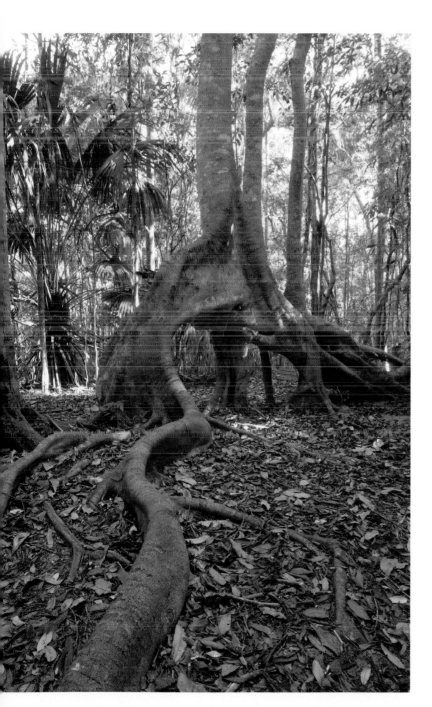

◄ **Strangler fig.** While it might be tempting to use only landscape-format images on your website to match the shape of the screen, it is important to keep some variety to show the breadth of your work. This strangler fig grows close to where I live. I shot it using a wideangle zoom with the aim of drawing the viewer into the frame using the root as a lead-in line.

Glossary

Adobe 1998 RGB
A wide-gamut colour space that is generally used when printing using a four colour (CMYK) process.

Aliasing
The appearance of jagged pixel edges that can be seen within any curves or lines of the image at or around 45 degrees. Anti-aliasing is the process used in Photoshop and other image software that helps to soften the edges of the image to reduce the effect of aliasing.

Algorithm
A mathematical equation that gives a solution for a particular problem. In relation to photographic imaging this relates to a set code that will define how values of particular pixels will alter in an image.

Aperture
The adjustable opening in the lens which can be altered in order to vary the amount of light admitted and the depth of field.

Archival value
The longevity of an image in any form, generally in relation to the combination of ink and paper.

Artefacts
Imperfections in an image which are generally caused by image manipulation, inherent flaws in the capture process and also by any computer errors which may manifest themselves in the image. These can be exacerbated by the process of compression, such as used by JPEGs.

Aspect ratio
The ratio of the dimensions of an image (width:height).

Batch conversion
Converting a number of files from a RAW format into your chosen format, usually JPEG or TIFF, at the same time.

Bicubic interpolation
A method of interpolation whereby new pixel data is created in relation to the value of the nearest eight pixels. This method is superior to other forms of interpolation such as bilinear interpolation and nearest neighbour.

Bit depth
The number of levels of colour graduation contained within an image. Typically either 8-bit or 16-bit.

Browser
Any software that allows you to view you image files, generally in the form of thumbnails and then as full-size previews when selected. Other functions may be included.

Burst depth
The number of images that a digital camera can shoot in a row, before the burst rate slows.

Burst rate
The number of frames per second that a digital camera can capture.

Calibration
Matching the output of a device to a standard to create consistency, for example, between the colour that you can see on screen and that produced by a printer.

CCD
Charge coupled device: a semiconductor that measures light and is is commonly used in many digital cameras.

Channel
Information within the image that falls into a group. Generally used in reference to colour channels; such as red, green and blue.

Clipping
The occurrence of image data that falls outside the colour gamut of the device being used or the dynamic range of the sensor. This records as pure black or white, without detail.

CMOS
Complementary metal-oxide semi conductor, an alternative to the CCD sensor that is widely used in cameras and computers.

CMYK
The colour mode used for the four-colour printing process, as opposed to RGB.

Colour gamut
Simply the range of colours able to be reproduced by a device and visible to the naked eye. Also the range of colours available within a particular ICC colour profile.

Colour mode
The way in which an image presents the colours and tones that it contains. Not to be confused with ICC colour profiles, colour modes include RGB, CMYK and greyscale.

Colour temperature
The colour of light in terms of a Kelvin rating. A low Kelvin rating of 5,500 or below renders warm tones while anything over 5,500 Kelvins renders cool blue tones. Colour temperature can generally be adjusted during the RAW conversion process, using a slider via a live preview.

CompactFlash

A popular form of memory card that, at the time of writing, is the most widely used for digital SLRs.

Compression

A process where a digital file is made smaller to save storage space. Compression comes in two types: lossy, where the image quality is degraded and lossless, where the original quality of the file is kept intact.

Contrast

The transition between highlights and shadows. This can be controlled by a slider during the RAW conversion process.

Conversion

This is the process that converts a RAW file into a different format. In the process it makes any changes that have been applied to the RAW file permanent in the final file. A number of additional functions such as renaming and keywording can also be carried out at the same time. More than one file can be converted at a time, with a similar set of parameters, this process is called batch conversion.

Cloning

The process of duplicating pixels from one part of an image and placing them onto another part. This is generally in order to remove blemishes.

Cropping

The process of reframing an image and sometimes altering the aspect ratio at the same time. Some applications allow you to also interpolate the image during the cropping process.

Curves

A tool that controls exposure via the use of a curve that controls the relationship between input values and output values.

Depth of field

The envelope of sharpness around the point of focus in the image. The greater the depth of field the more of the image (from front to back) appears sharp. Depth of field increases as the aperture narrows, the focal length shortens and you get further from the subject.

Desaturation

The most basic way of converting to a black & white image involves simply removing all of the colour saturation using the saturation slider.

Dialogue box

A box which allows you to make alterations to various aspects of an image in a program and often view those alterations before finalizing the effect or command.

Digital negative (DNG)

An open RAW format, in other words, one that was not created by a camera manufacturer and which has widely published specifications. This theoretically allows for better conversion, and safeguards the file from becoming an obsolete format.

dpi

Dots per inch is a term that is used to represent the resolution of a digital file or print.

Driver

A piece of software that is designed to control and run a perpheral device from the computer such as a printer.

DSLR

A digital camera that meters from light passing through the lens, and offers a view through the lens in the viewfinder.

Dynamic range

The range of different brightness levels that can be recorded by a digital sensor, without a loss of detail in the highlights or shadows.

Edge sharpening

Image manipulation performed to create higher contrast edges.

Embedded data

Data that is tagged onto a file for future reference, this includes ICC colour profiles and Exif data.

Enhancement

Changes applied to the image, brightness, colour or contrast, which are intended to improve its appearance, but not change the overall 'story' that the image tells.

File format

The format in which a digital file is stored. Each format has its own qualities, some use compression to make file sizes smaller. The format of a file will also determine its flexibility and which programs can read it. Common file formats include JPEG, TIFF and RAW. Note that the term RAW does not refer to one particular format, rather to a group of formats with similar properties.

Filter

Filters apply alterations to the complete or selectively chosen parts of an image, either by fitting an optical filter to the front of the lens, or by applying a digital filter later on computer.

Greyscale

A monochrome image which is based on 256 tones starting from white and going through a range of grey tones until it reaches black.

Healing brush

A more advanced version of the clone tool, which automatically blends source pixels with background pixels to create a more realistic effect, for example, when removing dust spots.

High resolution

The term high resolution generally refers to those files that are suitable to print, this is typically accepted as being those files with a resolution of 300dpi at the specified size.

Histogram

A graph showing the spread of pixels over a range of tones; the number of pixels are shown on the vertical axis while the range of tones, from black to white, is shown on the horizontal axis.

Hue

The colour of light as distinct from its saturation and its luminosity. This can be adjusted via a slide in the RAW conversion software.

ICC colour profile

International colour consortium profile. A named colour gamut that harnesses various characteristics and has openly available specifications.

Image circle

The circle of light transmitted by the lens onto the film or sensor.

Interpolation

A method of increasing the resolution of an image by inserting new pixels, the values of which are based on calculations from existing pixels.

ISO

The sensitivity to light of a piece of film or a digital sensor.

JPEG

A file format that was developed by the joint photographic experts group featuring built-in lossy compression. The compression enables otherwise large image files to take up a far smaller amount of space, with variable quality and compression.

JPEG 2000

A newer version of the JPEG file, being more flexible and allowing better quality, creating less visible artefacts.

Kelvin

The unit of measurement used to express colour temperature within an image, 5500 Kelvins is indicative of normal daylight, below this temperature images become progressively warmer and above this temperature images become progressively more cold. A colour temperature slider is available to apply alterations in most RAW conversion software.

Keyboard short-cut

Designated keys in software programs either preset or changeable by the user to run commands at a key stroke. This is in order to ease your workflow.

Large format

A camera using a film (or digital back) of dimensions of 5x4in or greater.

Layer

A floating copy of the original image, or in fact any image, which sits on top of the background image, multiple layers may be opened with different effects applied to each one. They are like virtual sheets of acetate sitting on top of the image. To preserve layers for future manipulations the image must be saved as a PSD format file.

Layer opacity

The opacity or transparency of each layer covering the background image. As the opacity is changed the layers beneath become more or less visible. This can be used to vary an effect that is only applied to one layer.

LCD

A liquid crystal display, digital camera screens for reviewing images and accessing menus as well as laptop computer screens are LCD screens.

Levels

A simple tool that is based on a histogram, which allows the correlation between input and output values to be adjusted in order to alter the exposure.

Low resolution

The term low resolution is generally taken to mean any image that is sufficient for display on screen, but not for printing.

Manipulation

A term for any alterations made to an image that stretch beyond enhancement and actually change the 'story' that is being told by the image.

Marquee tool

A selection tool of varying shapes used in Photoshop.

Mask

A tool that is widely used within Photoshop which allows the user to mask off areas which will be excluded from the various manipulations applied to the image.

Megapixel

One million pixels, multiples of which are commonly used to denote the resolution of digital cameras' sensors or of an image; for example, a 10-megapixel camera.

Microdrive

A memory card of the same dimensions as a CompactFlash card, but that includes moving parts, and is, as the name suggests, effectively a small hard drive.

Midtone

The range of tones in an image that reflect 18% of the light that falls on them. The basis for many metering systems in which calculations are based on an assumed midtone.

Monochrome

An image made up solely of various tones of grey, or for that matter any other single colour.

Noise

The randomly and incorrectly coloured pixels that can afflict a digital image. These are often caused by a high ISO setting or a long exposure. Lightening an image's exposure can make noise more obvious, particularly in the shadow areas.

Opacity

The transparency of an effect that has been applied to an image, or the transparency of one layer that is placed over another, this is controlled by the opacity slider in the layers dialogue box.

Out of gamut

A term that relates to colours that can be seen and reproduced in one colour space, but are not seen or reproduced when taken into another colour space. Such inaccessible colours are termed as being 'out of gamut'.

Overexposure

Either rendering an image lighter than it should be by allowing too much light to strike the sensor, or the complete loss of highlight information through tones being rendered too bright to be captured with detail by the sensor. The first is correctable, but the second is not.

Palette

A menu within the editing mode allowing select changes to the colour and the brightness of an image.

Pixel

The smallest part of the image, the building block of the image, stands for picture element.

Pixelation

The visibility of individual pixel edges within an image, often caused by excessive enlargement.

Plug-in

An accessory file that operates through another program. Typically this will be Photoshop and the plug-in will be incapable of running independently. Plug-ins perform specific functions such as sharpening.

Preset

While many corrections to RAW files are made using sliders, there are also generally a number of presets that are available. For example, while the white balance can be adjusted by using the colour temperature slider provided, it can also be altered by selecting a white balance preset such as 'daylight', 'tungsten' or 'flash'. The same is true for other parameters.

RAM

Random access memory. A rapid form of memory communication where the computer stores data in order to process functions.

Photoshop itself is very dependent on RAM requiring approximately five times the image size in order to run smoothly. RAW conversion software also relies on being able to display and quickly update full-sized previews so the demands placed on RAM are very high.

RAW

A generic term for the many proprietary file formats that are produced by different manufacturers' digital cameras. A RAW file contains the raw sensor data and is accompanied by a set of parameters which remains flexible and can be altered during the RAW-conversion stage. Most RAW files need to be processed before being used outside of RAW software.

RGB

A colour mode where all the colours within an image are made up of red, green and blue. RGB is the most commonly used colour mode for digital cameras, home printing and screen display.

Resampling

Changing an image's resolution by either removing pixel information and thus lowering the resolution, or by adding pixels via interpolation thus increasing the resolution of an image.

Resolution

Either the absolute number of pixels that an image contains or that a sensor can capture – see megapixel – or the number of pixels that can be printed or displayed over a certain distance, see high resolution and low resolution, typically expressed as the number of dots or pixels per inch. In the later case resolution is only relevant in relation to an absolute value for the size at which an image will be printed or displayed.

Saturation

The intensity of a particular colour, the more saturation the more intense the colour. An image with no saturation will be rendered greyscale. Saturation can typically be altered in RAW conversion software via a slider or series of sliders.

Sharpening

The application of increased contrast to areas of transition in order to create the illusion of an image being crisp.

Shutter speed

The length of time for which the shutter is open. This has an impact on the appearance of subjects in the final image.

Slider

An adjustment tool that is commonly used in many RAW conversion programs to make alterations to variable parameters such as contrast and saturation.

sRGB

A colour space that is narrower than Adobe 1998 RGB, but is commonly used for display on computer monitors and output through home printers.

Thumbnail

A low-resolution preview image of a larger image file, used to check what the image is before opening the full-sized file. These are used in many browsers to enable you to scroll through a number of images.

TIFF

Tagged image file format. A format that is widely used by professionals as it is compatible with the vast majority of programs on both Macs and PCs and can be archived as it does not use compression.

Underexposure

Either rendering an image darker than it should be by allowing too little light to strike the sensor, or the complete loss of shadow information through tones being rendered too dark to be captured with detail by the sensor. The first is correctable, but the second is not.

USM

Abbreviation for unsharp mask, a process where the image is sharpened using the unsharp mask filter in Photoshop.

Vibrance

A so-called 'intelligent' saturation tool that seeks to enhance only those parts of the image for which it is appropriate.

White balance

The in-camera function that allows compensation for different colour temperatures. This is also a function that can be access through most RAW conversion software.

Workflow

The process from prior to the intial capture, to the archiving of the final file.

Useful websites

Inspirational photographers

Peter Adams
www.padamsphoto.co.uk

Theo Allofs
www.theoallofs.com

Ellen Anon
www.sunbearphoto.com

Andris Apse
www.andrisapse.com

Niall Benvie
www.sol.co.uk/n/niall.benvie

Steve Bloom
www.stevebloom.com

Alain Briot
www.beautiful-landscape.com

Clyde Butcher
www.clydebutcher.com

Christopher Burkett
www.christopherburkett.com

Laurie Campbell
www.lauriecampbell.com

Richard Childs
www.richardchildsphotography.co.uk

Joe Cornish
www.joecornish.com

Charles Cramer
www.charlescramer.com

Bruce Dale
www.brucedale.com

Peter Dombrovskis
www.view.com.au/dombrovskis

Ken Duncan
www.kenduncan.com

Jack Dykinga
www.dykinga.com

Michael Fatali
www.fatali.com

John Fielder
www.johnfielder.com/index.php

Michael Hardeman
www.michaelhardeman.com

Ross Hoddinott
www.rosshoddinott.co.uk

Robert Glenn Ketchum
www.robertglennketchum.com

Frans Lanting
www.lanting.com

Mark Lucock
www.marklucock.com

Peter Jarver
www.peterjarver.com/about.php

Tom Mackie
www.tommackie.com

Phil Malpas
www.philmalpas.com

Joe & Mary McDonald
www.hoothollow.com

Thomas D Mangelson
www.imagesofnature.com

Leo Meier
www.leomeier.com

Art Morris
www.birdsasart.com

David Muench
www.muenchphotography.com

William Neill
www.williamneill.com

David Noton
www.davidnoton.com

Colin Prior
www.colinprior.co.uk

Nick Rains
www.nickrains.com

Andy Rouse
www.andyrouse.co.uk

Galen Rowell
www.mountainlight.com

John Shaw
www.johnshawphoto.com

Tom Till
www.tomtill.com

Steve and Anne Toon
www.toonphoto.com

Larry Ulrich
www.larryulrich.com

Charlie Waite
www.charliewaite.com

David Ward
www.davidwardphoto.co.uk

Peter Watson
www.peterwatson-photographer.com

Art Wolfe
www.artwolfe.com

Photography news and reviews

Digital photography review
www.dpreview.com

Ephotozine
www.ephotozine.com

Fred Miranda
www.fredmiranda.com

Luminous Landscape
www.luminous-landscape.com

Rob Galbraith
www.robgalbraith.com

Steve's Digicams
www.steves-digicams.com

Manufacturers' Websites

Adobe
www.adobe.com

Apple
www.apple.com

Canon
www.canon.com

Ebony
www.ebonycamera.com

Epson
www.epson.com

Extensis
www.extensis.com

Fujifilm
www.fujifilm.com

Hasselblad
www.hasselblad.com

Horseman
www.horsemanusa.com

Mamiya
www.mamiya.com

Nikon
www.nikon.com

Olympus
www.olympus.com

Pentax
www.pentax.com

Realviz software
www.realviz.com

Sekonic
www.sekonic.com

About the author

Mark Lucock grew up in the east of England, and after graduating with a degree in Applied Biology he obtained his PhD in 1991. Today he is an elected Fellow of the Institute of Biology and a Chartered Biologist. Mark took the huge step of moving from the UK to the sublime and amazingly photogenic Central Coast of New South Wales, Australia in 2003 – a decision that he has never once regretted.

Whenever he gets the opportunity, he is out photographing the natural world. His work features a range of destinations – including the UK, India, Australia, North America and much of Europe – and reflects the broad spectrum of nature and landscapes from around the world.

Mark has had many publications in the popular press and *Digital Nature & Landscape Photography* is his fourth photography book. His first book *Photography for the Naturalist* was published by GMC Publications in February 2002 and covers the technicalities and aesthetics of shooting all manner of animal, plant and landscape images. Mark's second book, *Professional Landscape and Environmental Photography: From 35mm to Large Format* was released in February 2003. Again technicalities and aesthetics are examined, but the book also considers photography in a range of environments, from steamy rainforests and dry deserts to bustling cityscapes at night. His third book, *Succeed in Landscape Photography* (published by RotoVision SA) was released in October 2004.

Mark adopts a parallel approach to digital and analogue image capture; although he still uses medium- and large-format film cameras, much of his work is now carried out using Canon digital SLRs. He believes that because of advances in technology, the future of photography is bright, and that the democratization of the photographic process provides everyone with the opportunity and the potential to excel.

Index

Photographers' Institute Press, an imprint of The Guild of Master Craftsman Publications Ltd,
166 High Street, Lewes, East Sussex, BN7 1XU Tel: 01273 488005 Fax: 01273 402866 www.pipress.com